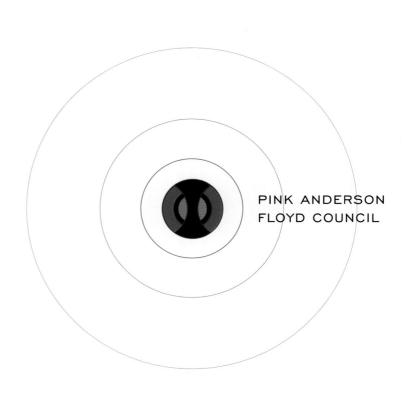

PINK ANDERSON
FLOYD COUNCIL

FRONTISPIECE
'TREE OF HALF LIFE'
CATALOGUE CAMPAIGN 1997

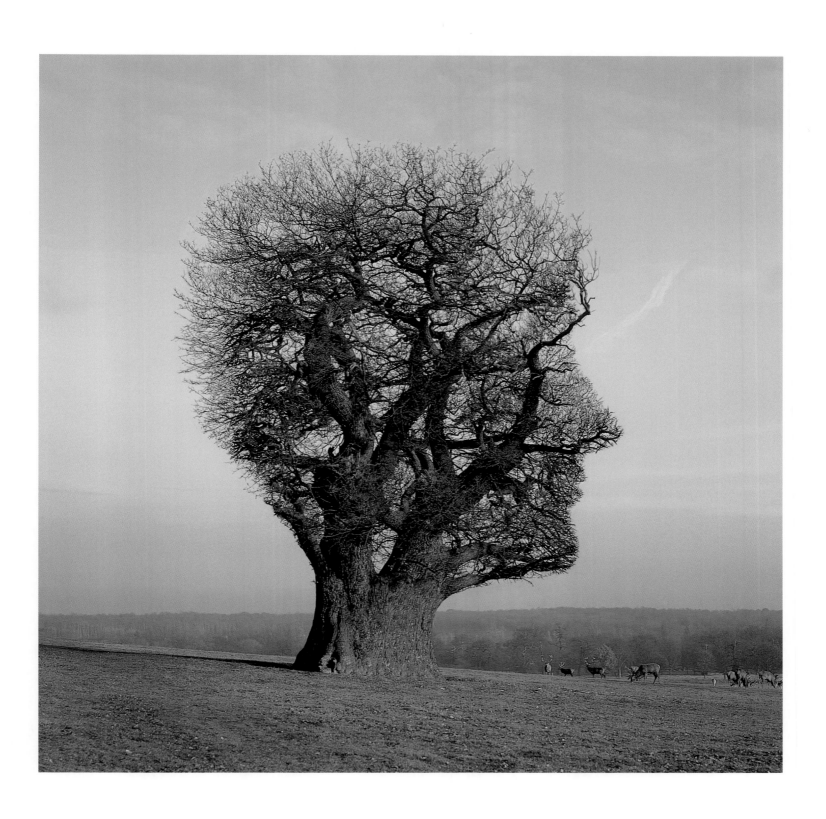

MIND OVER MATTER

THE IMAGES OF PINK FLOYD

Compiled and Designed by
Storm Thorgerson and Peter Curzon
Text by Storm Thorgerson

OMNIBUS PRESS

MIND OVER MATTER
THE IMAGES OF PINK FLOYD
FOURTH EDITION

Text: Storm Thorgerson
Book Design: Peter Curzon & Storm Thorgerson
Assisted by Dan Abbott
Editors David Gale & Chris Charlesworth

Author's Acknowledgements

My thanks to the following for their contribution to the production of individual artworks
in this book: emotionally, intellectually and technically, way beyond any call of duty.

Badger, Lee Baker, Richard Baker, Peter Barnes, John Blake, Keith Breeden, Robin Bernard, Sue Browne,
Paul Bigrave, Sam Brooks, Colin Chambers, Jessica Chaney, Cathy Cleghorn, Finlay Cowan, Kimberley Cowell,
Darrin Crawford, Graham Crawshaw, Jon Crossland, Peter Curzon, James Diener, Robert Dowling, Andy Earl,
Richard Evans, Mark Fenwick, Tracy Finch, Paul Fletcher, Jill Furmanovsky, George Hardie, Tony Harlow,
Bush Hollyhead, Stella Jackson, Ruth Katz, Paul Loasby, Richard Manning, Tony May, Angus MacRae,
Merck Mercuriadis, Julien Mills, Jane Monkswell, David Noade, Rob O'Connor, Steve O'Rourke,
Paul Rappaport, Jason Reddy, Joshua Richey, Stephanie Roberts, Jane Sen, Shuki Sen, Anthony Taylor,
Rupert Truman, Keith Turner, Sue Turner, John Whiteley, Robbie Williams, Ian Wright, Bob Ezrin,
and especially Peter Christopherson and Aubrey Powell – better known as Po.

And, last but not least, thanks of course to Pink Floyd, David, Nick, Rick, Roger and Syd.

This book is dedicated to Barbie.

Copyright © 2007 Storm Thorgerson Pink Floyd 1997.
First edition © 1997. Second edition © 2000. Third edition © 2003.
This edition © 2007 Omnibus Press (A Division of Music Sales Limited)
ISBN 13: 978.1.84609.763.8
Order No: VO10307

Exclusive Distributors, Music Sales Limited, 14/15 Berners Street, London, W1T 3LJ.

Music Sales Corporation, 257 Park Avenue South, New York, NY 10010, USA.

Macmillan Distribution Services, 53 Park West Drive, Derrimut, Vic 3030, Australia.

Printed by: Kyodo Printing, Singapore
A catalogue record for this book is available from the British Library.
Visit Omnibus Press on the web at www.omnibuspress.com

Several images from this book can be purchased as fine art prints via:
www.stormthorgerson.com

FOREWORD

STORM HAS ALWAYS HAD A BIG MOUTH. When I first met him he was fifteen and I was in short trousers. I still have a picture in my mind of this schoolboy holding forth to a group of similar-minded teenagers his views on things like Art, Drugs, the Meaning of Life and Immortality. Nothing much has changed (apart from my trousers). I am enormously fond of Storm. He has been my friend, my conscience, my therapist and of course my artistic advisor for over thirty years. He, with a changing team of friends/artists, has been responsible for most of our album covers (which can be seen in this book), as well as many of our videos and some of the films that we have used as part of our stage shows.

There was a time – during the making of the *Momentary Lapse Of Reason* album – that we were persuaded to consider other artists for the cover. The ideas presented by these "proper" designers seemed to be based on purely commercial terms which didn't fit what we were about. It was with relief that we went back to the devil we knew. Storm's ideas are not linked to anyone's ideas of marketing: that they are atmospherically linked to the music is a bonus. I consider what he does to be art.

David Gilmour

APOLOGIA

IT IS A LATIN CUSTOM to provide some indication of the substrate from whence a tome emerges and disclose in the interests of truth and honour the limitations thereby imposed. This book contains views and opinions that are the sole responsibility of the author and are in no way representative of Pink Floyd, or of individual members, or of anybody else for that matter. Such deliberations that may appear outside the given province, that is the mechanics of the imagery, are merely the untethered ramblings of the author's mind and bear little resemblance to truth or objectivity.

Approximately half the work contained herein was completed under the auspices of a design studio called 'Hipgnosis', a name derived from the alchemical mixture of the old gnostic and the new hip, whose members were Aubrey Powell (Po), the author and, later, Peter Christopherson. The remainder of the work was completed by the author in a number of loose affiliations, by far the most significant of which was the current 'team' displayed at the end of the book.

The author regrets the minor incompleteness of the great circle, namely two missing items, in so much as he was temporarily relieved of his post. The author recommends however that the relevance of much of the imagery is enhanced by the playing of appropriate albums. Music while you view.

No slander, distortion or unkindness is intended, and despite reasonable care all errors and misconstruances still remaining are the fault of the author, along with a fairly unrestrained egotism. For all these he most humbly apologises, such obeisance being another Latin custom.

Front cover The Piper At The Gates Of Dawn repackage 1994

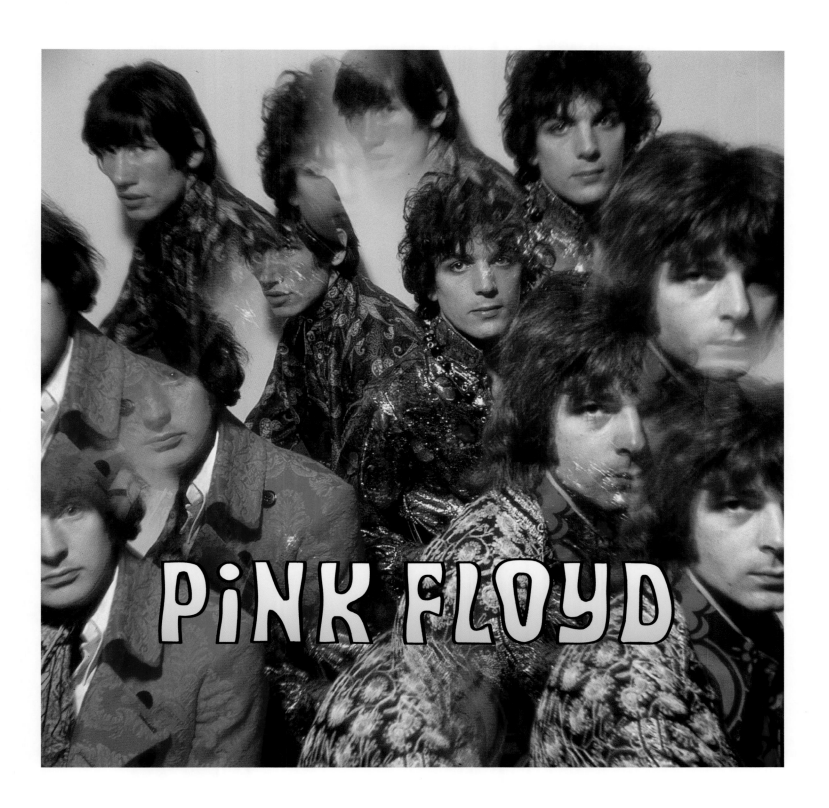

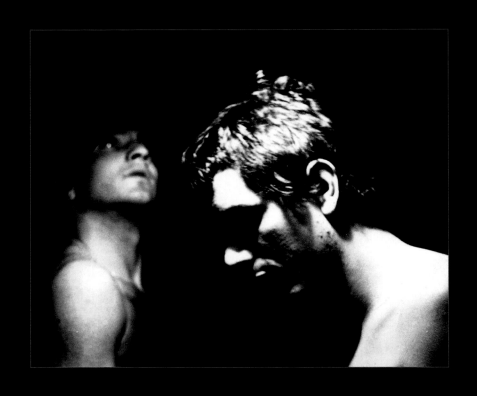
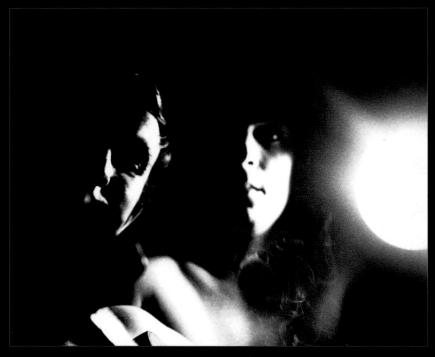

IN THE BEGINNING WAS SYD. Actually that's not true. In the beginning were The Abdabs, The Tea Set, Sigma 5 and other early incarnations of Pink Floyd. In the beginning Roger, Rick and Nick were together at architectural college forming a band and playing rhythm and blues.

Before the beginning though was Cambridge, university town, and home to a local county grammar school. Roger in one year, me a year below and Syd a year below that. David Gilmour was at a neighbouring school. But Syd never played sports like we did because he was into painting and The Beatles long before we were, and he had girlfriends and was good looking, and most particularly he played the guitar. An old Spanish

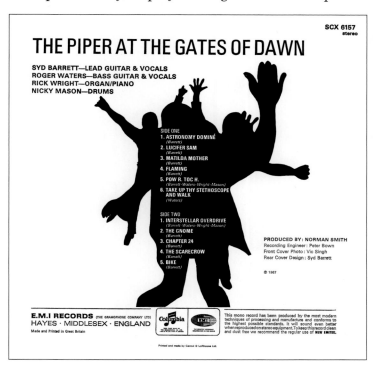

job, or acoustic with steel strings, or anything that was to hand. And he played Beatles songs, asking enthusiastically 'Have you heard this?' and strumming and singing 'Please Please Me'. He also sang his own songs, such as 'Effervescing Elephant', a sort of whimsical mix of nursery rhyme and rock song, and played them at parties, many of which we gatecrashed. I clearly remember Syd singing and playing at the late Ponji Robinson's house; his efforts were nice enough but showed little indication of the greatness that was to come.

One sunny afternoon in David Gale's garden, which was like a mini orchard, we sat around on the grass and drank 'orange juice'. For several hours Syd was very

preoccupied with three objects — a matchbox, a plum and an orange — which he kept close by him all day. They seemed to provide profound and endless fascination, as things do when one is under the influence. David Gale is with Syd in the pictures opposite, which were taken by me at another time — early experimentation with black and white film, low lighting conditions and the sensuality of half naked youths with guitars. Moody.

One of the many extraordinary things about Syd was that he was not so extraordinary — at least not to us at that time. He seemed to be normal, as much as any of us were, and one of a large Cambridge peer group whose other members like Paul Charrier or Emo, Willa or David

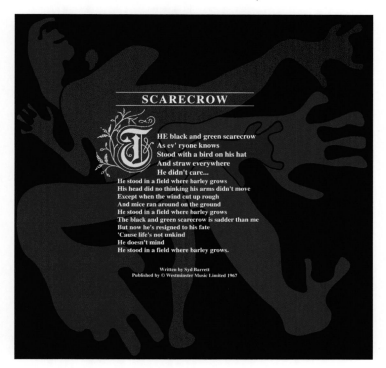

Henderson, would seem just as individualistic. Greatness under one's nose. It's amazing what you don't notice because it's right next to you.

It is perhaps fairer to say that in the beginning of Pink Floyd there was Syd. Prior to his arrival, the band comprising Roger, Rick and Nick, and Bob Klose, and Juliette, and Chris Thomson and other now ghostly figures who drifted in and out, was not only called by other names, but also played different kinds of music. By a set of unlikely developments too convoluted to go into, not unless you've got a couple of days, Pink Floyd emerged with four demos, a deal with EMI, and a first single 'Arnold Layne' released in March 1967.

That's forty years ago! I remember believing, as a virulent teenager, that talking to people over forty was bad enough, and deeply uncool, let alone the actual passage of forty whole years of time. I've got to lie down.

Syd wrote the first three singles and much of their first album, *The Piper At The Gates Of Dawn*. He was also responsible (we think) for the artwork for the back of the album cover, shown on the previous page, though not the lettering, I suspect. Next to it sits our contemporary adaptation and homage, executed for the repackaged CD by 'mad' Jon Crossland. On page thirteen is the actual front cover for *Piper* photographed by Vic Singh, revamped subtly for the same CD repackage by making the lettering slightly pink (gosh!). I don't think this front photo was made by sandwiching transparencies or by multiprinting; more likely by a multiple exposure actually in the camera, though I could be wrong. The picture goes some way towards evoking the contemporary sensibility – a nod in the direction of psychedelia – and provides a sense of the lovable mop tops (after The Beatles), as Nick likes to call early Floyd, as well as current styling trends in floral jackets and cravats. The Floyd themselves were probably all too excited by stardom to have had that much input. Vic Singh, where are you now, to tell us the actual genesis of this piece?

Displays of contemporary fashion in the rock business are commonplace, if not de rigueur, in any era. In matters of wardrobe the Floyd were no different from anyone else at this time. Many groups wore velvets, decorative shirts, floral or leather

THE PIPER AT THE GATES OF DAWN

jackets — some sported exotic hats and tall, leather boots. Belt buckles and scarves. Our friend Nigel Gordon was more flamboyant than any musician. It was perhaps just a question of nerve and interest. Those without either, which is more where I fit in, tended to be dowdy, continually wearing the same T-shirt and leather, suede or cord jacket, saving velvets for the weekend, and kaftans for outdoor events. Cooool.

The Floyd did not continue this trend. By '69 their dress sense was restrained for the most part, even undistinguished, while band or press photos became less regular and less sought after. The band grew bored with this kind of rigmarole and consequently remained visually unknown. Even after *Dark Side*, when they were truly humongous and world famous and known by nearly everyone in the entire country, they could still, unlike the Stones, walk down the street unrecognised and unbothered. Quite a feat, if you think about it.

By this time, however, Syd had long departed, orbiting wildly into regions unvisited by the rest of us. His legacy is, I hope, maintained to some extent by our feeble attempts to represent his whimsical brilliance visually in the repackaged CD booklet you see opposite. Although I do, on reflection, consider some of the design elements a little obvious, I think that this is a minor detraction, more than compensated for by the decision to feature the lyrics, and to put them centre stage, illustrated capitals and all.

I hope you're alright wherever you are, Syd, though I sadly doubt it. We have your music, and the purity of your words to remember you by. God speed.

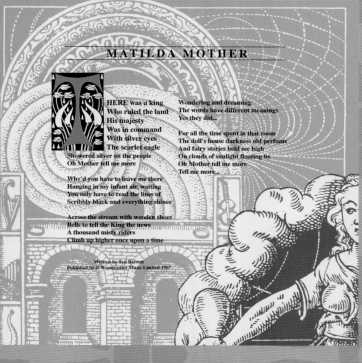

MATILDA MOTHER

THERE was a king
Who ruled the land
His majesty
Was in command
With silver eyes
The scarlet eagle
Showered silver on the people
Oh Mother tell me more

Why'd you have to leave me there
Hanging in my infant air, waiting
You only have to read the lines of
Scribbly black and everything shines

Across the stream with wooden shoes
Bells to tell the King the news
A thousand misty riders
Climb up higher once upon a time

Wondering and dreaming
The words have different meanings
Yes they did...

For all the time spent in that room
The doll's house darkness old perfume
And fairy stories held me high
On clouds of sunlight floating by
Oh Mother tell me more
Tell me more...

Written by Syd Barrett
Published by © Westminster Music Limited 1967

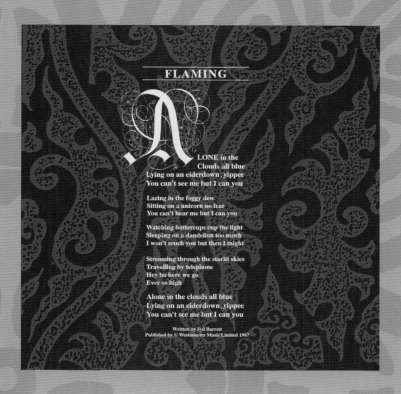

FLAMING

ALONE in the
Clouds all blue
Lying on an eiderdown , yippee
You can't see me but I can you

Lazing in the foggy dew
Sitting on a unicorn no fear
You can't hear me but I can you

Watching buttercups cup the light
Sleeping on a dandelion too much
I won't touch you but then I might

Streaming through the starlit skies
Travelling by telephone
Hey ho here we go
Ever so high

Alone in the clouds all blue
Lying on an eiderdown, yippee
You can't see me but I can you

Written by Syd Barrett
Published by © Westminster Music Limited 1967

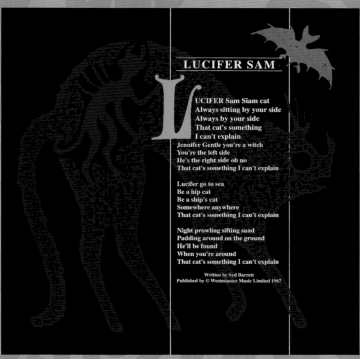

LUCIFER SAM

LUCIFER Sam Siam cat
Always sitting by your side
Always by your side
That cat's something
I can't explain
Jennifer Gentle you're a witch
You're the left side
He's the right side oh no
That cat's something I can't explain

Lucifer go to sea
Be a hip cat
Be a ship's cat
Somewhere anywhere
That cat's something I can't explain

Night prowling sifting sand
Padding around on the ground
He'll be found
When you're around
That cat's something I can't explain

Written by Syd Barrett
Published by © Westminster Music Limited 1967

ASTRONOMY DOMINE

LIME and limpid green,
a second scene,
A fight between the blue
you once knew.
Floating down the sound resounds
Around the icy waters underground
Jupiter and Saturn Oberon Miranda
And Titania Neptune Titan
Stars can frighten...

Blinding signs flap flicker flicker flicker
Blam pow pow
Stairway scare Dan Dare who's there...

Lime and limpid green
The sound surrounds the icy waters under
Lime and limpid green
The sound surrounds the icy waters
Underground

Written by Syd Barrett
Published by © Westminster Music Limited 1967

LYRIC PAGES PIPER REPACKAGE 1994

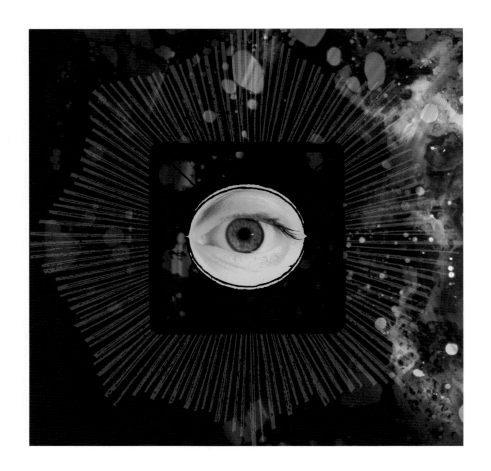

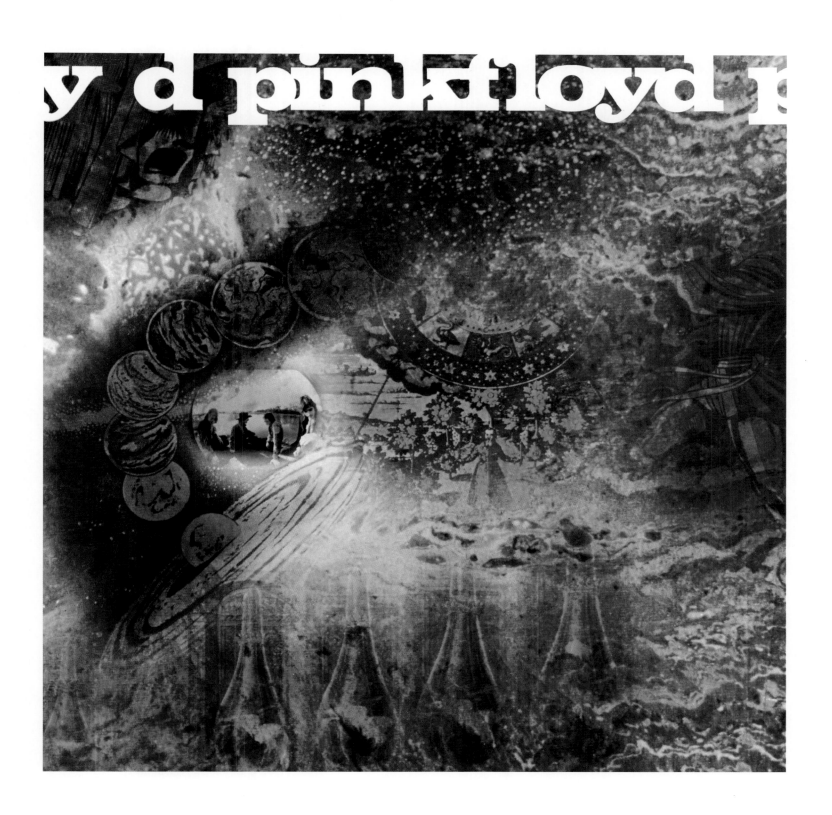

LET'S FACE IT, a whole lot of rubbish is written about the sixties. Like it was really wonderful, and there was unlimited freedom of expression, revolutionary new philosophies, exciting art developments, oodles of free love, terrific music and loads of sex and drugs. Art, politics and morals underwent a vast change. A dynamic confluence of ideas and people turned the world upside down. The most fundamental social changes of the last thirty years originated in the sixties. Youth culture, for want of a better word, asserted itself with a vengeance, etc etc, blah de blah, and so on.

Maybe the synaptical patterns of teenage existence blaze a path through the brain that is never dissolved and so everyone looks back with exaggerated fondness (or terror) at their teen years. It seems, though, to my unblinkered view that the sixties were all that they were held to be and more. It was a truly fantastic time. The 'love' revolution was funded by relative affluence, underpinned by drugs, and inadvertently led by music heroes like The Doors, The Beatles, Bob Dylan, the Stones and, wait for it, Pink Floyd. Perhaps a key difference was the spread. The sixties felt like a worldwide event, from London to San Francisco. Not a disjointed collection of trends, like Goths or Grunge. Even Punk was diminutive in terms of size.

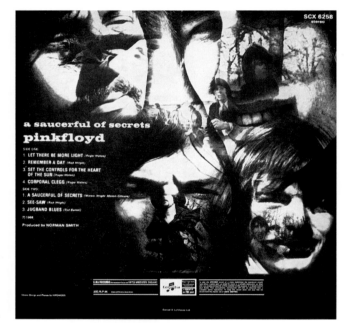

Anyway, the really important aspect was that I was there and so were the Floyd. Even though I knew them from Cambridge, where Syd Barrett and I shared the same peer group, and although Roger Waters' mum and my mum were best friends, I didn't have anything to do with them in their early incarnations. Towards the end of 1967 I was asked if I had any clues as to why Syd was going off the rails, and what could the rest of them do about it, and should they get David Gilmour in to replace Syd, and how fucking awful it was anyway dealing with all this emotional turmoil. I don't think I was much use in any of this stuff, but when another friend failed to do the cover for *Saucerful* I volunteered my services. They were more useful in this respect than in any counselling role. I didn't know much about design, but I knew even less about unbalanced minds and the ambitions of a rock 'n' roll band.

Naïveté and enthusiasm are great bedfellows. I plunged into the cover for *Saucerful* without a second thought. I didn't know any better and what doubts I had were soon engulfed by waves of keenness. I was so keen, it was sickening.

At the time the physical centre of our universe was an old Victorian mansion block in South Kensington called Egerton Court. Nigel Gordon lived there. He knew Allen Ginsberg and Mick Jagger. David Gale lived there. He introduced us to the ideas of RD Laing. Later he founded Lumiere & Son Theatre Company. Ponji Robinson passed through on his way back from India with tales of spiritual enlightenment attained through a religious practice called Sant Mat. Syd Barrett lived there later, when descending into hell and isolation. David Henderson, artist, craftsman and very angular person, lived there. Zillions of cockroaches also lived there, though not related to any of us. And the police visited Egerton Court a few times, usually looking for drugs, and sometimes for Aubrey 'Po' Powell who, they claimed, really knew how to make the most of credit cards.

Po and I were partners in Hipgnosis, a design company that had emerged from a loosely connected group called 'Consciousness Incorporated' (I am glad we changed that name). In conversation with the Floyd it seemed that the best way to 'represent' the music visually was to show some of the things they were interested in and to present them in a manner resonant with the music. Marvel comics, astrology, alchemy,

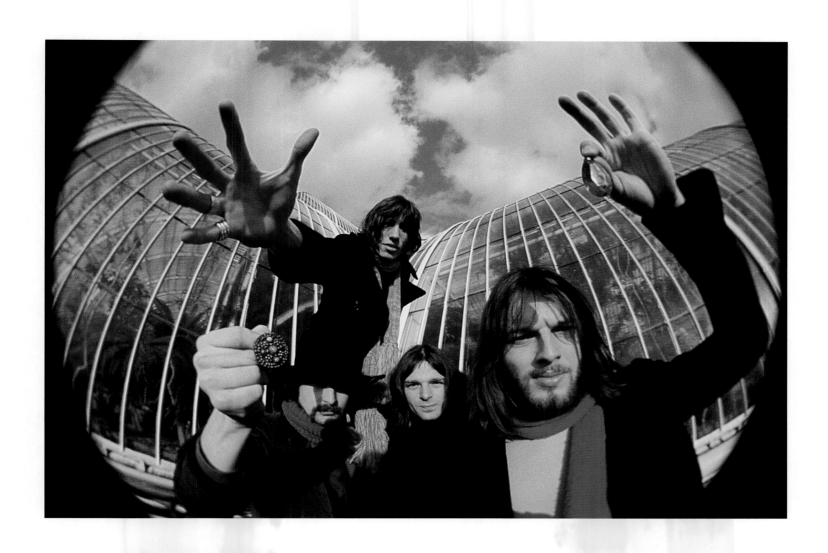

PINK FLOYD AT KEW GARDENS LONDON 1968

A SAUCERFUL OF SECRETS

(nm) THIS WAS THE START OF THE HIPGNOSIS DYNASTY. WE WERE SOLD AN IDEA THAT WAS INITIALLY DESCRIBED, AND THEN ROUGHED UP... NOT LITERALLY I HOPE... CONSISTING OF FAR OUT LATE SIXTIES IMAGERY. WHAT WE AND THE HIPPO BOYS WERE INTO — MARVEL COMICS, ASTRAL SIGNS (SHUDDER OF SHAME), WITH THE USE OF INFRA RED FILM TO GIVE COLOUR VARIATION TO THE GROUP PIC WHICH WAS REALLY QUITE MODERN AND WEIRD AT THE TIME. IT FEELS CLOSER TO THE WILDER, MORE IMPROVISED ASPECTS OF THE TITLE TRACK. WHAT OF IT NOW? YOU COULD STILL ROLL IT UP AND SMOKE IT.

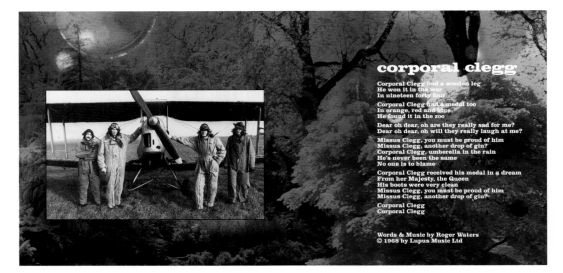

swirling patterns, outer space and infra red weird photography, were thrown together like an immiscible oil and water bubble slide at an early Floyd gig, superimposed upon each other, drifting around in a dreamlike fashion, not a million miles away from certain minor hallucinatory states that are alleged to result from taking narcotic substances.

In retrospect I feel the manner was more relevant than the contents. Complex photographic vignetting, now so easy with graphic Paintbox or Photoshop, was very different then, especially in colour printing, which had to be done in the pitch dark. I did a guide version in black and white first because it was fairly easy, very exciting and relatively cheap. It was one of those darkroom experiments, along with multiprinting, solarisation and negative prints, which can be done by anyone naïve and enthusiastic enough just to go for it. Sandwiching negatives, or multiprinting, to create complex superimpositions is great fun because the results happen in front of your eyes, right there in the developing dish, like magic. Vignetting and rejoining are more difficult but equally dynamic in impact. Much of Hipgnosis' early work is the result of messing about in the darkroom without being weighed down by knowledge or preconceptions. Maybe it was all those fumes from the fixative.

Actually, I didn't care for the darkroom much, liking neither the smell of the chemicals nor the crusty crystalline deposits left by old fixative. Nor the darkness, being vulnerable and abandoned when a young boy...but we haven't time for that now, have we? Our confection, our bag of goodies, for *Saucerful* included some original marbling care of the great Shropshire Mystic John Whiteley — he made the beautiful marblings in this very book — and the dimly perceived figure of Dr Strange, natty dresser and wily magician, crosser of thresholds and explorer of the mind. Amidst the stars, planets and zodiacal charts lurk the band, photographed in infra red weird colour type film, more of which is on pages 48 and 49.

Superimpositions abound, indicating the lessening of boundaries between states, old limitations removed, as one event or feeling merges with another — cascades of experience like the cascading Floyd music. Fish eye lenses and dislocated colour lend further disruption to normality, while locations like Kew Gardens' glasshouse (see previous page) and fashion accessories including long hair, moody hats and bright scarves, further enhance the sense of heightened perception often called psychedelic, or mind-expanding. Something different, out of the norm, a view over the garden wall...it's a shame that such valuable and exciting experiences should later become reduced to the status of 'merely' psychedelic or druggy or even uncool.

Floyd music, along with The Beatles, Dylan and the West Coast sound, etc, was breaking new ground, stretching limits, altering perceptions. Try listening to some of it and you too may find it invigorating. I certainly did, and tried my hardest to embody it in the cover designs, none more so than *Saucerful*, the spirit of which we endeavoured to extend — myself and Peter Curzon, a designer, brought up on a diet of Punk and Ska — in the repackaging twenty-eight years later, seen on the opposite page.

None of this, however, quite explains the naff jewellery that David and Nick seem to be offering to camera in the photo on page 21. Quaint, or what?

It's awfully considerate of you to think of me here
And I'm almost obliged to you for making it clear that I'm not here
And I never knew the moon could be so big
And I never knew the moon could be so blue
And I'm grateful that you threw away my old shoes
And brought me here instead dressed in red

And I'm wondering who could be writing this song
I don't care if the sun don't shine
And I don't care if nothing is mine
And I don't care if I'm nervous with you
I'll do my loving in the Winter.

And the sea isn't green
And I love the queen.
And what exactly is a dream?
And what exactly is a joke?

jugband blues

Words & Music by Syd Barrett
© 1967 Westminster Music Ltd.

Recorded at EMI Studios, Abbey Road
Produced by Norman Smith
Remastering supervised by James Guthrie
Digitally remastered by Doug Sax at
The Mastering Lab, LA
Cover design by Hipgnosis
Remastered design and photography
by Storm Thorgerson and Peter Curzon
Digital Remaster ℗ 1992 The copyright
in this sound recording is owned by
EMI Records Ltd © 1994 EMI Records Ltd

set the controls for the heart of the sun

Little by little the night turns around
Counting the leaves which tremble at dawn
Lotus's lean on each other in yearning
Over the hills a swallow is resting
Set the controls for the heart of the sun

Over the mountain watching the watcher
Breaking the darkness waking the grapevine
Knowledge of love is knowledge of shadow
Love is the shadow that ripens the wine
Set the controls for the heart of the sun

Witness the man who waves at the wall
Making the shape of his question to heaven
Whether the sun will fall in the evening
Will he remember the lesson of giving?
Set the controls for the heart of the sun
Set the controls for the heart of the sun

Words & Music by Roger Waters.
© 1967 Westminster Music Ltd.

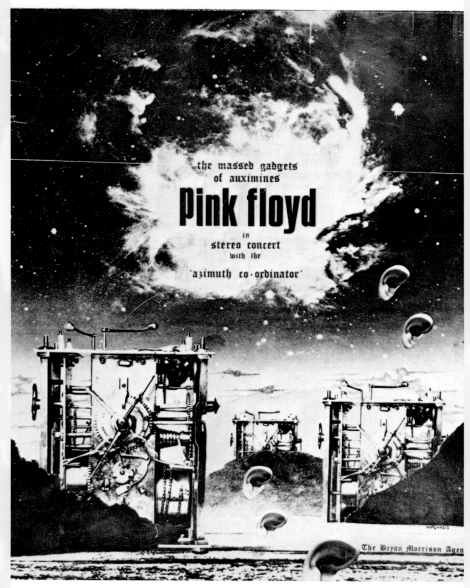

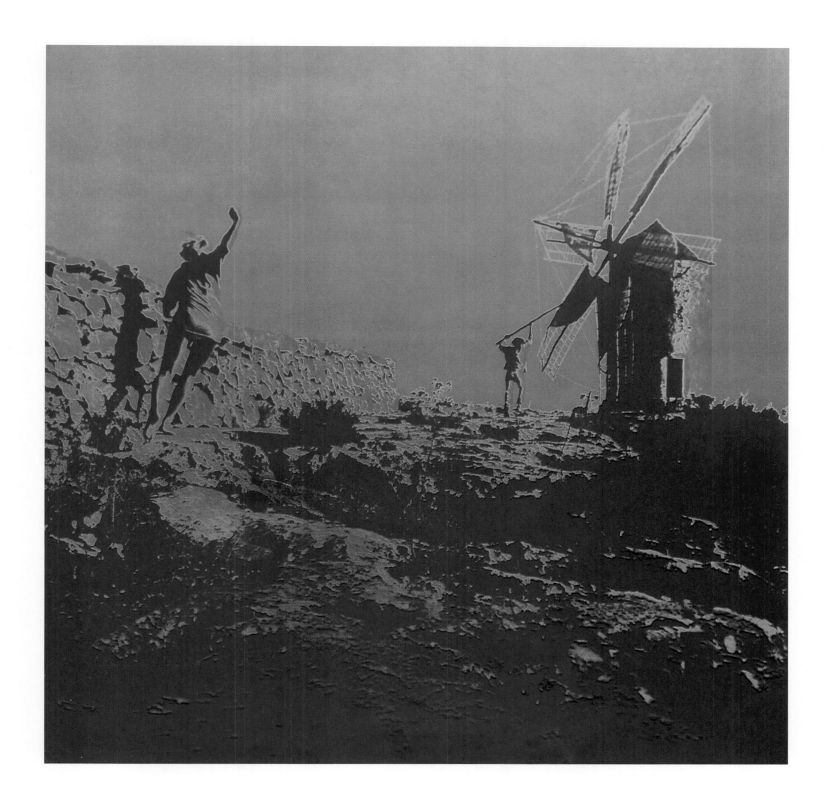

FRONT COVER MORE 1969

BARBET SCHROEDER made a film in Ibiza circa 1968 starring Mimsi Farmer. He told us that it was, loosely speaking, the story of a girl whose appetite for life was insatiable. The more she got, the more she wanted, be it good fun or romance. Barbet explained that it was a cautionary tale, and at the close, her wilfulness would end in tragedy. "C'est la vie," he assured us, with a shrug.

Barbet was so endearing that one could be easily forgiven for believing him. Though the film had a low budget and improvised charm, it was in many ways a slight piece about sex and drugs, Ibiza and Mimsi Farmer's chest.

(As an aside I've often wondered why the Floyd made this record. Was it simply because Barbet asked? He wasn't rich or famous, nor was the film artistically challenging. It can't have been money. More likely that getting into films was an alternative profession, especially in an uncertain future.)

Barbet went on to greater things (*Barfly*, *Circle Of Deceit* and *Kiss Of Death*), but back in these heady days of '68 he had at least one finger on the pulse — some sense of what was happening, and the nous to cobble together, in the best creative sense of the word, the necessary ingredients. A little Gallic charm, a fantasy location (Ibiza), plenty of sex and drugs, and music from Pink Floyd. The finished film should've been better.

The finished cover certainly should have been better. It does bear some relation to the movie since it displays an excess, at least of colour. Po and I did not have the confidence to suggest anything other than using stills from the film, and the most evocative image was a windmill in Ibiza. Perhaps there was some resonance with the message of the film (tilting at windmills) but, in truth, this was the most interesting of a dull bunch. The objective then was to make this ordinary image more exciting.

If I were a teacher I'd be reactionary. To hell with auto cameras, I'd say, give me manual every time! Back into the dark room, hands on the developer! Make your own mistakes, discover your own tricks. Somewhere between the enlarger and the fixative is the real magic of photography. Out of nowhere onto blank paper spills an image, emerging from the void, ghostly creeping, seeping from the developer onto the print. And every time you alter the light, or interfere with procedures in any way, you achieve a different result. Magic.

One of those creative 'interferences' in the dark room is to flash light when it is not prescribed. This usually results in an absence of an image by causing severe 'fogging' (rendering film or paper unusable by prior exposure). Obviously a dark room doesn't want light, otherwise it would be a light room! Do you think I'm daft? But the 'controlled' and very brief exposure to light sometimes produces interesting results. It's technical term is solarisation.

The *More* album cover (see previous page) is solarised negative colour. While exposing the negative (in darkness) the paper is briefly flashed with light. One is never sure of the exact effect, but tests were promising. We knew from our own black and white solarisation, and from those of the great Man Ray no less, that, along with a reversal of tone, 'negative' edging was achieved, as if the image itself was internally illuminated (most noticeable in the vanes of the windmill). When using colour film, blue sky went orange, and the hot yellow Ibiza ground became purply green. Very trippy.

I am a little critical of this cover now so when we came to do the CD repackaging (opposite page) in '96 we spoofed it. We designed the booklet in the style of a sixties magazine. Don't you just love those bongos, and Roger's jacket, and Rick's belt buckle recently acquired from a curtain rail. That Rick, doyen of fashion and economical at the same time.

We may not have provided Barbet and the band with a great cover but we did give them a title. After Barbet had described the movie to us in great and enthusiastic detail he admitted that he still didn't have one. We observed drily that the central character always wanted more — more thrills, more sex, more drugs, more this, more that, and 'more' was a short, pungent word in most languages (*plus* in French, etc). Easy to remember. He was delighted. He kissed us both. He never told us, however, what he thought of the cover.

Pink Floyd often have difficulty with titles, as do many other bands. Floyd's titles have varied a lot. *Dark Side* is good, although it was used a year previously by another group (ten points if you know who). *Atom Heart Mother* is great and came from a newspaper headline. *The Piper At The Gates Of Dawn* comes from a book, *The Wind In The Willows*. *The Wall* is directly relevant to the subject. *Wish You Were Here* is postcard irony, but what does '*Ummagumma*' mean? And who the hell thought of '*Meddle*'?!

I guess *Meddle* (page 41) must have some oriental relevance that escapes me, since it was concocted by the band while on tour in Japan. Maybe the phone lines were bad and I couldn't hear properly when they told me back in England. The title was actually something different but sounded like *Meddle*. By the time the band had returned the cover was done, and it was too late to change it. It was that old fickle finger of fate, meddling again.

It goes to show that you cannot judge a record, let alone a book, by its cover or title. The same goes for a person and their clothes. "Les choses ne sont pas qu'ils semblent," as Barbet might have said, with a shrug.

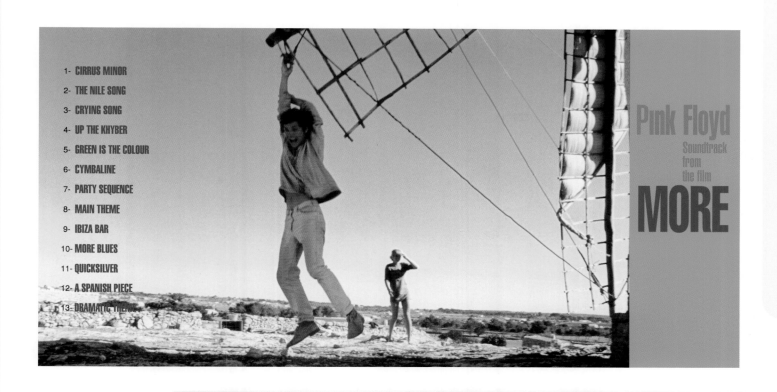

1- CIRRUS MINOR

2- THE NILE SONG

3- CRYING SONG

4- UP THE KHYBER

5- GREEN IS THE COLOUR

6- CYMBALINE

7- PARTY SEQUENCE

8- MAIN THEME

9- IBIZA BAR

10- MORE BLUES

11- QUICKSILVER

12- A SPANISH PIECE

13- DRAMATIC THEME

Pink Floyd
Soundtrack
from
the film
MORE

MORE

PINK FLOYD

DAVID GILMOUR
- Guitar, Vocals

ROGER WATERS
- Bass Guitar, Vocals

NICK MASON
- Drums

RICK WRIGHT
- Keyboards

PARTY SEQUENCE
(Waters, Wright, Gilmour, Mason)

MAIN THEME
(Waters, Wright, Gilmour, Mason)

IBIZA BAR

MORE BLUES
(Waters, Wright, Gilmour, Mason)

QUICKSILVER
(Waters, Wright, Gilmour, Mason)

A SPANISH PIECE
(Gilmour)

DRAMATIC THEME
(Waters, Wright, Gilmour)

All titles: © 1969 Lupus Music Company

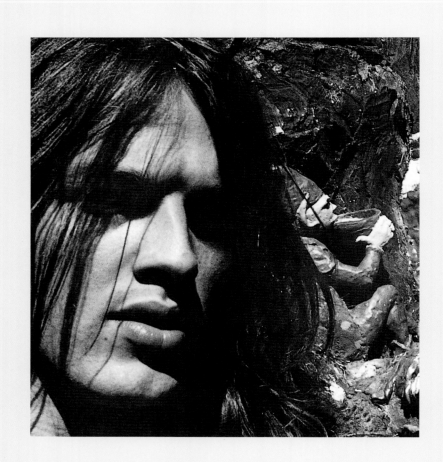

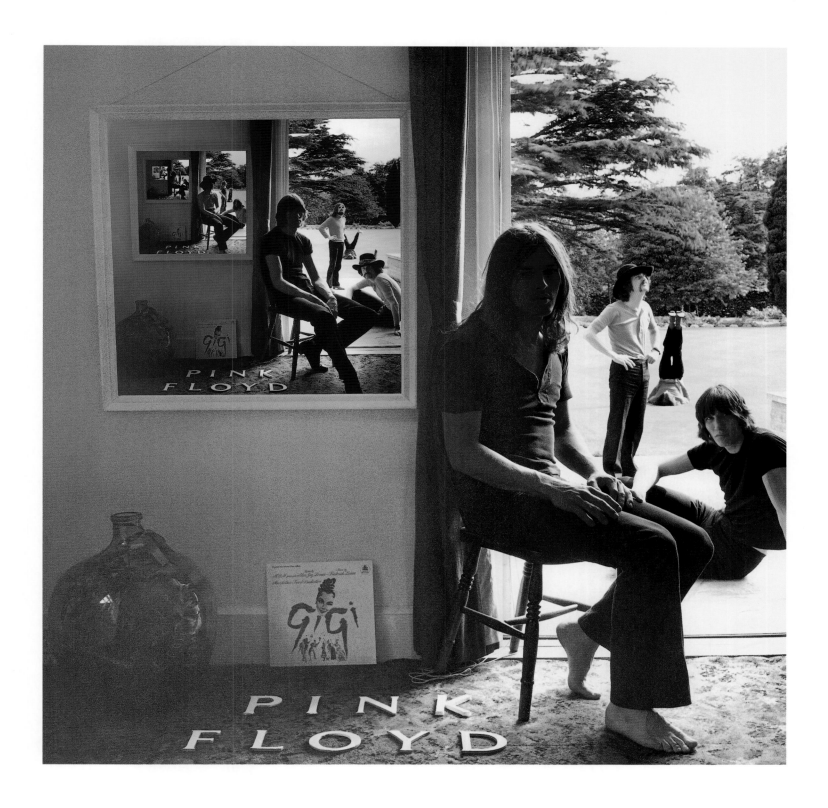

Front cover Ummagumma 1969

$\mathcal{U}m$MAGUMMA

THE *UMMAGUMMA* ALBUM cover was photographed with a 120 Hasselblad camera using a wide angle lens and colour negative film. Photo prints were made from selected contacts to the required sizes, then cut and collaged together, with trusty blade and cow gum. Close inspection of the original artwork would reveal my shaky hand and poor glueing skills, which led to the rather messy edges of the receding pictures. Despite being a technophobe I'm glad to say that the version on the previous page is the repackaged and remastered model following a thorough computer clean up.

Notwithstanding the amateur artwork, the limitations of colour negative, and the perspective difficulty caused by the wide angle lens, and despite the crude lettering placed clumsily on the floor, and the curious but purposeful inclusion of the *Gigi* album, and not to mention the poor lighting of the photos (no 'fill' for David), or possibly *because* of all these 'mistakes of youth', the finished design worked pretty well. The sense of receding dimension, of layers beneath layers, of different realities was firmly established. You could imagine stepping literally into the second 'room'. The first may be a picture, but the second is a place.

This 3D illusion served to illustrate the simple idea that Floyd music was multilayered, more intricate than most, and offered a depth, should you choose to explore it. No cheap pop here, no brute but shallow riffs, no domestic limitations, but depth of mind. Not simply surface pretty pattern psychedelic stuff, but true, mind shifting, eye disturbing, metaphoric, cosmic stuff. Space beckoned, but not the physical space out there between the stars, but mental space, unlimited and impenetrable, set deep within one's own mind, available to anyone brave enough to venture in.

But I didn't like this record that much. Can't like all Floyd music, that would be unnatural. I'm very lucky to work for a band 90% of whose music I like – without any effort.

The actual idea stemmed from a 'psychological' black and white line illustration of receding infinity ▣ which is also an illusion – is the perspective going away from you, or towards? Are

you looking up a shaft? Or down at a tiered building rising back up to meet you? We turned a line drawing into a photograph, an illusion on a page into a real, live event. I did the same with *Division Bell* twenty-five years later, but in a much more detailed and extended fashion. Not just because I'm lazy, but because visual illusions are forever changing, continually diverting and capable of many different ways of interpretation. It was Libby, the mother of my child, who suggested infinity drawings as Floyd type material. God bless her. Behind every man is a great woman, and behind every great woman is…

And behind every great band is a great bunch of gear. Well, not really, but we *did* want to show the equipment and the roadies because *Ummagumma* was a double album, half of which was a live recording. The other half was 'individual' contributions, which also accounted for the individual, yet group, pictures on the front. Each in their own world, 'leading' the others. Which is, in turn, why the members of the band are rotated. David at the front of the first stage of events, Roger at the front of the second and so on. It always surprises me how few people notice this. The design is about a picture within a picture, a room within a room. It's not a mirror, nor a photo of a photo. It's a real place. There was no 'pecking order' intended here, more a case of who was the best looking and, of course, it was David. He always was handsome with a truly disarming smile. So annoying that. Talented, wealthy and good looking. "But is he happy?" I hear you ask.

I'm sure the roadies were well happy because they 'made it' at least onto the back cover. If memory serves correct it was Nick Mason who suggested that the equipment would be best displayed if arranged like a military aircraft, items in order of size, stretching back like the perspective of the front image. It is fun to compare this set of gear, which at the time seemed humongous, with the gear used for the *Division Bell* tour in '94. It could all get into one truck back then, but twenty-five years on the Pink Floyd needed fifty trucks.

I make that two trucks a year.

IT SUGGESTS SOMETHING WE WOULD LIKE TO FEEL WAS ABOUT THE MUSIC…MULTILAYERED, NICE SURREAL COLLECTION OF ITEMS AND IMAGERY, TAKING THE REPEATING PICTURE A STAGE FURTHER WITH THE CHANGES, POSES AND POSITIONS IN EACH ONE. THE BACK COVER WAS BASED ON A PHOTO I LOVED OF A PHANTOM BOMBER WITH ALL ITS ARMAMENTS LAID OUT. IT'S NOW A GREAT ARCHIVE OF EARLY EQUIPMENT AS WELL AS OF FRIENDS AND ROADIES. I THINK IT'S A GOOD EXAMPLE OF THE SYMBIOSIS ATTAINABLE BETWEEN SLEEVE AND MUSIC. IT MAY NOT BE A WORK OF ART, BUT IT'S A NICE PIECE OF CRAFTSMANSHIP.

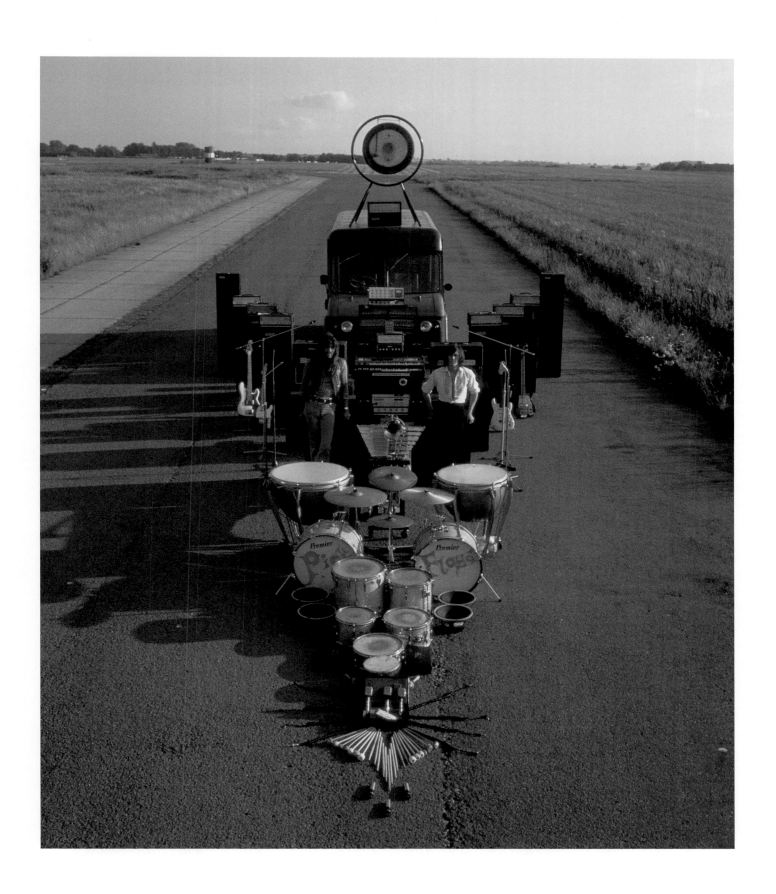

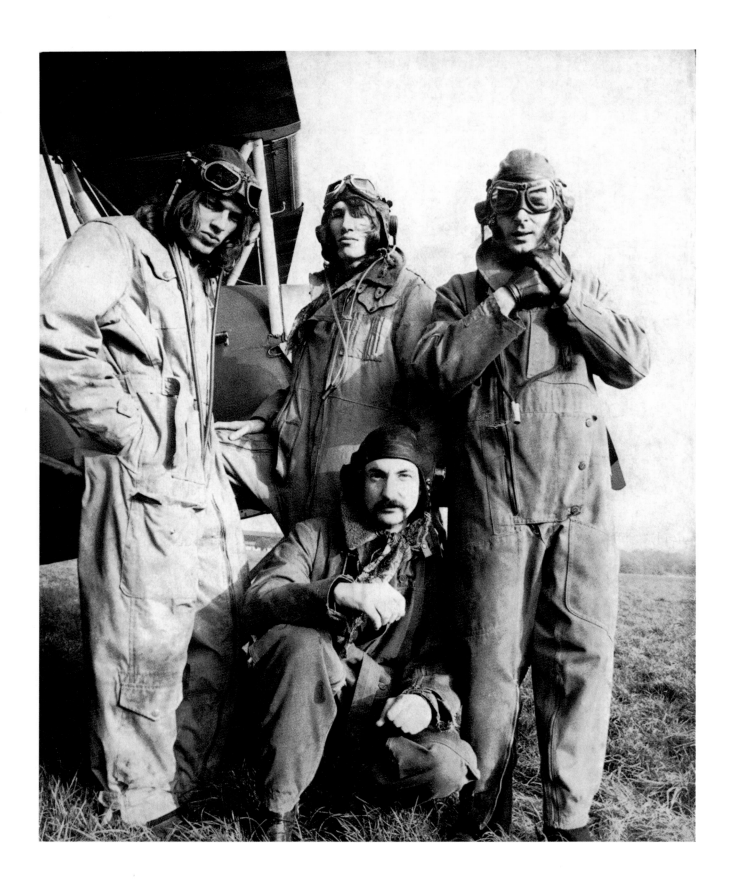

SEVENTIES

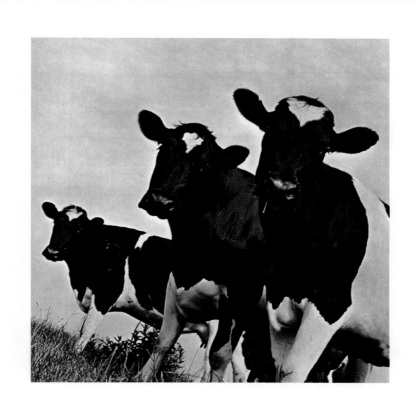

DO YOU THINK it's alright to openly like your own work? Do artists, greater and lesser, actually enjoy the fruits of their labour? If you went up to Mr Hockney, for example, and asked if he liked his paintings, what would he say? Would he say it's not really a question of liking — painting is simply what I do. Would he say the question is at best naïve, and at worst meaningless. I don't know about Mr Hockney but I do like some of my own work. Some of it I don't like, that's for sure, but the cow for *Atom Heart Mother* — this I like.

When looking at pictures one can admire a whole range of attributes such as the composition, lighting, texture,

technique and so on. What I like here is none of these things, but the attitude. There is no haunting mood, no dramatic lighting or evocative setting: there is no cosmic intent, no swirling landscapes of the mind, no graphic/logo type simplicity. Just a cow. No deep and meaningful statements. No psychedelia. Just a cow.

There is also no reference to the music, or rather, no specific reference to this specific record, which is as close in music design to heresy as you can get. Holy cow!

It's not the attitude of the cow herself, who seems to be saying "What do you want?", out of curiosity rather than aggression, but the whole nonsensical "What the fuck is an ordinary old cow doing on the front of one of the

world's most progressive psychedelic albums?" attitude and... more blasphemy... no title nor name of the band anywhere to be seen. The Floyd were deep in experimental mode at the time, and the music for *Atom Heart Mother* is kind **ATOM** of strange in places, rather contrary, obscure and occasionally naff. Overall I think it is stimulating (choral bits, funky bits), and very brave. But the band had no title, no definite theme, no great concept. The title itself was taken eventually from a newspaper headline of a story about a woman, mother of five, who was having a heart pacemaker inserted. The pacemaker was powered by an atomic battery. Nothing

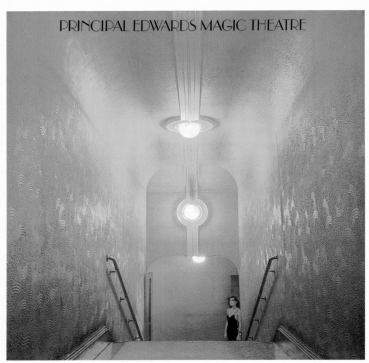

ostensibly to do with the album: they just liked the words, the sense of something weird, the contrary mix of technology and biology.

In the spirit of such irrelevance I wanted to design a non-cover, after the non-title and the non-concept album something that was not like other covers, particularly not like other rock or psychedelic covers — something that one would simply not expect. Not shocking, not mind altering, just unexpected. I told this to our good friend John Blake, who looked like an out-of-work Mexican actor but was in fact a photographer and maker of fine but obscure installations, and he **HEART** suggested a cow. This was added to two other prototype ideas, a diver on a diving board, and a woman going through a door, all of which exerted a sort of low key normality. Dry, meaningless and very non-Floyd on the surface.

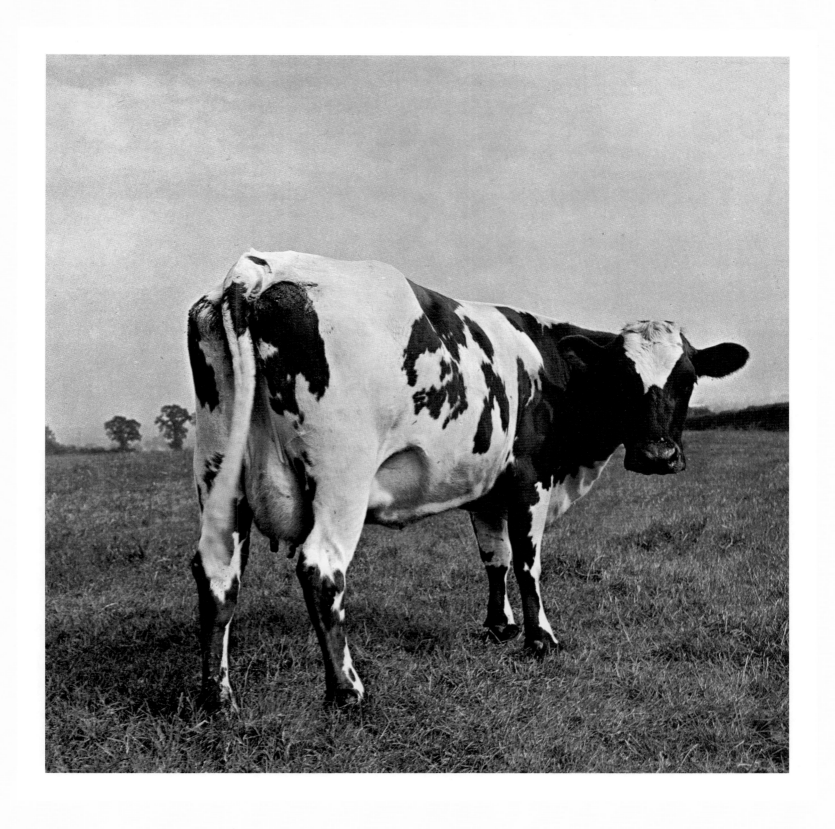

MOTHER

But only the Floyd could take a non-Floyd. They preferred the cow, because it seemed funnier, odder even than what they had envisaged. It was also open to other interpretations. Down the years the favourite seems to be a vegetarian one – with lifestyle implications – a non-meat eating cover.

The two other ideas soon reappeared. The diver turned into a Def Leppard cover, of all things, and the lady going out the door ended as the cover for Principal Edwards Magic Theatre and The Asmoto Running Band. What I had thought was a very low key and anti-promotional, rather dry affair, proved in the end to be very fruitful.

And, to cap it all, our lowly cow worked an absolute treat. The cover looked great amidst other covers trying so hard, just like we at Hipgnosis normally did, to be eye-catching or provocative. The cow was in fact more 'eye-catching' than I had ever dared imagine; it was so different because it was so normal: so ordinary, it stood out a mile. Somehow the photographic angle and the position of the cow were textbook stuff. The cow was your regular cow, your standard cow, what every cow should look like. A cow qua cow.

And the record went to Number One, even without any band name or album title written on it. And the cost of all this satisfaction was…peanuts. I took the picture using only two rolls of 120 film in the first field we came to driving north out of London. Petrol, food, film and processing thirty-five quid tops. No graphics, no retouching, no expensive model fees. Well cheap, compared to the endless river of beds for *Momentary Lapse* (page 98) which involved 700 wrought iron hospital beds, two articulated lorries, three tractors, thirty helpers, two photographers, a dog handler (and his dogs), two models and a microlite. It also had to be set up and photographed twice. Two whole times. Why this madness? Because the first

time was rained off at the last moment. All of which cost an indecent £49.5K. And that's without my fee!

I tried to maintain the spirit of irreverence when we repackaged the *Atom Heart* CD in '95 and added lyrics, etc, to the remastered music. It wasn't that easy to find or take photos of things that were intended to look as if they were not intended. Designers like certain unwritten rules, or governors, what they loosely call criteria of 'good design'. These usually involve proportion, colour resonance, a sense of space, a dash of elegance, but mostly neatness and control. Tastefulness. Got to keep the little poo piles in order.

The Punk approach was not appropriate: sledgehammer to a nut. Creeping anarchy was needed, the subtle upending of expectation. Design and contents that gave the appearance of relevance but weren't, like 'wots' on the page opposite. The boots, though, do start to indicate a tinge of relevance, as does the psychedelic breakfast on this page. But then we go very peculiar with garden nasturtiums spreading across the ground, as if the entire design was about to be overrun by something unthinkable from *Gardeners' Question Time*. Don't have expectations, don't make assumptions, don't cast nasturtiums.

The music of *Atom Heart Mother* has nothing to do with kitchen recipes so, of course, we included one with the repackaging. It was printed on greaseproof paper and inserted in the CD jewel box, so that all you good housewives out there in Floydland could take it out and put it up on your kitchen wall and consult while cooking, or listening – or both. Music while you work. One of the recipes was for a Bedouin wedding feast, and went like this: one medium camel, one North African goat, one spring lamb, one large chicken, one egg, one leaf of fresh coriander and 450 cloves of garlic. Serves up to 250 in a tent in the Sahara. Yummy.

PREVIOUS PAGE FRONT COVER ATOM HEART MOTHER 1970

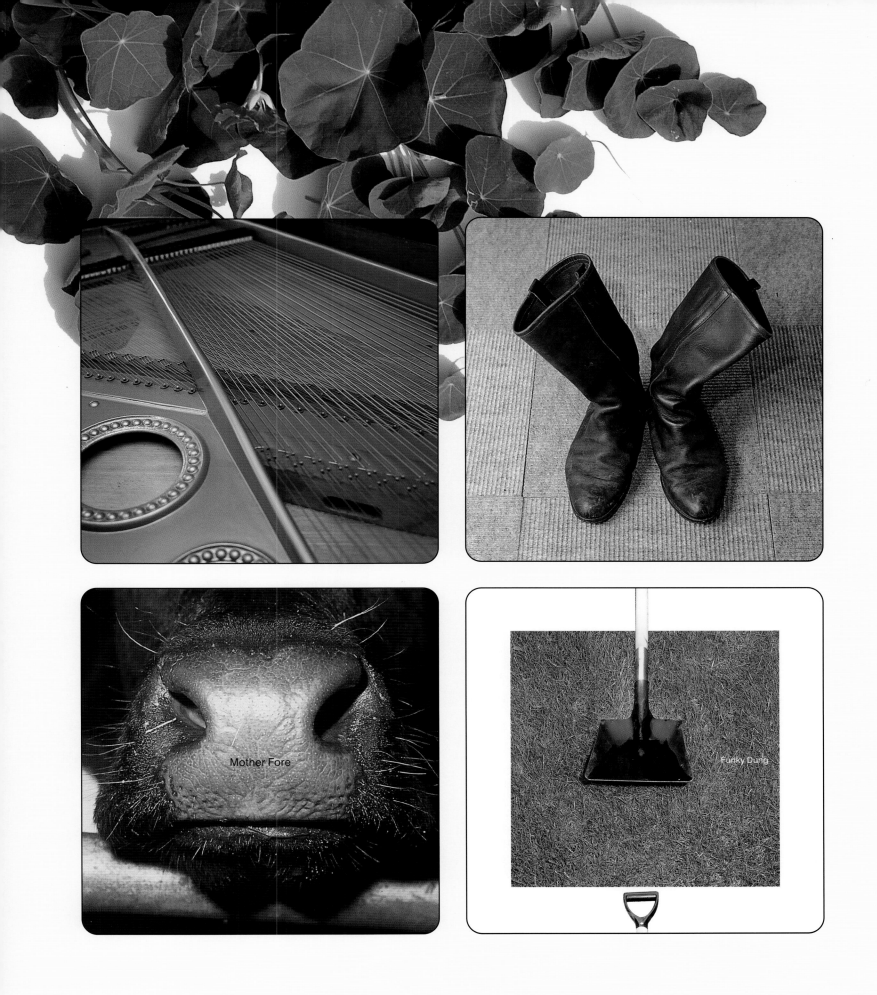

Mother Fore

Funky Dung

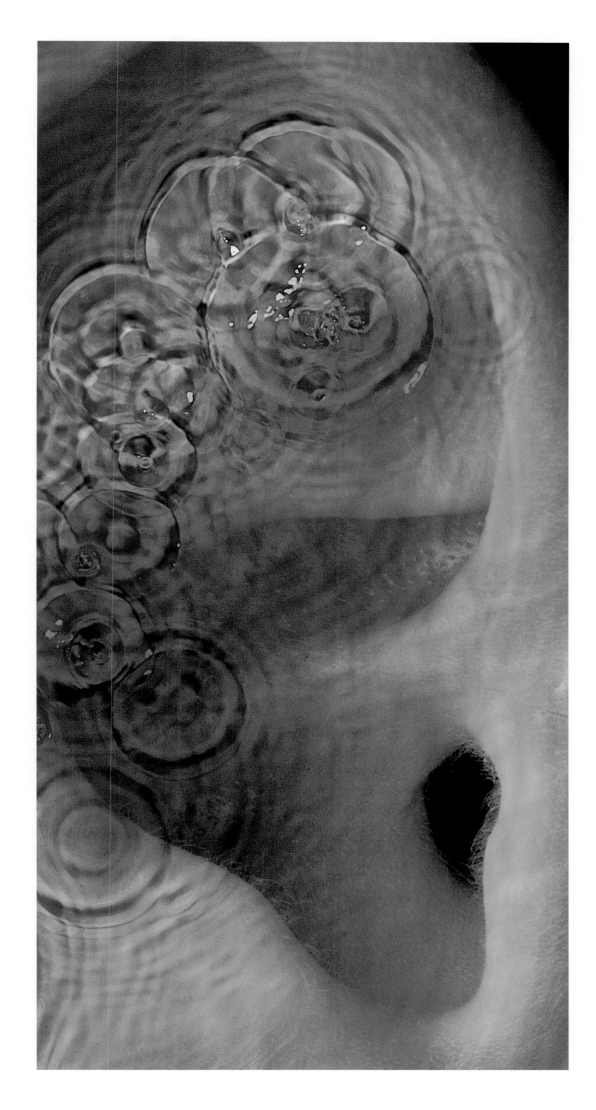

Front and back covers
Meddle 1971

NOW HERE'S A COVER never fully understood. Not then and not now. I didn't understand the title, either, nor the specific design suggestions made down a crackling phone line from the Far East by the band. They had gone on tour to Japan in 1971 and had taken their wives with them. I wonder what that was like? (I just realise, as I write this in 1997, that here's a possible reason for that title. Spouses do not as a rule accompany bands on rock 'n' roll tours. Perhaps the wives in this instance altered or even disrupted the usual patterns of tour activity, just by being there or by wanting, naturally, some attention. None of those wives remained, since the Floyd all remarried by 'choice', including the manager. And the moral was…don't *meddle* girls, or the game is up.)

We enlisted the 5/4 expertise of Robert Dowling esquire to take the initial photographs of the ear in close up and the brightly lit rings of water. Robert was a professional, a specialist, eminently reliable and could shoulder the responsibility, especially if there was a cockup. Good plan. The two separate images, ear and water were sandwiched together − 'sandwich' being a technical term for super-imposition − to produce the final indifferent result. No fault of Robert's, more "a long-distance what the fuck are you talking about, I don't know if I like that idea very much, but I'd better do the best I can" kind of a fault.

I needed to make amends, nagged by the feeling all those years that the music was very good, but the cover wasn't, and that I had failed the Floyd. The remastered and repackaged CD version in '94 provided an opportunity. I put the original two transparencies into the computer, through a Quantel graphic paintbox retouching system, and 'cleaned' them out, enhanced colour and contrast, and superimposed them more accurately and more carefully than I ever did back in '71 (see previous page).

The water ripple theme was continued throughout the new CD booklet (see opposite) to provide interesting backgrounds upon which to place the lyrics. Your modern fan got remastered music, reworked front cover, full lyrics never before published and delightful new backgrounds for his money. Good value eh? Even if he is buying what he's already got. Funny world, the music business. Selling back catalogue, or 'flogging a dead horse', as cynics call it, is common practice in the music business, but ethically problematic, and I shall return to the matter later (*Shine On* − page 122).

These backgrounds, or evocative wallpapers, utilised exactly the same water ripples as the front cover, but positioned differently, and superimposed in the computer over small objects newly photographed. These 'still life' studies consisted of items that were appropriate to the songs, such as shells and sand for 'San Tropez', or jewellery and perfume, love tokens,

for 'Pillow Of Winds'. I really like these 'evocative wallpapers': you can nearly see in your mind's eye the rain, or water droplets, falling onto the actual page as much as onto a photographed surface. You can if you try really hard.

I felt better. The package design was improved. It wouldn't match the record, but perhaps it never could, partially because the Floyd were so far away at the time (I blame them!), and partially because the record was rather excellent. 'Breathless' and 'Pillow Of Winds', excellent. Not to mention 'Echoes'. *Meddle* was perhaps musically discontinuous, unlike *Dark Side*. But the theme of water, however, is continuous, and reappears in Floyd's visual history, especially in *WYWH*, in *Momentary Lapse*, *Shine On* and *Pulse*. In Rick's solo albums, *Wet Dream* and *Broken China*. Also in videos, such as *Signs Of Life*, not that you can see them in this book. Now, if we were a CD-ROM…

Floyd like swimming: I like swimming. David and I are Pisces. Roger is called 'Waters'. Some of the music has watery sounds, and watery references, but water, as such, is not a Floyd preoccupation any more than animals, which is another recurring visual theme. I think it's more that water is photographically useful. Water is variable yet controllable. Water lights beautifully. Water is evocative, serene, haunting, powerful. Water is cheap.

MEDDLE

You may be forgiven for thinking that water is so commonplace and ordinary that it doesn't warrant close inspection, but you'd be wrong. "Water has amazing properties, particularly when compared to most other forms of matter known in nature" says the usually staid *Encyclopædia Britannica*. It should be a gas at room temperature like H_2S (hydrogen sulphide), not a liquid. Its boiling and freezing points are much higher than expected from its gross chemical structure. It is most dense, or heavy at $4°C$ in its fluid form (not solid), which is very fortunate, otherwise ice wouldn't float, oceans would freeze from the bottom up and kill all marine life! If water didn't expand when freezing there would be no fragmenting of rocks, no geological evolution, as we know it. On the molecular level H_2O means that oxygen's unfilled outer shell of six electrons is completed by two electrons from two hydrogen atoms − water is very stable. But the molecule is part negative, part positive, which makes it polar − water can act as acid or base, and is therefore the most versatile solvent there is, providing a crucible for life to emerge. Water exhibits 'hydrogen bonding' causing it to be 'sticky', and 'short range ordering' giving it a continual sliding structure, forming, and reforming, providing viscosity and high surface tension. Water's fundamental form is spherical, as in a water droplet.

I could go on, but I won't. I need a drink.

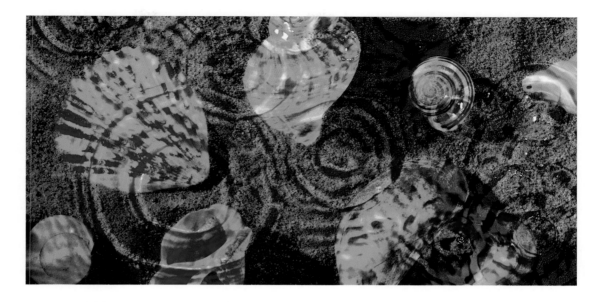

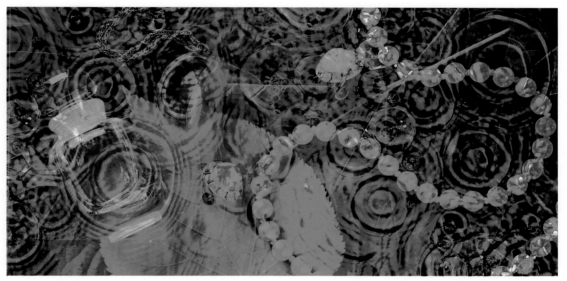

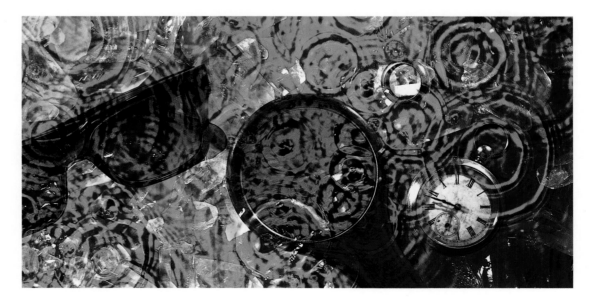

Lyric backgrounds
designed for Meddle CD
repackage 1994

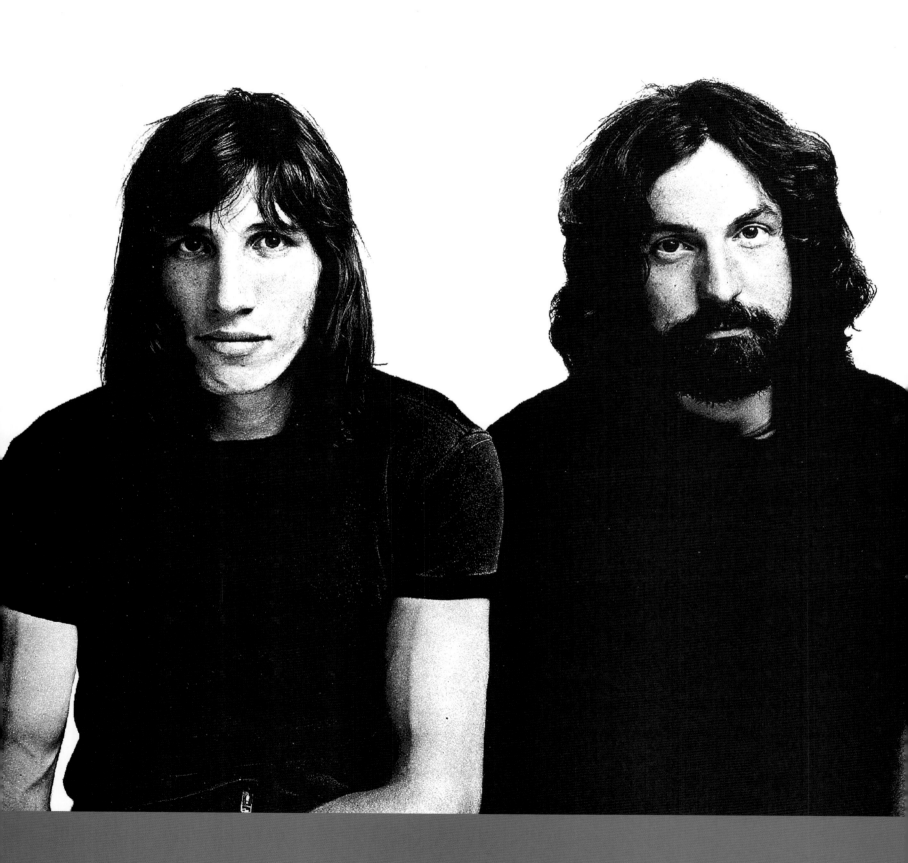

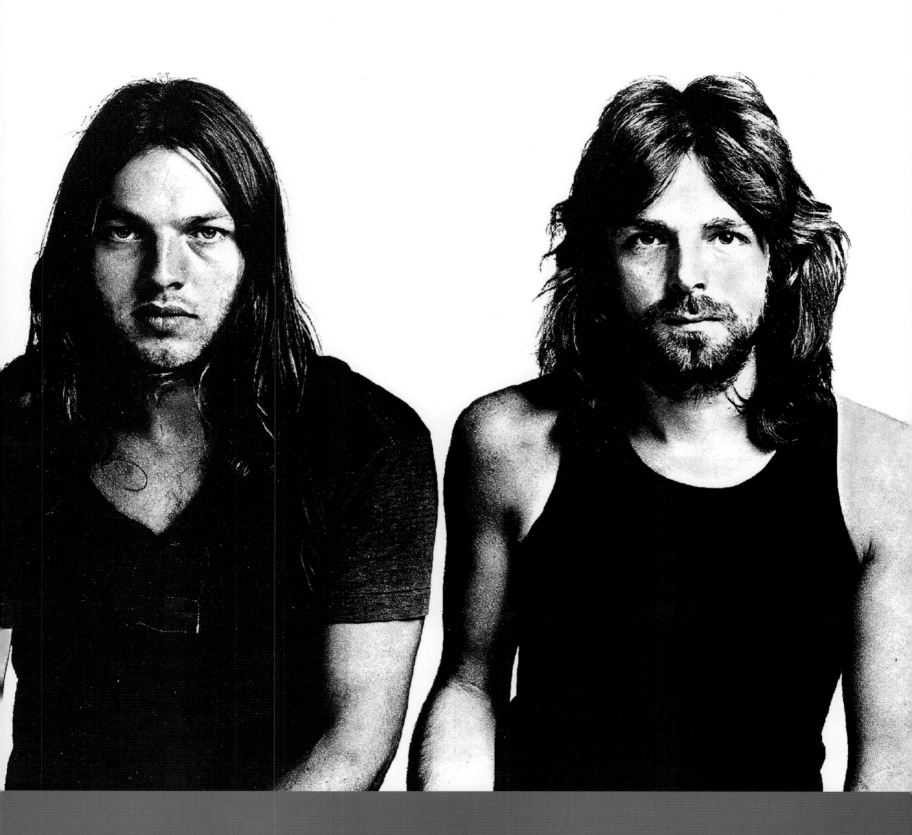

FRAGMENTS OF MEMORY, as out of focus as this picture opposite, swim into view. Grimy studio in Denmark Street. Affable film director Barbet Schrœder. Dusty old film projectors. A movie plot as obscure as its title. And a problem.

It was always a problem to design something. It still is, in terms of filling the empty page. Since *Obscured* was film music we felt obliged to use some imagery from the film itself for the cover. I suppose that one doesn't absolutely have to, but if you cast your mind's eye over your favourite film posters it's hard to recall one that doesn't use this approach. We had to fill the blank page, and we had to use film stills. I make that two problems.

Barbet Schrœder had taken a film crew, actors, his wife Bulle Ogier and her chest to a remote valley in New Guinea, but not much of a script. Despite exotic locations, weird natives and sex, the film was only passable. More problematic, the imagery was uninspiring. Nothing to nick, thereby making life easy. Not of course that we'd ever want to (see *Delicate*, page 109).

Po and I trawled through the film stills umpteen times inserting 35mm slides one by one into an old projector (or did we run bits of actual film? The memory is still out of focus). The lens did not fit snugly. In trying to make it fit better, using that old standby 'brute force', the image went severely out of focus and, hey presto! Everything looked better. The slide in question – a man in a tree – soon came up and the defocused lens caused the little chinks of sunlight between the leaves to expand and transmute into incandescent hovering spheres, reminiscent of the old bubble slides used in early Floyd concerts. The man became a primal shape, a symbol of reaching forth, of striving after some goal, groping for meaning in a gossamer world of floating shapes as ineffable and ultimately deceptive as life itself. Suddenly, in front of our very eyes, the out of focus quality imbued an ordinary image with more transcendental qualities, reflecting eternal human dilemmas, and resonating with the characters in the film, who were looking for something in that remote valley in New Guinea. Probably something fundamentally internal, or so we told Barbet.

At the least the genesis of this album cover was not far removed from the way the Floyd probably worked on the music. Borrowing, no doubt, bits and pieces from the ol' musical cupboard and mixing them with sessions played off

the cuff while viewing or just after viewing the movie stimulated a more modest yet more spontaneous offering. It was, and still is, my considered opinion that *More* and *Obscured* are very fine albums and greatly underrated. (Check them out.)

At the time of writing out of focus is fashionable, both in graphic design and in filmland, particularly TV adverts and music videos. This is largely due to various technological advances in computers, via sophisticated retouching programmes, in video matting and in new split focus cinematic lenses. It is now possible to defocus selectively, or smear and so highlight chosen areas. It is possible to render complete backgrounds out of focus or any typeface or part of a letter or graphic, to any degree. Some critics believe this aspect of contemporary design betrays an over reliance on the computer. Out of focus is a hallmark of the times. Out of focus is trendy.

We did experiment with focus loss in obvious ways using long lenses and wide open apertures. We put Kev and Lol of 10cc out of focus, once, and John Wetton, if that's him, and later the great Robert Plant's cover *A Question Of Balance* was selectively blurred. There are times when defocus adds a lustrous quality, or a sense of the mystical. Simple procedures like enhancing grain by forced processing or multiple transparency duping, lend magic to otherwise straightforward images. Selective over exposure and blurring from movement add a welcome softness to what in essence is a hard-edged medium, ie photography.

Photography, it is purported, represents reality. A photograph depicts clearly and figuratively what is there. It displays the outer form (not the inner essence). The arrival of photography meant that painters no longer needed to represent things realistically. What's the point in painting a portrait or a nude if a photograph can capture it just as well, if not better and quicker? Thus the emergence of photography at the close of the nineteenth century heralded the end of figurative painting and the birth of modern abstract painting, or so they tell you at art school. Just as painters need to express inner qualities, private perceptions, and deeper insights by using cubism, modernism, futurism etc, so photographers might use out of focusness in all its forms as part of their arsenal to express things beyond the normal hard-edged clear-cut reality. It seems Picasso, Braque et al may owe us snappers plenty.

OBSCURED BY CLOUDS

Since we believed that the Floyd were obviously beyond normal reality then out-of-focus was cool. So was distorted or unnatural colour, like infra red film — a film developed initially for military purposes, I suspect, where normal colours were changed depending upon the original colour and on the exposure. Green grass might turn purple. Blue sky might turn yellowy green. We first used it on *Saucerful* to photograph the band (see page 19).

When repackaging *Obscured* in '96 Jon Crossland suggested using infra red landscapes as backgrounds. I

thought them so atmospheric that they should be promoted. And here they are, courtesy of Angus MacRae. And, yes Angus, your cheque is really in the post.

NB: Self-doubt, or paranoia, is a great motivator. Doubting the quality of our accidental out-of-focus suggestion for this cover persuaded us to soup it up a little by rounding the corners of the actual finished LP sleeve and by printing on the reverse side of the board. No one else had done this at the time, I swear, so eat your heart out 23 envelope.

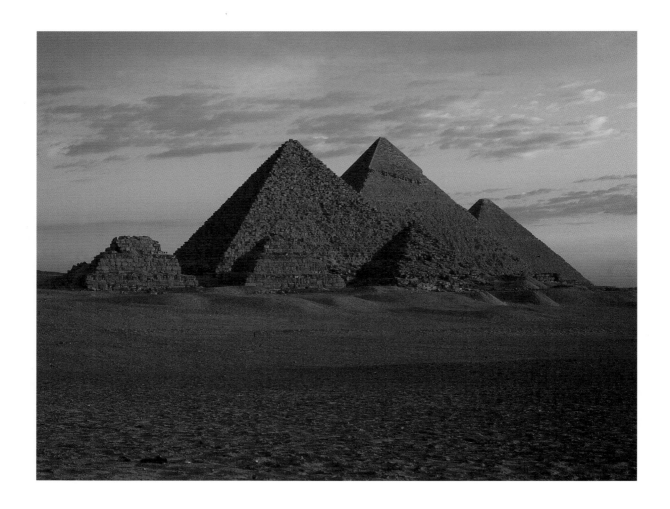

Card for *Dark Side* Twentieth Anniversary box set 1993

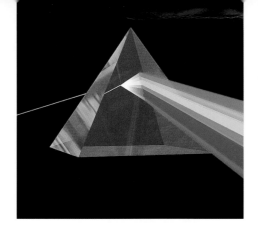

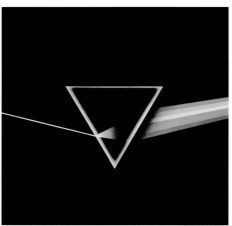

THE DARK SIDE OF THE MOON

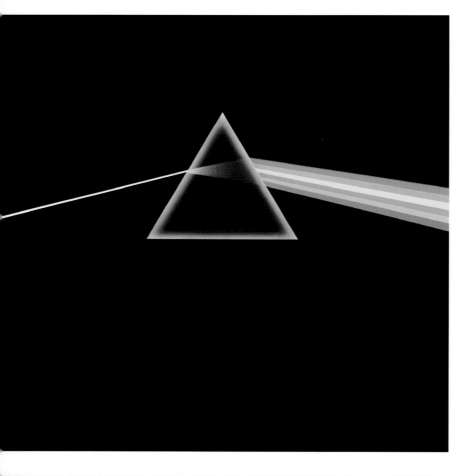

BACK IN THE MISTS OF TIME, shortly after the release of *The Dark Side Of The Moon*, Steve O'Rourke, fabled Floyd manager and Clark Kent lookalike, was walking down London's fashionable Bond Street in a cheery mood. He put his arm round my shoulder and pointed to an expensive looking sports car and asked me why didn't I have one of those. He knew of designers in LA who did, he added. I answered that I didn't earn enough money. Come off it, he said. I might, I ventured tentatively, if the Floyd would pay me more — not that I'm complaining. He withdrew his arm. Not a chance, he said, and changed the subject. Bye bye sports car.

But let's talk art not sports cars, or rather, let's talk phenomenon. Normally speaking I would quite easily discuss the art of *Dark Side* in voluminous detail, but I will resist, mostly because the phenomenon of the record itself is really so much more interesting. After all, the design is simply a mechanical tint lay, which means we (or rather George Hardie) drew outline shapes, black on white, and indicated what colours they were to appear when printed. Dead easy. The idea itself was cobbled from a standard physics textbook, which illustrated light passing through a prism. Such illustrations are usually very similar, since they describe a property of nature, not an artistic creation. *Dark Side* was in fact a simple but telling extension of something we had previously designed for a new label for Charisma (original home of Genesis) called Clearlight, which had been rejected.

Of minor significance was the simple, elegant layout against black. Standard textbook illustrations did not do this. Of greater significance was the art direction, or rather the fortuitous decision to listen to Rick Wright, who suggested we do something clean, elegant and graphic, not photographic — not a figurative picture. And then to connect this idea to their live show, which was famous for its lighting, and subsequently to connect it to ambition and madness, themes Roger was exploring in the lyrics…hence the prism, the triangle and the pyramids. It all connects, somehow, somewhere.

Of major significance was the appropriateness to the record. Luck, rather than talent, brought this about. Only in retrospection can it be recognised. Through some alchemical mixture of artistry and technique, circumstances and perseverance, inspiration and experience came *The Dark Side Of The Moon*, arguably the world's greatest long playing record (not that I'm biased). In fact

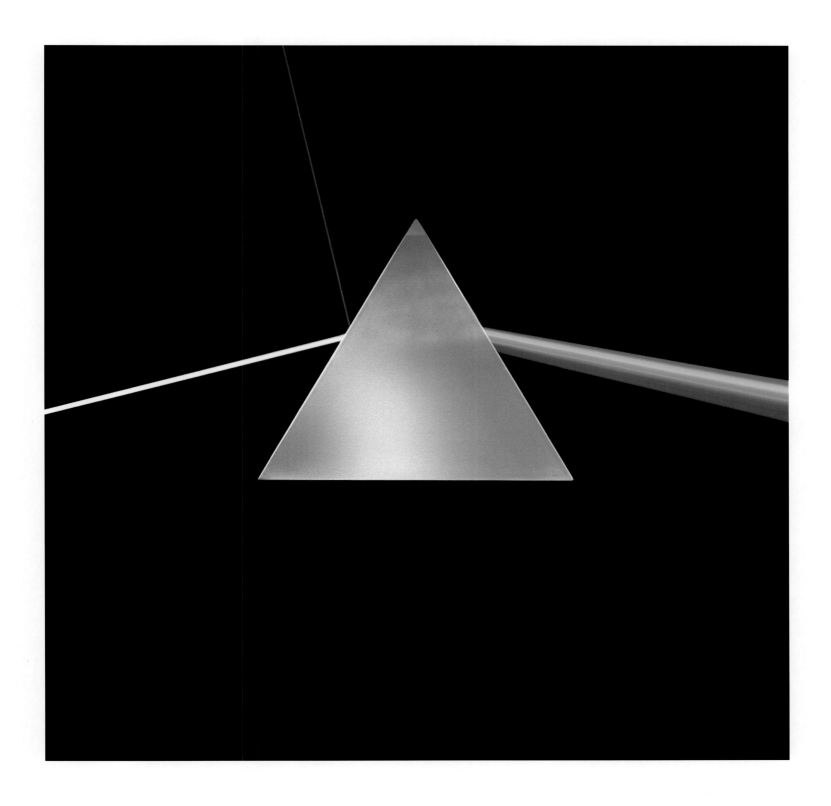

FRONT COVER TWENTIETH ANNIVERSARY CD BOOKLET 1993

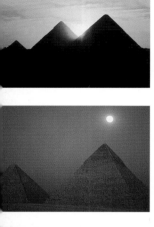

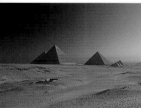

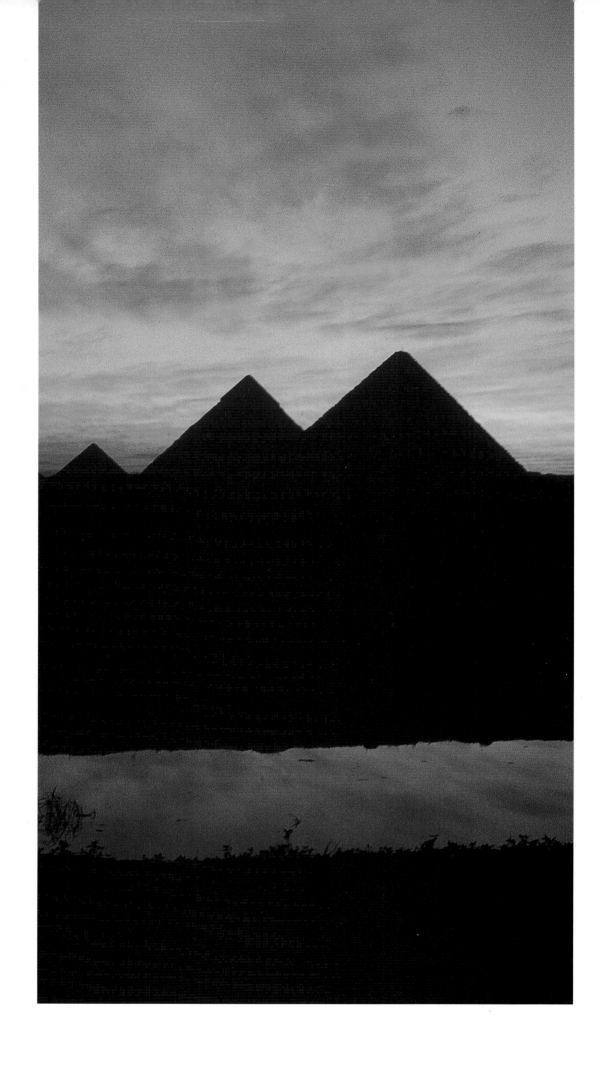

the enigma of its success is very Floydian. There was no string of hit singles (no single at all in Europe), no videos, no famous personalities; no catchy hook lines that people hummed, no scandal, no mammoth tours. All in all no obvious reason to account for *Dark Side* being a critical success and spending the longest time in the charts by miles, fourteen whole years in Billboard's Top 200, and selling over thirty million copies. When repackaged with a real photograph instead of a graphic in '93, *Dark Side* sold another two million, and went back in the UK charts to Number Four, twenty years after its initial release. Phew!

So, was the success due to the production quality? Was it the 'no duff track' theory? Was it the songs, the seguing, the overall concept? Was it the judicious mix of melody and effects, atmosphere and powerful rhythm? Was it majestic guitars and cascading keyboards? Is it that *Dark Side* is the best stereo tester ever? Neither pundits nor the Floyd themselves have any conclusive answers.

I guess that it must have been the cover after all. George Hardie's simple black and white illustration with colour instructions seemed so slight—the design invited development and extrapolation. Light is continuous: if the spectrum were to extend onto the back cover it could reverse 'theoretically' through another inverted prism, and re-emerge as white light. In a blatant 'shop front manœuvre' we envisaged that this reappearing strip of white light could rejoin the front cover, or more specifically, the front of an adjacent cover. Thus, if one put cover next to cover, there would be an endless connected strip of light changing from white to spectrum back to white, and so on. Roger Waters cleverly suggested that the spectrum could become a graphic representation of the heartbeat that begins the music, and as seen on oscilloscopes in hospital movies when the post-operative patient struggles to stay alive. This spectrum heartbeat could then extend across the inside spread of a gatefold and join up with the spectrum of the front and back covers, providing an even longer chain of connected outer and inner spreads. What a fabulous shop window display, stretching right across the window, right round the shop interior, out the door and into the street.

All this concentrated commercial thinking got us nowhere. I never did see, nor did I ever hear, this attribute being utilised in the sale and promotion of *The Dark Side Of The Moon*. It's just as well that the individual cover worked. But it taught me a lesson…don't pay too much mind, old son, to those commercial requisites so enthusiastically paraded by record company personnel. They don't last. They don't

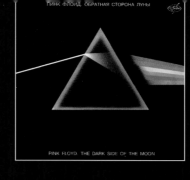

mean shit. The Russian version of *Dark Side* is a treat — back to front and upside down. They obviously don't give a shit: for commercialism, or even much for artistic, or scientific correctness. A collector's piece, no doubtski!

When the album was remastered and reissued in '93 as a twentieth anniversary thingy, I decided to 'remaster' the front image by taking a photograph of the same thing in the flesh, so to speak. What you see is simply what we saw — white light passing through a glass prism breaking up into the spectrum on the far side and sending a thin, faint reflection line upwards on the near side. The light is made visible by being cast across white paper upon which sits the prism. I think a little 'fill light' has been added to 'bring up' the prism itself, but that's it. The only cheating — I mean artistic licence — was to alter the angle of entry and exit of the beam of light on computer so as to match faithfully the original angles of the original graphic cover of '73. Reality bent a little to fit artistic requirements, which is, of course, only right and proper. *Mind Over Matter*.

The magic of such a simple phenomenon — light passing through a prism — so took our breath away that we used another photo involving several prisms on the back of the repackaged CD booklet (see page 51). Tony May is the photographer. As he has been on all our designs since *Momentary Lapse* in '87. Tony is reliable and pragmatic. He could get you across the Mongolian desert in a wheelbarrow, if necessary, even if you hadn't asked. He can take photos high up in the Ecuador mountains or, as with the prism, within the confines of a small studio. He is also very good at word games.

I could no more complete designs without Tony than I could without Georgie Hardie who designed the stickers opposite, as well as contributing to *WYWH* (page 75) and

the black object on Led Zeppelin's *Presence*. When asked what I personally do I reply in a variety of ways. For Her Majesty's Customs I am a photographer. For the music press — a graphic designer. For film people I'm a director. For my mother an artist! For my loved ones, a pain in the butt. Sarcastic musicians see me as an organising ponce who doesn't do much actual work. True believers, ie employees, however, know I make images. I think of ideas, often in collaboration, and turn them into tangible visuals, be they still photographs or movies. Since I cannot draw for toffee I work with photography. I can just about take my own photos, as I did for *Atom Heart*, but I'm concerned as much with the location, or the objects and models, or the computer retouching, or the borders or cropping, as I am with the actual photography. Tony takes the photographs with me for the Floyd, allowing me to concentrate on all those other things, and, of course, lots of poncing about.

The repackaging CD of *Dark Side* also involved Rob O'Connor (Stylorouge) better known for Blur designs and for being an all-round courteous fellow. He designed the graphics and the CD label, silver on silver, and helped devise the rayograms on this page and opposite. These 'negative' prints were first invented by the wonderful Man Ray, and are made very simply by placing small objects directly onto the photographic paper in the darkroom and then exposing them to enlarger light. The shape, contours and transparency of the objects affect how dark or focused their imprint. With diligent examination you might determine wine glasses, a slinky, watch parts, jinx and marbles. The negative rayograms were then coloured in the computer scans to echo the seven colours of the spectrum. It fell by chance that 'Money' got to be green.

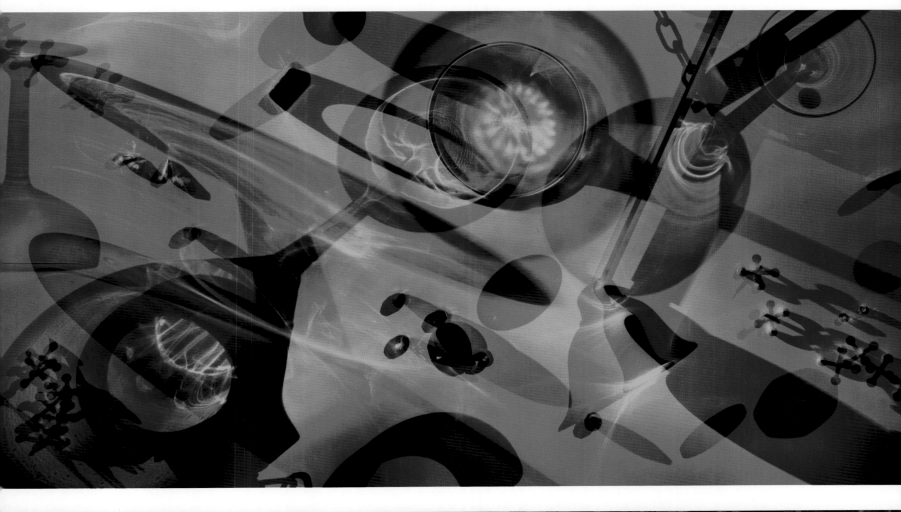

The rayograms were basically intended as backgrounds on which the lettering of the lyrics could be 'reversed out' to appear white. They are not supposed, therefore, to be too demanding on the eye, more of a wallpaper, albeit diverting and referential to the song. I confess I got very partial to the one opposite, and so promoted it from background wallpaper to centre stage.

One of the problems with contemporary computer-based graphics is the plethora of so-called 'wallpaper' designs — designs that are pretty, tasteful, merged, discrete, selectively focused, smeared, etc etc, but not about anything in particular. Not idea driven. Though there is a view that visual design has no need, perhaps no place, to be 'idea driven', it clearly isn't my view. Some, if not quite a lot, of computer stuff is very nice — but that's what it is. Very nice. It rarely moves me. Titillates the retina, but moves the heart or tells the head very little. If dancing rods and cones is what I want, I'll take Miro any day, but not recent computer graphic design. I prefer the computer in my head; at least for the moment. It's bigger and quicker, and cheaper. (I'm whingeing in part because I'm stuck in old neural

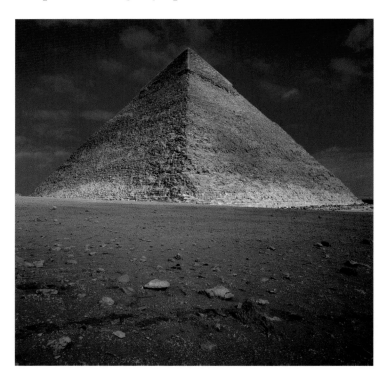

patterns, and can't use a keyboard to save my life.) Art for art's sake, money for God's sake, computers for lethargy's sake. "Makes life easy." "It's a tool, like any other." It's a restricted menu, is what it is, giving you the illusion of wide choice while confining you to computer land.

Talking of art for art's sake, the original *Dark Side* cover included two posters, one for true fans, featuring the band playing live (how did they get back in? I thought there was a policy to keep them off covers), and one designed to be purely 'artistic': something that would artistically represent aspects of the music — appeal to both fans and non-fans — and give dear ol' Hipgnosis a chance to get its rocks off. The pyramids of Egypt were similar in (silhouette) shape to the prism, and were appropriate symbols of vaulting ambition and madness. More than symbols, they were designed as stepping stones to the heavens from which the Pharaoh's soul could ascend, along with all his princely baggage buried alongside him. Talk about gravestones! "You can't take it with you" was not an expression favoured by Egyptian kings. So a photograph of the Great Pyramid of Cheops, taken by moonlight of course, was finally agreed upon.

I went to Cairo with Po, my girlfriend Libby and our son Bill, all of whom fell ill. I therefore ended up on my tod in the middle of the night standing before the awesome pyramids beneath a full moon, not a soul around and scared shitless. Then in the dead of night, three dimly lit figures approached. Closer and closer. There was nowhere to hide. Nowhere to run. I could hit them with my tripod, or camera case. Closer and closer. Three Arab soldiers with guns. All my stereotyped xenophobic fears swept rapidly across my mind. I could see the headlines. "Slit from ear to ear, young photographer found in desert, buggered to death, beaten and tortured, left naked and helpless, to die a painful and lonely death in a far-off land." The soldiers were, of course, quite friendly and informed me that I was on Egyptian army land (firing range actually), and should consider going home forthwith. But I needed to continue taking photographs. Couldn't leave my post. A little money seemed to do the trick and they left, muttering something about crazy English people.

So you see, I do sometimes take my own photographs. If I have to. But where were you, Tony, when I needed you?!

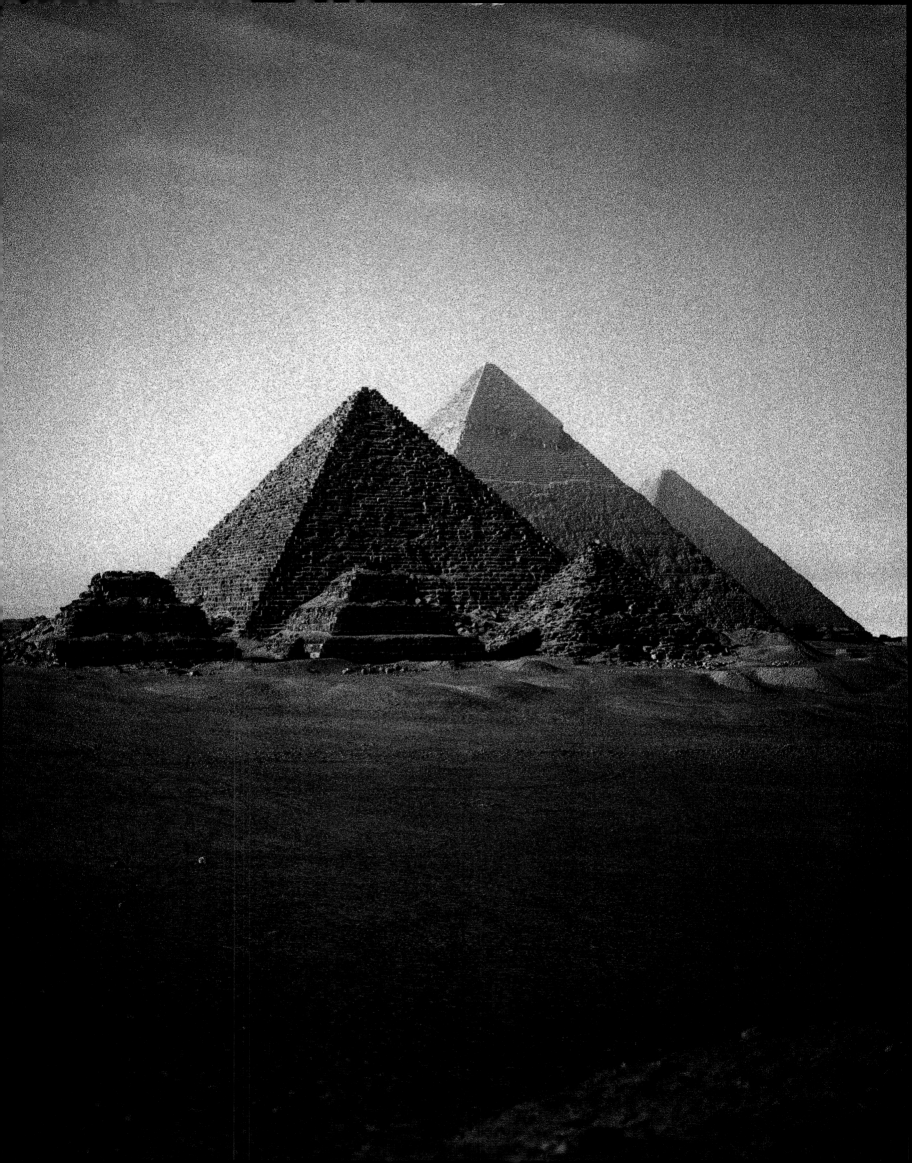

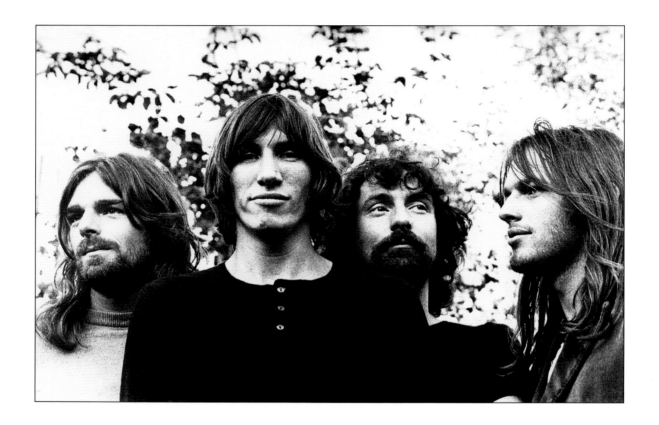

COUNTRY CLUB BELSIZE PARK LONDON 1972

MIND OVER MATTER

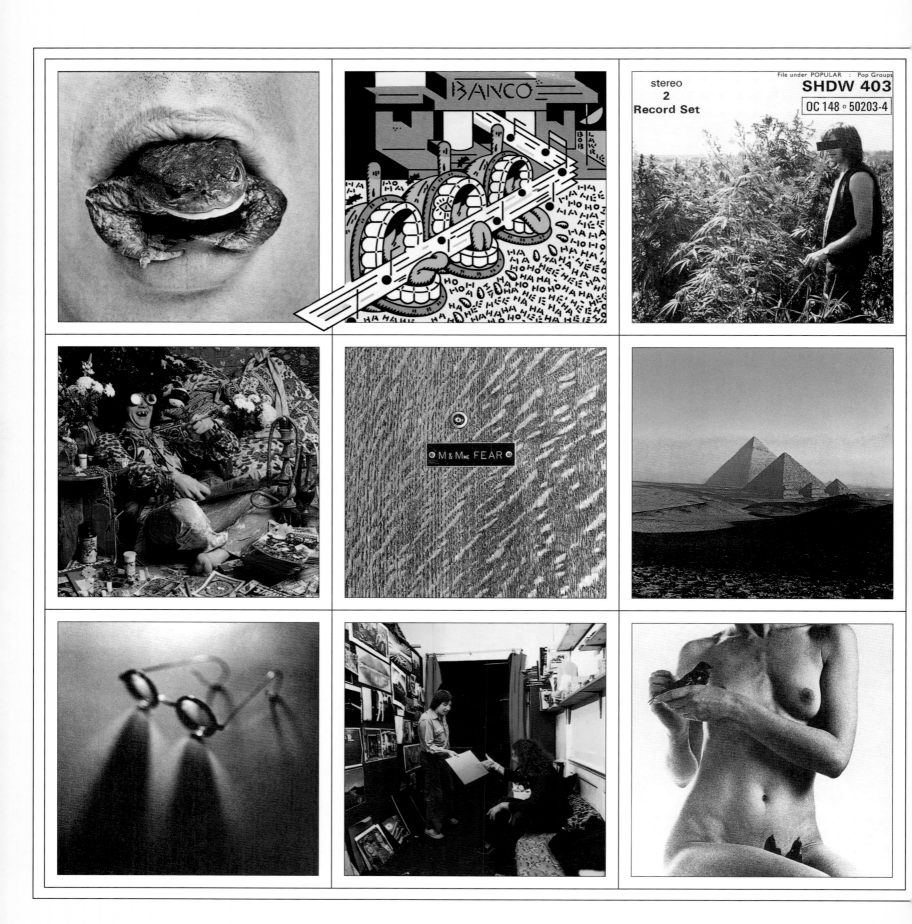

FRONT COVER A NICE PAIR 1974

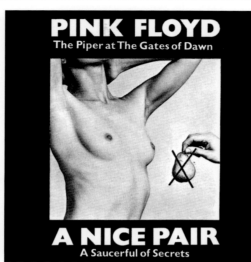

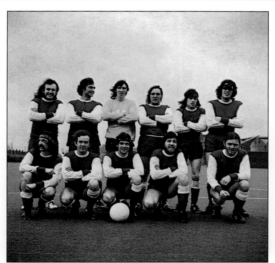
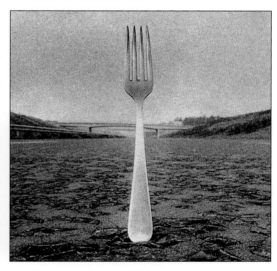

THERE IS A PERSISTENT RUMOUR in some quarters of the Internet, and in some back alleys of Marrakech, that the experience of listening to Pink Floyd music is enhanced by the ingestion of narcotics. There has been a perception down the years that the Floyd could be a 'druggy' band, that their music is derived in part from so-called drug experiences, that there are veiled (and not so veiled) references to drug experiences in their lyrics and that members of the band themselves might have spent some of their lives taking illegal substances.

Absolute tosh. I will scotch this rumour once and for all by citing the Pink Floyd sports team initiative of the seventies. In the winter there was a soccer team and in the summer, quite fittingly, there was the cricket team. Physical exercise, sporting endeavour and some deep and meaningful (male) bonding were the objectives. The soccer team consisted entirely of Floyd personnel, including, on the far right at the back, bonecrusher O'Rourke, feared Irish defender. I must reveal, however, that the cricket team contained two itinerant musician friends from David's second band Flowers, namely Willie Wilson and

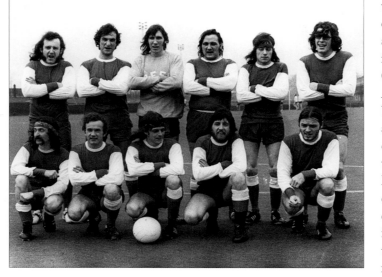

Rick Wills, plus one genuine ringer. Bottom right is the late John 'Ponji' Robinson, scorer and beloved good friend.

One of the few occasions in life when my knees have literally given way and I have collapsed, crumpled into a heap, not fainted precisely, but slumped weak and feeble to the ground, was when David told me that Ponji was dead. We'd known him since we were seventeen. Ponji had been confused, depressed and wracked for years. He was invariably broke, often kipping for the night, getting fed, seeking company but never sponging, travelling incessantly on the London underground, wearing the same coat forever, and taking his shirt, vest and cardie off and on as a single all-in-one sort of 'combination' piece. I loved him. He

threw himself under the tube train at Charing Cross and was crushed to death. So sad. And so annoying. Nowhere to put my love and deprived of his in return.

The team photo was included on the cover for A *Nice Pair* (see previous page) released late in '73, before the success of *Dark Side* had been properly registered by the outside world. *Nice Pair* was a double album re-release of the Floyd's first two albums, *Piper* and *Saucerful*, though the logic or reason for such a decision escaped me. Either it was a nice thing to do for Syd, to get him some extra royalty payments, or it was not such a nice thing to do and was a cynical cashing in by the record companies not the band, on the success of *Dark Side*. Or both.

Nice Pair is another strange title. As I've mentioned elsewhere in this book, titles are a problem, but *Nice Pair* is…well, sexist or dull. Certainly not mind-expanding. A nice pair of albums certainly, but what else? A nice pair of antique chairs? Turtle doves or matching vases? Check trousers? Fluffy kittens? I hate to admit it, but I think it could be an example of male chauvinism. Perhaps the title illustrates, in part, what I think might be the band's misogyny (or my own) — like a lot of men, they love women but see them sometimes as objects, as affection turns to mistrust and respect turns to fear. Or, alternatively, the title showed their healthy lack of interest in re-issues (see *Collection Of Great Dance Songs* page 94). Or both.

My own misogyny led me to go along with it, and display a nude female chest on the cover (see previous page). My occasional sensitivity and good sense led me to demote such a procedure from becoming the whole twelve square inches of LP cover, not that this, I suppose, gets me off the hook. If an attractive naked woman's chest was not the whole enchilada, what was? Couldn't use the old covers — too boring.

A SORT OF MINESTRONE OF IDEAS REALLY USING SOME OF STORM'S OLD STOCK, I SUSPECT, PLUS A LOAD OF PARTICULAR VISUAL JOKES THAT I THINK HE HAD BEEN YEARNING TO USE FOR YEARS. THIS ENTIRELY ACCEPTABLE, I THINK, SINCE THE RECORDS WERE SIMPLY REPACKAGING. WHAT IS NICE IS THAT SOME PICTURES ARE NOT JOKES PER SE, AND SOME JOKES HAVE STILL NOT BEEN INTERPRETED BY ALL THE VIEWERS. WHAT OF IT NOW? STILL A FEW CHUCKLES.

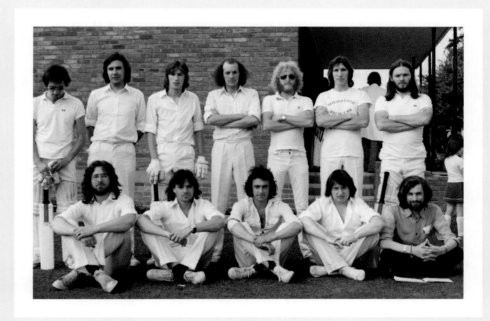

PINK FLOYD CRICKET XI

A NICE PAIR

Nothing new musically to provide a theme or context for us to get our designers' teeth into. What could we do? What we could do was to think up several other ideas which, like the naked breasts, were not fitting nor strong enough to be the whole story. So we designed eighteen covers altogether, eighteen different ideas, and used the lot. That's what we did. Or we were indecisive and submitted many different roughs. Or both.

As much as the rumours of drug experiences and the Floyd are clearly mistaken, so too is the tag of seriousness. The Floyd are of course serious about musical integrity, emotional commitment, intellectual thrust, etc, but not that serious. Atmospheric pieces, dramatic lighting, deep implications, elegant lyrics, of course, of course, but not without a few jokes here and there, a few lighter moments, a bit of rock 'n' roll, bump and grind. *Nice Pair* was a jokey title, even if a trifle misguided. The pictures, or mini covers, are therefore jokey – ironic and cynical puns revealing further phobias, like nip in the air, bird in the hand. . .or real flying (tea) saucers, out-of-focus glasses belonging to the near-sighted photographer. . .a paranoid peephole that actually existed, a Zen monk about to spit on holy ground, a fork in the road, and a drug free soccer team. All in all a different kettle of fish. Oh, and a late friend standing in a field of cannabis free marijuana, of course. Last, and definitely least, Po and me making a rare appearance – *Nice Pair* indeed!

On the inside spread (some of which is on the page opposite) is a historical selection of band photos arranged in a similar layout to the front, except that the precision and exactitude of the front (square after square) were beginning to take their toll, beginning to affect the designer deeply, causing him to lose his composure and make him go quietly insane. Gradually the artwork deteriorated, the line gets ragged, the photos get marked or ink dropped on them; they are not cut accurately, nor fitted properly. It was my little joke about having to be so fucking precious about designing all the time, about making borders equal, right angles correct, type the right size, sitting level and square, after square, after square. It was, and is, enough to drive you bonkers. You got to break out, or break down. The designer, ie me, is breaking down and cannot any longer keep things clear and ordered.

The design for the inside of *Nice Pair* was also intended as a reference to, and a comment upon, the business of band photography, this band or any rock 'n' roll band. The majority of album covers, and the majority of rock visual imagery, comprises photos of the band. Perhaps there is nothing so wrong with this. Many punters like to see their favourite groups; they like to see who plays what, who is responsible for what. But if I cast my jaundiced eyes across my stepdaughter's bedroom walls, this is what I see: personality posters of Pulp vying for wall space with those of Blur and Kula Shaker (three bands popular at the time of writing). There have been great photos of Captain Beefheart or the Stones, of REM or Oasis. Prince's *Lovesexy* album has a delicious tongue in cheek photo on the front, his vulnerable naked body reclining in a flower, his loins cupped by petals.

But somewhere down the line it can get to you. How many times do you need to see Queen, Duran, Jackson or Oasis? What endocrine systems are involved here? What intellectual processes? What can photos of a band tell you about the emotional breadth of the music? How can another mugshot allude to the atmosphere, to the range of feeling, visions and ideas conjured by forty minutes of music? Seriously, folks, how many times do you need to see a posey, cosmeticised, dull picture of yet another rock band adorned with obligatory fashion statements and gormless expressions?

I'm not knocking a good portrait, you understand, but rather the over-reliance, the blunted vision and the predictable attitude involved in their constant use. Anyway, I can't take good portraits, so my unremitting egotism requires different answers. Fortunately the Floyd sort of agreed, and so the use of their likeness began to peter out, and *Atom Heart Mother* was the end of band photos, except for the inner spread of *Meddle*, which was intended as wry humour – cosmic band presented as uncosmically as possible. There are those music biz sages who think this was actually a Floyd policy (not to have band photos) and that this said something about their attitude, and proved to be a good and useful thing in promoting mystery, and reflected a healthy disdain for the more glamorous and outrageous indulgences of the rock world. Of course it was. Who are we to disagree?

Taking band photos was always very awkward for us, especially since it wasn't our forte. Easier to deal with objects than people. I once photographed The Pretty Things and it was a disaster. It wasn't that things were awkward exactly, or that the lighting or composition was inferior. It was more a case of no pictures at all. An entire afternoon's studio session and absolutely nothing to show for it. No exposures. I had been smoking a little dope, it's true, and had failed to switch the camera from manual to flash, such that the shutter opened *after* the flash had gone off. I was taking pictures in the dark. Literally. Which is where the band were when they later asked how the session had turned out.

But I'm clean now. Have been for years.

INNER SPREAD A NICE PAIR

SITTING ON AN EQUIPMENT BOX in the darkened wings of a theatre in San Francisco, summer 1975, listening and watching the Floyd play 'Shine On' followed by *Dark Side*, feeling, thinking, "This is something special. I am here in the presence of greatness." The music and lights washing over a spellbound, rapturous audience. Moments of grace.

Royal Albert Hall, London '68 or '69, the band are premiering quadraphonic sound by playing the noise of a tractor ploughing up and down a field, going round and round the hall, so clear that one felt it was actually there. Earls Court '80, Roger sitting in a chair high on the wall, David standing backlit on top playing 'Comfortably Numb'. UFO '67, Tottenham Court Road – makeshift slides play across wayward freak dancers as Syd meanders through another long bizarre guitar solo. Detroit '87 the bed for 'On The Run' hurtles across the arena high above our heads, plunging into the side stage with a massive explosion. Then there was the one marvellous concert when all the band members, all the crew and all the audience just knew it had been perfect – Liverpool Apollo 1974, of all places.

Earls Court '94, three weeks of great concerts, jam-packed every night, radiant eyes of enthusiastic fans gleaming in the half light, reflecting the fabulous light show and huge circular film screen (providing the basis for *Pulse* design page 145). Not to mention the flying pig, Roger's screams, animated clocks and hundreds of other floating memories from hundreds of concerts wafting like psychedelic debris through my mind. Never forgetting the quality of sound and production that invariably sustained a show even if the Floyd now and then played below par.

I am fortunate.

ON TOUR '75

The truly unfortunate aspect of touring, however, is the travelling, symbolised in our design of bike parts. Not interested in mundane planes, trucks or limos to represent touring we opted instead for the unlikely – bicycles – gleaming chrome, highly painted metal, elegant frame, designer accoutrements (helmet, pants, saddle, bottles, etc). High grade style and streamlined technology – that's the Floyd. I was also interested in 'layers' in pictures, where one part or layer of a picture was completely at odds with, and separate from, the other part. The viewer had, in effect, to look past the front layer, the floating bicycle parts, in order to see the landscape behind (Knebworth poster on page 70). The cosmic cyclist, the 'Miguel Indurain' of the mind,

stands proudly across a road (remember the band were 'on the road'), his beloved bicycle having metaphorically exploded across our view, like the sound and light of a Floyd gig. If you defocus the highly coloured, clearly illustrated George Hardie bits you might see the photographic, Hipgnosis landscape uncluttered beneath, sweeping away from you, round the corner of a lake in Switzerland.

As usual this is all highly romanticised, as are most of our images. The humdrum is ever present in our lives; we don't need more of it, do we? Not in this book, nor on album covers. Nor is it appropriate for Pink Floyd who, it is to be hoped, elevate us, if only temporarily, from the said humdrum – from so-called reality. Touring, however, is not romantic. The daily grind of dislocated living, getting out of one box (hotel) and into another (car) then into another (bus or aeroplane), and finally into another (next hotel) is enough to drive you mad, if not make you jumpy and neurotic, or cause you to withdraw into a protective shell. Touring separates the strong from the weak, that's for sure, and the latter deal with the pressures by avoidance and heavy indulgence.

The US tour of '75, for which the 'bike parts' were designed, epitomised the great range of behaviour commonly associated with rock 'n' roll touring. Fabulous concerts at one end of the spectrum, and debauchery and gross infidelity at the other. One of the Floyd told me when I objected to infidelity that I should get the fuck off my moral high horse because I had no idea of the difficulty in resisting temptation, especially when offered 'on a plate', late at night, with pert little breasts straining at the seams. The argument ran like this – touring musicians tend to be unfaithful because someone offers to oblige. You don't need a moral high horse to think that being unfaithful is unkind, that the "I was on tour and couldn't resist it" routine is pretty shabby, and that any morality based on "I will do it, because I can do it," is full of holes. Or shit. (Let him who cast the first stone, I hear you murmur.) The other routine, of course, was not to tell. Keep shtum. "What they don't know about they don't worry about," is a maxim of rock 'n' roll touring, and in no way particular to the Pink Floyd. Touring can be hell, turning good family men into liars and cheats, or into weak and feeble innocents, led astray by wicked temptation.

But being on tour can also be heaven, especially when sitting in the wings of a theatre in San Francisco and feeling the haunting brilliance of 'Shine On' suffuse your body and wash across your soul. Thrilling and redemptive at the same time.

OVERLEAF KNEBWORTH POSTER 1975

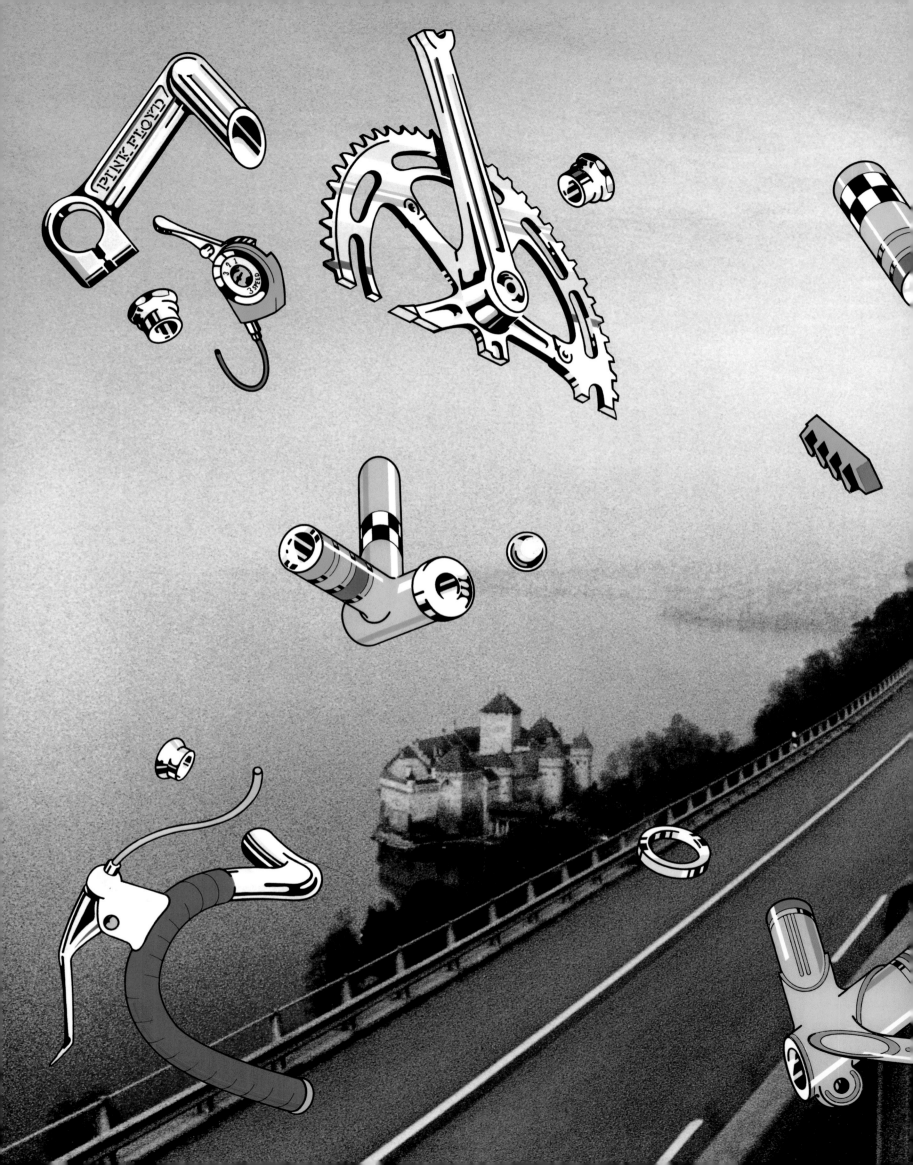

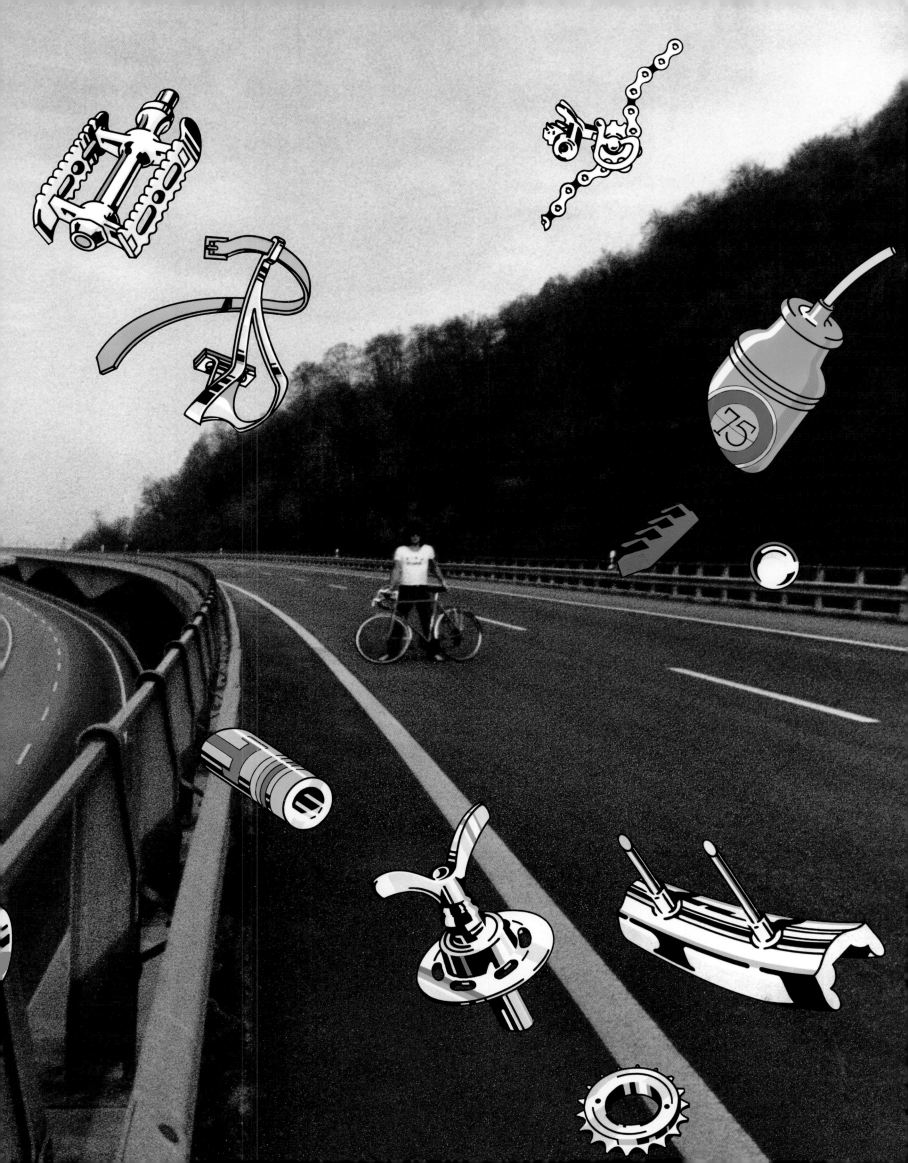

IT IS SAID THAT SARTRE DRANK thirty cups of coffee a day in order to function creatively. It is also said that Philip K Dick used vast amounts of speed. Picasso had a lot of sex. Baudelaire surprisingly relied on routine, while Magritte preferred suburbia. Charles Dickens was spurred on by deadlines. Mozart liked solitude. Some artists work late at night, others early in the morning. Some are quiet, some talk a lot. Many drink a lot.

Clearly the whole issue of inspiration is unclear. It arrives in many different ways for different people at different times. It just as mysteriously disappears, or dries up, and this is considerably more pressing. Writer's block is heavy news and very depressing, removing both raison d'être and rent money. Finding inspiration is crucial: sustaining it is even more so.

I get ideas in two ways: in private and in collaboration. They may, in the first instance, just appear in my mind

after thinking consciously about a specific job. This private thinking involves mulling, recalling the music, turning titles and lyric lines over and over in my mind. Images rarely arrive spontaneously, or via dreams, or as a result of concentrating on something completely different, which is a pity. I dreamt a Peter Gabriel cover design once, the 'melting face', but more normally, images or ideas are the direct outcome of focusing, even loosely, on the matter in hand.

More often I get ideas in collaboration. This takes a very simple form viz we just sit in a very ordinary room, listen to Floyd music and talk. We natter. We discuss what the music feels like to us. Or the intention of the lyrics. Or what the album may really be about, even if the Floyd haven't said it, or don't yet know it. We look for deeper meanings, or broader brushstrokes, not because we are deep, of course, but because we need, as designers, to refer

to a whole spectrum of experience – namely the album. The front cover is usually a single design or photograph, intended to represent the whole forty or so minutes of an enterprise that has involved huge amounts of effort, talent and emotional commitment. One little image to represent all that music.

On other occasions it's just a small thought, an aside or a little word that provides a sort of key, which is then turned by further discussion to open the design door to release an image, or several images. This is done in company. In the early days it was with Po, then George Hardie and then Peter Christopherson, with whom these meetings were particularly fruitful. Then there was Colin Chambers, eccentric to the last. And Keith Breeden, who was a very good designer of album sleeves until he chucked it in for the life of a painter in the wilds of Wales. Sensible man. Lastly, Peter Curzon, who helped get this book together, Mad Jon Crossland and Finlay Cowan, who is tall, cadaverous, often wears black and has a predilection for Arab culture and drawing mysterious women.

To all these good people, and many others I'm sure I've omitted, I doff my hat. Without their invaluable help this book, or any of my/our designs and images, would not have come about as they have. The essential axis of these design meetings is the presence of the other. And this is not to demean anybody's individual contribution, but it is the act of talking it out loud, and the act of thinking about the job, in the presence of another that is vital – vital to me. The other person can become a sounding board, a challenge, a mirror and a source. The other presence says, "Come on then let's design something. Let's do this thang." It is their very presence that can prevent kidding oneself, yet forces one to function in the nicest possible way. If I work alone I could easily procrastinate or settle for second best and so on. Or get lonely. I don't as a rule trawl through source books, or rifle through plan chests full of references. I'm not even organised enough to keep all the old rough ideas which is, sadly, why I can't reproduce them for you. I just sit down with good pals, listen to the music, and ask out loud "What are we thinking of? What's this album all about then?"

This procedure for getting ideas is probably similar to many other designers and film makers. Meet and thrash, I think it's called. Let's face it, we are not islands, are we?

FRONT COVER WISH YOU WERE HERE 1975

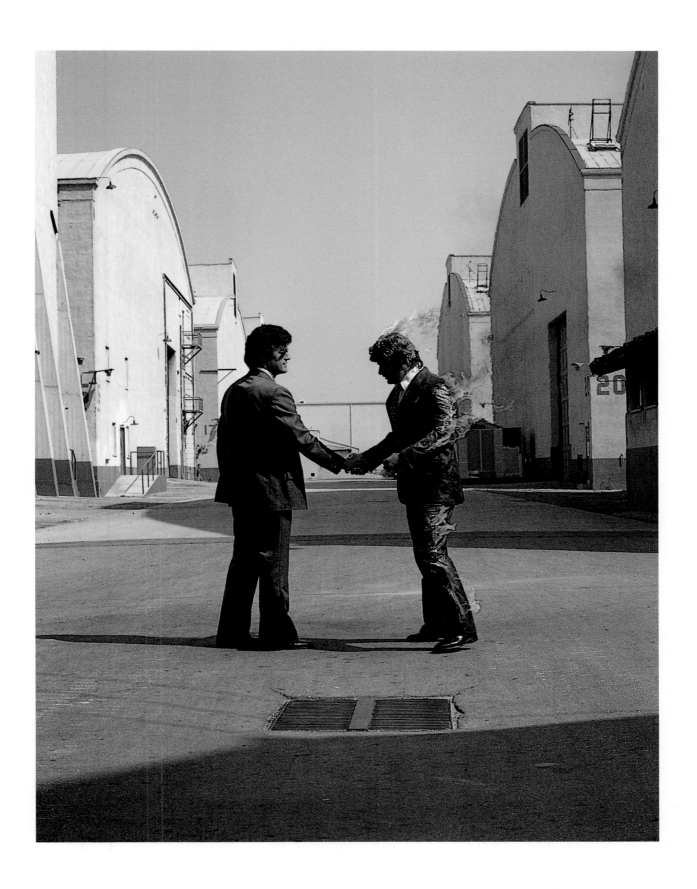

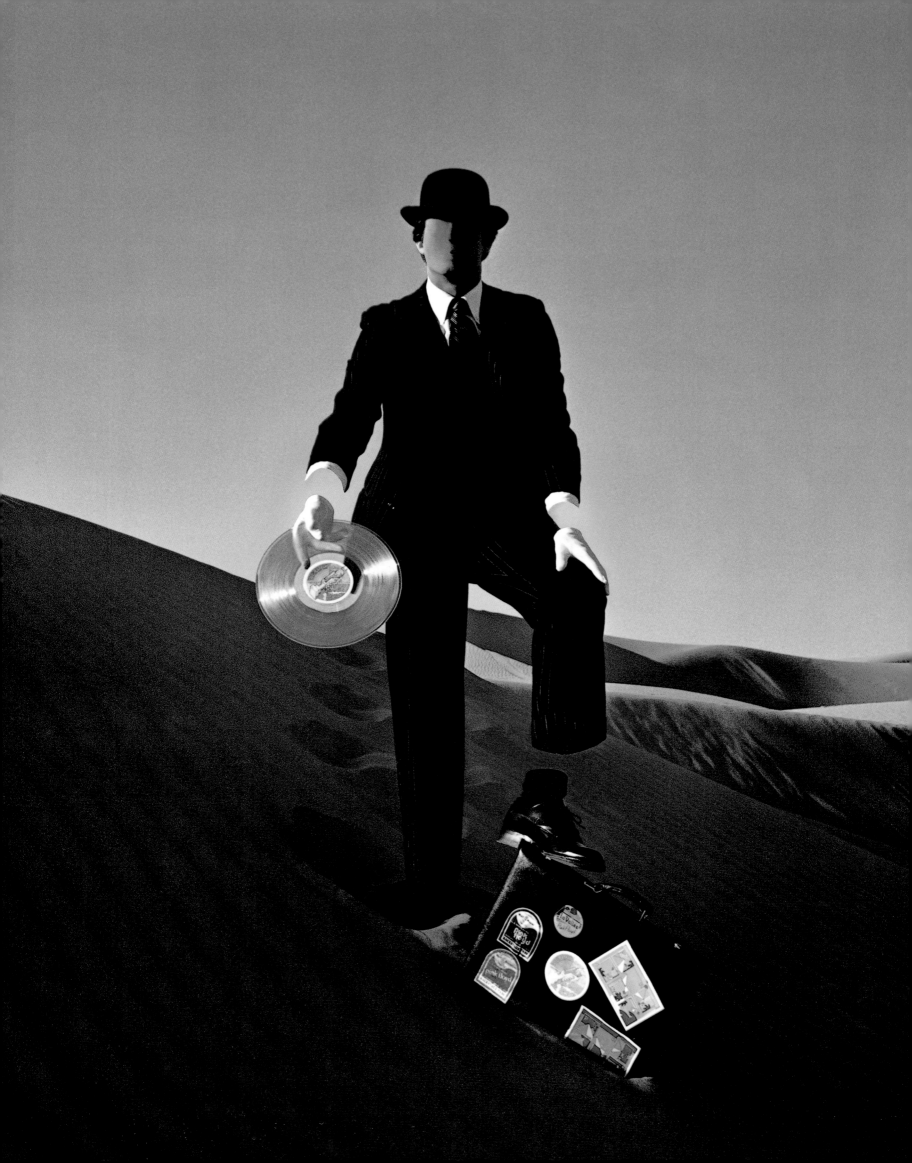

There is no self without others to define it. If you were the only person in the world you wouldn't be you since there's no me to tell you. Anyway, the great advantage of this approach is that someone else can think of an idea in these meetings (in case I don't) and if it's any good I'll show it to the Floyd and claim the credit. Do you think I'm stupid?

Having procured some ideas, by either private or collaborative means, they are drawn up and coloured as roughs. These are illustrations of what will be a photograph

in the end and are sometimes accompanied by photographic reference. In the case of *Dark Side* (page 52) we submitted seven roughs, I think. The Floyd convened in a drab back room at Abbey Road and reviewed the material. It took them all of three minutes. They looked at each other and agreed that the prism was cool. At the time I protested. I wanted them to consider some of the other depositions that we had slaved over, but they declined. The prism was OK and they needed to continue with the real business of making the album.

Wish You Were Here was a different story altogether. Lengthy discussions, particularly with the band, much internal focusing and repeated exposure to the haunting brilliance of 'Shine On You Crazy Diamond' led inexorably to one point, led to one theme, in fact to the one word, 'absence'. And nothing more poignantly, or powerfully, could have illustrated this thought than the sudden completely unexpected out-of-this-world experience of Syd, lovely sad spooky soul-laden Syd, arriving at Abbey Road while the backing vocals of 'Shine On' were being laid down and they were about him! We hadn't seen him for six or seven years. I don't know to this day what made him turn up just then, looking terrible, his head shaven, eyes sunken, complexion jaundiced, his body fat, asking awkwardly if he could be of any help. But he was out of it. Roger cried. David cried. The rest of us were stunned. Syd was so very absent, this absence made more stark by his presence.

I suspect that the feeling of absence pervaded some of the band's personal relationships. The numbing sense that despite trying hard they were only going through the motions. Loved ones were physically present but emotionally absent, somewhere else mentally. Pink Floyd, or so Roger later contended, were also not fully present, not entirely together as a band. They were in part going through the motions – present but absent – not that this prevented them from making something beautiful like 'Shine On'.

But how do you represent absence? Especially with a presence, ie the presence of a design. We couldn't do a blank cover because The Beatles had done that with the *White Album*. Instead we devised a hidden cover. LPs in those days were often 'shrink' wrapped in clear, thin plastic, like cellophane, same as many CDs today. We suggested it was made black and opaque so the public could not see what was inside. They were theoretically obliged to break open this plastic wrap to get at the record, the valuable part within. I have heard it said that some folks carefully cut the edge with a blade and slid the record out. Thus they have the album to this very day still wrapped in black plastic and have never seen the burning man on the front. How absent can you get?

Liner bag Wish You Were Here

For those photographically minded, this picture is taken with a Nikon 35mm SLR with a wide angle lens using available daylight and normal colour transparency film. For those geographically minded, this picture is of Lake Mono in California, just south of Death Valley. For those filmically minded, it is a location used subsequently by Clint Eastwood in *High Plains Drifter*. And for those sexually minded, there ain't no sex here. It is absent, like the splash.

The hidden, or absent cover, was the art part. Didn't need to meet any so-called commercial criteria (eye-catching, bright, clearly labelled, etc) because the public couldn't see it anyway. Sony, or Columbia as was, were particularly sore about this, complaining bitterly what was the point of doing 'great' (record companies are so devious) and expensive-to-print 'graphics' (Americans always called images 'graphics') if no one could see them? Which, of course, was just the point. Within the privacy of your own home the images could entertain or disturb you in a variety of ways. Could be low key, obscure, intriguing or ambiguous. Perhaps better if they were. Might last longer like the music.

Either way these ideas were brought together as one complete rough, including black shrink wrap. No alternatives like *Dark Side*. It was presented to the band not privately, but at a meal in Abbey Road Studios, with all the technicians, the manager and a few others. I was very self-conscious. Luckily they thought it was fine. In fact, they gave me a little round of applause. Very moving, for me.

The only deference to the whole notion of making the record clearly recognisable to the public ('selling' is the word in record companies) was to put a label on the front so it could be identified. This label, illustrated by George Hardie, embodies the handshake from the burning man...as empty (or absent) a gesture as you can get. The man is really on fire. He wore an asbestos suit under the cloth suit, which extends over the head where a wig was attached. The first attempts at setting him alight were in the wrong wind direction. The flames were blown back and ignited his real moustache for an instant. A close shave, one might say. People often shy away from emotional commitment for fear of rejection. Absent through fear of being hurt, of being 'burnt'. The photograph was taken with ordinary 35mm colour transparency, though the American version was another photo taken on 120mm colour. Same but different. The Floyd liked both shots so that was cool. Nobody could see them at first to raise any objection.

The diver on page 78 photographed by Po and Peter is just great. So beautiful. Takes the breath away. Took the model's breath away as well. He is really there, I think, doing a yoga

headstand in a submerged frame, and holding his breath for two or three minutes to allow the ripples in the lake to die away. A dive without a splash, an action without its trace. Is it present or absent? It was used also as a postcard insert with the original vinyl package – a postcard because that's where one most often says 'Wish You Were Here', not necessarily meaning it. The red muslin veil is a universal item, or symbol, of hiding the face, either culturally as in Araby, or for respect as in funerals. What's behind the veil? The businessman (page 74) is, on reflection, a rather crude attempt to indict the record business for all its hypocrisy. Business ethics consist of permitting any behaviour if it's good for the business. An absence of care and concern for others is perhaps a defining characteristic. Our Floyd salesman is morally absent, lacks integrity, not really who he thinks he is, and is therefore absent, no face, or faceless. (Isn't that biting the hand that feeds you, I hear you murmur.)

The comic on this page was devised as a programme for a live concert in London, circa 1974, I think, judging by the prism reference that is on the front. The other detail (overleaf) is the back and depicts the procedures for a fan to follow in order to transmute onto another plane of existence, without the ingestion of any illegal substances. There was a brief craze amongst Floyd audiences for doing this sign en masse, but it didn't last. I guess it didn't work too well.

Last, but by no means least, is the swimmer in the desert opposite, the Yuma Desert to be precise. (Do you remember Van Heflin in *3.10 To Yuma*? Or in *Shane*?) But I'm digressing... This swimmer was not found on the original package, but has appeared in the *WYWH* songbook, *Walk Away René*, repackaged CD and *Shine On* book. It's not the absence of water that was in my mind when I thought of it, more the absence of awareness (he didn't notice he'd left the sea) and the absence of purpose – he just swims on and on with blind intent, going nowhere really. And for no reason either.

This swimmer is one of the very few images I've designed that always needs its title – it was designed long before Monty Python appeared, I might add. Talking of titles, or more especially, the difficulty of finding good titles, *Wish You Were Here* works very well, I think. Wish I'd thought of it...

The Meaning of Life

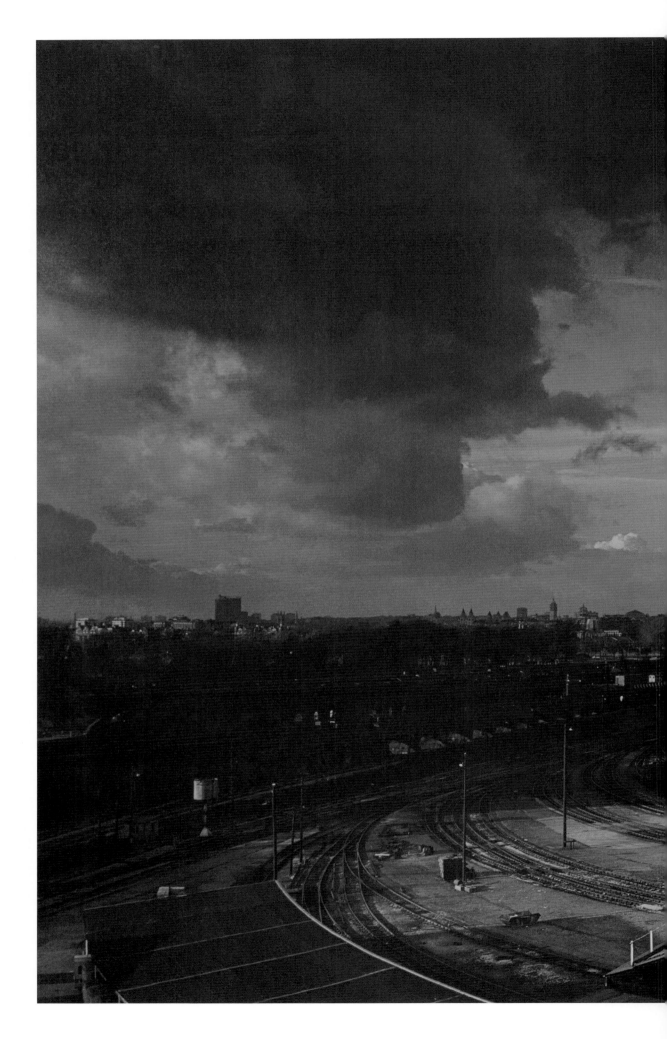

ANIMALS FRONT COVER 1977

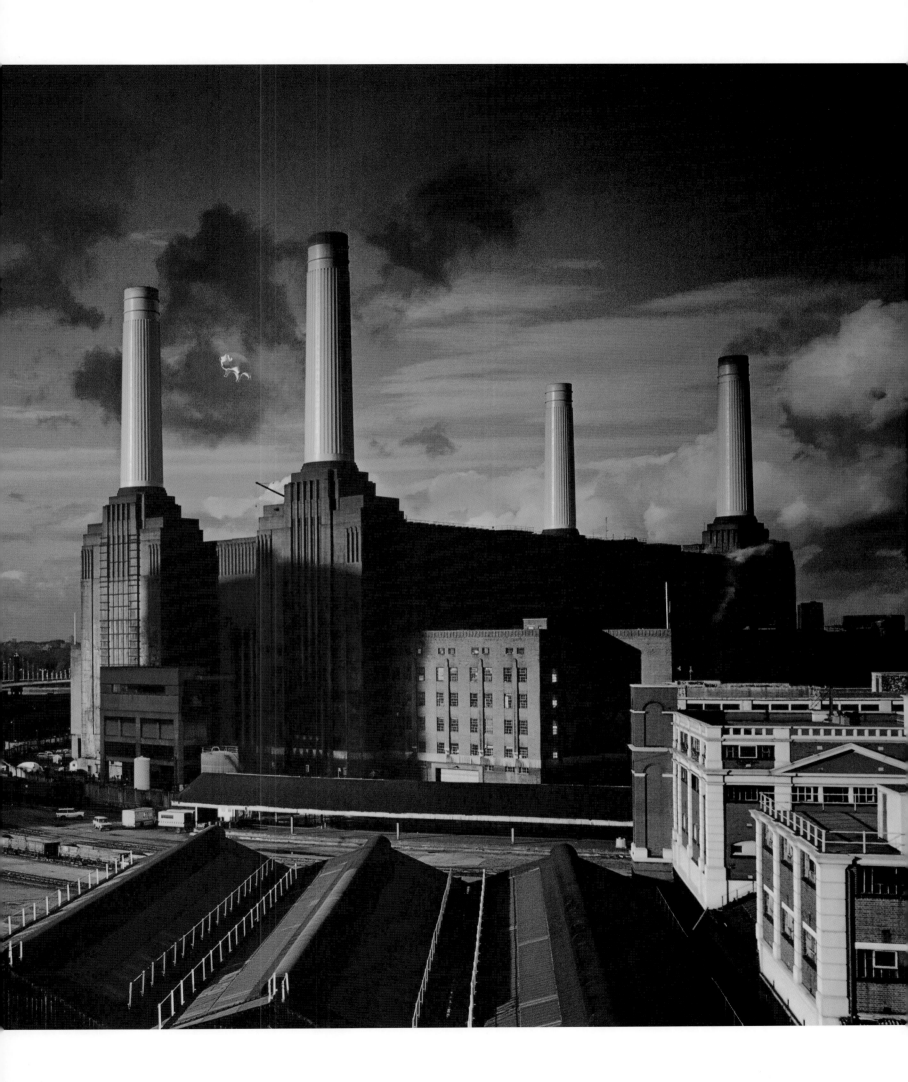

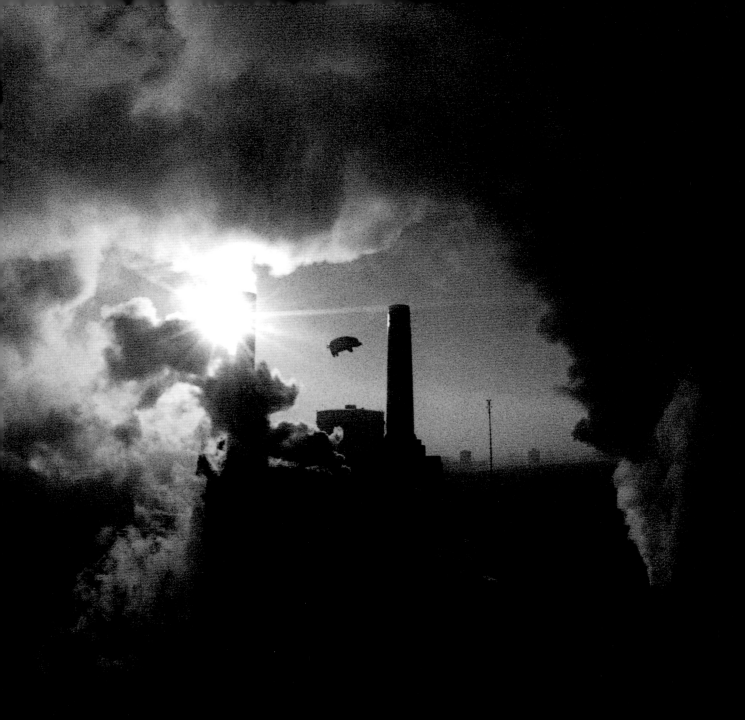

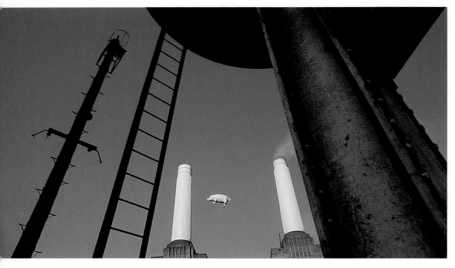

THE DESIGN AND CONCEPT for Floyd's cover for *Animals* was suggested by Roger. And a brilliant idea it turned out to be. At first I was miffed since the band rejected my suggestion (see page 83), not only because I hate being rejected, but also because I thought that the psycho jungle of our early lives was presented with a witty freshness. But the event of the flying pig itself, the finished artwork and the subsequent years have proved the point. At the time of writing this wonderful building, the Battersea Power Station, is in sorry decline, literally crumbling away through neglect. So hopefully our cover will serve as a great memorial, if not a fitting epitaph.

The inflatable pig was a dirigible about 30ft long and 20ft high, and it was brought to the site near the River Thames in London, upstream from the Houses of Parliament. The Floyd's road team, in concert with technicians from the dirigible company, endeavoured to inflate it. Po and I had organised a veritable army of photographers (at least eleven of them) and had deployed them at key positions round the power station, covering nearly every conceivable angle, including the roof. The floating of the pig was going to be an unrepeatable event and we didn't want to miss it.

We waited. Everyone was in position. Steve O'Rourke had the foresight to employ a marksman in case the inflatable pig escaped and caused damage or injury. The pig started to take shape from the unformed fabric. A leg here, an ear there. But then nothing. Technical difficulties prevented further inflation, and the pig never even got off the ground. But the weather had been magnificent. Dramatic clouds gathering to the left had encircled a spot of blue sky streaked with cirrus, through which the sun briefly illuminated the building in all of its deco splendour.

But no pig. Everyone returned the next day, took up similar positions and waited expectantly. The sky was cloudless, a brilliant blue. The pig, all pink and rubbery, took shape as it was inflated. When fully formed it was slowly steered up the side of the building with various guide ropes and much excitement, chucking of hats and general back slapping. But, before we had photographed it adequately, before the ground crew were ready, a gust of wind twisted the hapless animal and forced it free of its mooring ropes. It shot off into the sky, rising with unexpected speed, and disappeared in a few minutes into the blue yonder. As a matter of economy, the marksman had, of course, not been re-employed, and could not shoot it down, though I doubt he'd have had the time.

Again no pig. Or rather extremely short-lived pig. Some photos, but not many. And to add to the general disappointment was the dawning realisation that the pig had escaped high into the airlanes used by incoming æroplane traffic to Heathrow Airport. You should've seen the next day's headlines in the national newspapers. Several jokes about if pigs could fly, incredulous pilots reporting unidentified flying pigs, and so on and so forth. But all of this did not deter the Floyd, whose roadies rescued the pig that evening from where it had fallen on a Kent farm. Picture the scene, farmer on the porch, wife inside preparing dinner and him saying "You won't believe this, dear, but..."

Next day, ie day three, the dirigible was back outside the power station, repaired, inflated and ready to go. The sky was again cloudless. All the photographers and now a film crew and helicopter were ready. The inflated pig was floated between the towers of the power station and stayed there all day like the good pig that it was. It had had its fun. Now for work.

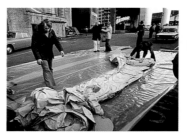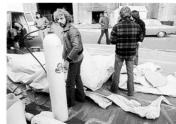

The photographs that you see come from all three days. Since there were so many photographers working with all types of film and equipment, I can supply very little in the way of details other than to tell you that the finished artwork comprised a real pig (day three) with a real background (from day one). We had suggested previously that the whole thing could be 'stripped' together. There was no need to photograph the pig actually on site, we said smugly. We were wrong. The great virtue was in staging the event, and the beautiful and dramatic qualities were best achieved by doing it for real. Roger had insisted all along that it was done for real. He was right, as he was about using this idea in the first place. Damn it.

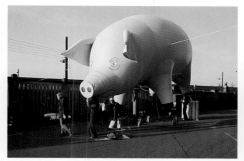

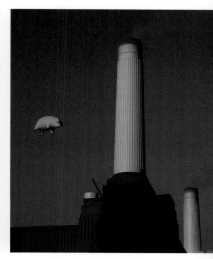

ANIMALS

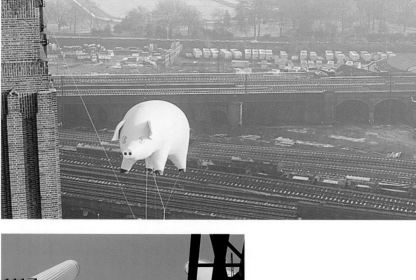

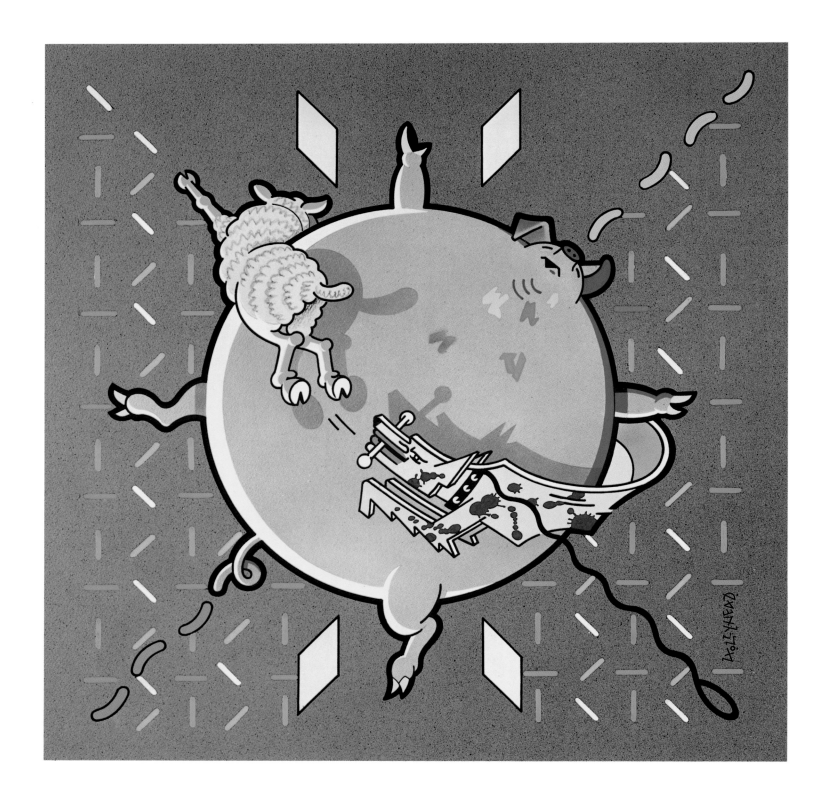

Animals Songbook by Bush Hollyhead

EIGHTIES

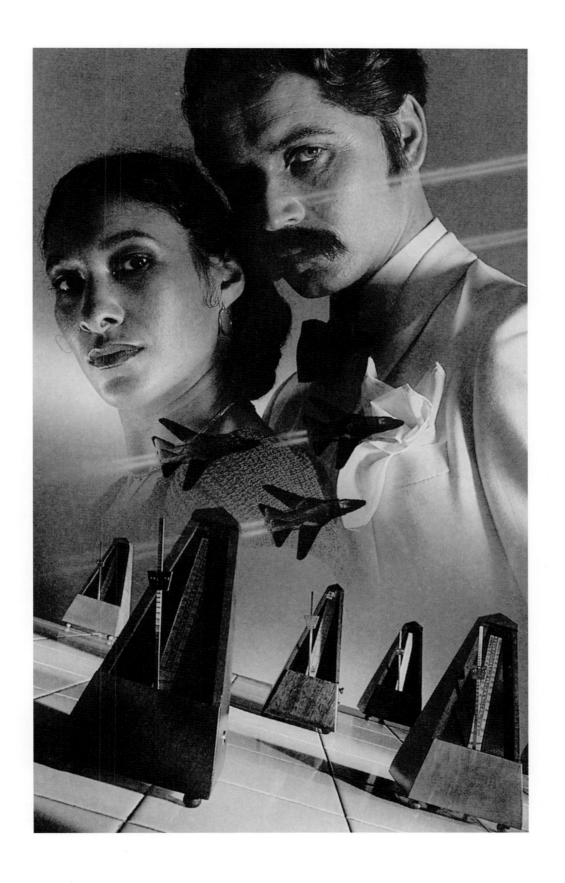

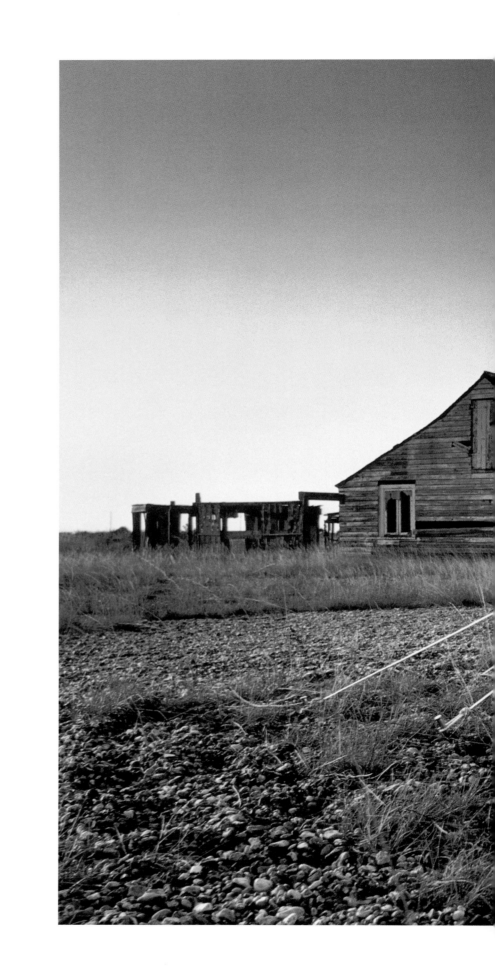

A Collection Of Great Dance Songs front cover 1981

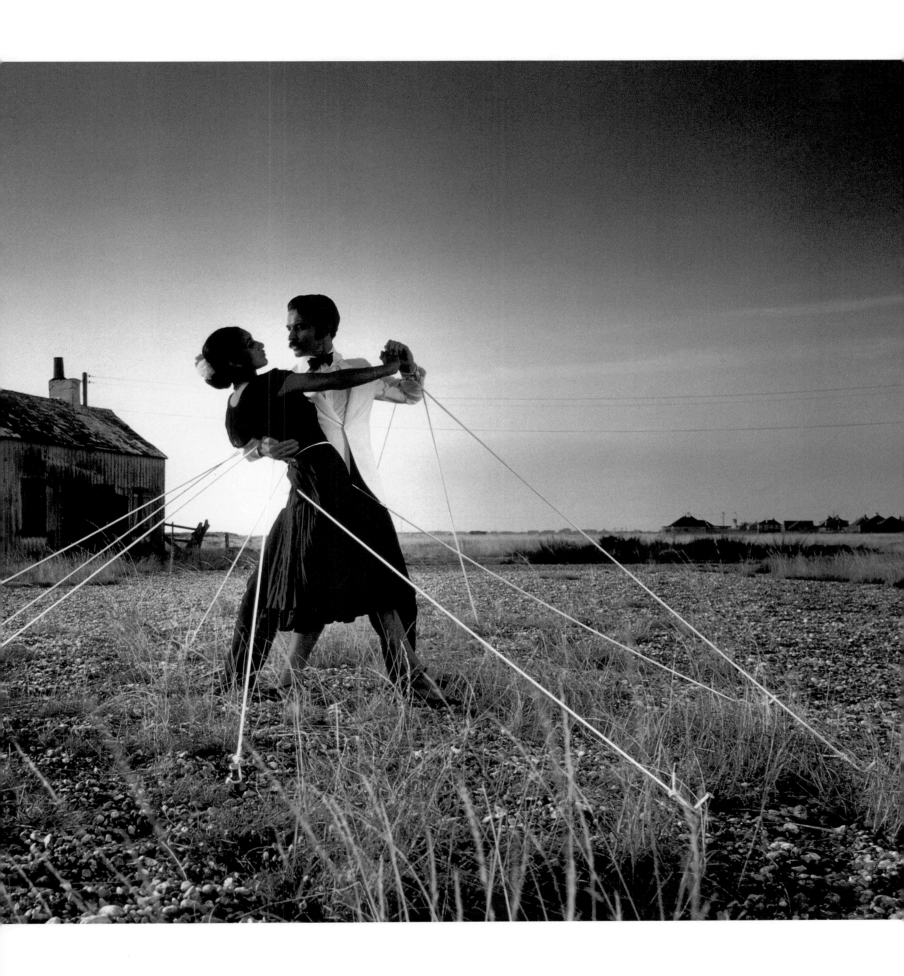

A COLLECTION of great dance songs my arse. What dance songs? The title of this album sounds more like Mantovani than Pink Floyd. Can't see it myself…a bunch of old dears waltzing around…not the atmospheric music I know. No way José. Whoever thought of this title must be an idiot.

Like *Relics* and *Nice Pair* this is a compilation album. The criteria for track selection appear bizarre. Two songs are singles, the rest not. Some are up tempo, some not. Most of the tracks are well known, especially to Floyd fans, but there are other tracks as well or better known. No rhyme nor reason. A typical record company idea. I blame the Americans.

The problem is that the concept of 'a compilation', or the 'best of', is, well, not Pink Floyd. They neither make singles, nor produce albums of pretty tunes from which extracts can be easily taken. 'Best of' is a pop music notion, not a Floyd notion. Of course, you can physically do it, I'm just saying that it isn't suitable, particularly in television commercials where record company promotional men want a thirty-second sound track made of a medley of favourite Floyd songs for chrissake!

Following the thread of contrariness apparent in both the album's existence and its title, I suggested a pair of dancers who couldn't dance, where the attributes of movement and flow were denied, caught forever in a static pose, tied down by guy ropes like a tent. Undancing dancers.

The photograph was taken in 120 Hasselblad with a wide angle lens in available daylight using Ektachrome colour transparency film and a soft-edged chromofilter for the sky. The location is Dungeness on the south coast of England, a strange dislocated place between a shanty town of wooden fishermen's huts and a nuclear power station. The neat trick was to secure the pair of dancers with elastic rope, so that when they 'swung' into position the ropes were kept taut.

In my mind, the dancers were a couple from *Come Dancing*, a dated and surreal British television show featuring ballroom dancing. They were dead keen to win a championship, but were also very much in love. She was South American, and might well have needed a permit to stay. They would be married beneath an air force fly past, their love of dancing symbolised by metronomes moving together. This warped fantasy was supposedly embodied in the photo on page 93, for which we superimposed three separate b/w images in the darkroom and then printed as a duotone of red and black for the back cover.

The liner bag was made of small segments of a variety of culturally different dancers to illustrate Floyd's worldwide scope. The layout, graphics and lettering were nicely executed by Neville Brody, renowned for his work on *The Face* and for his numerous designs and typefaces.

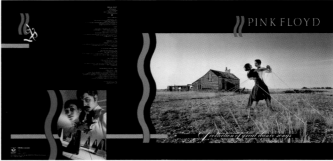

A COLLECTION OF GREAT DANCE SONGS

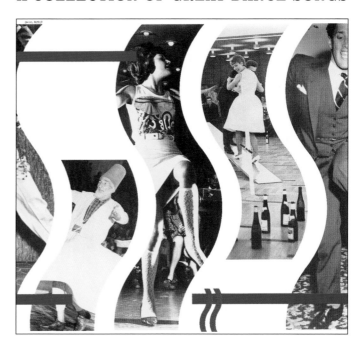

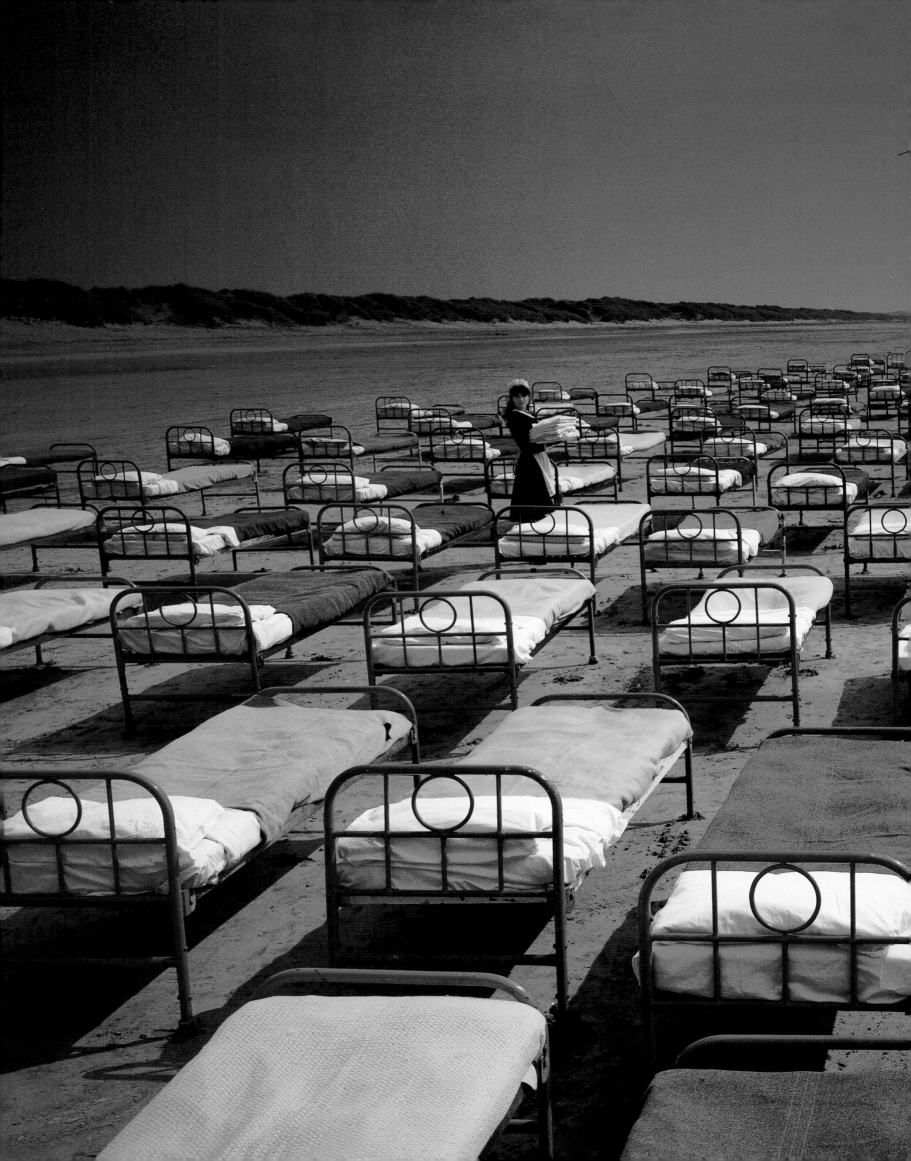

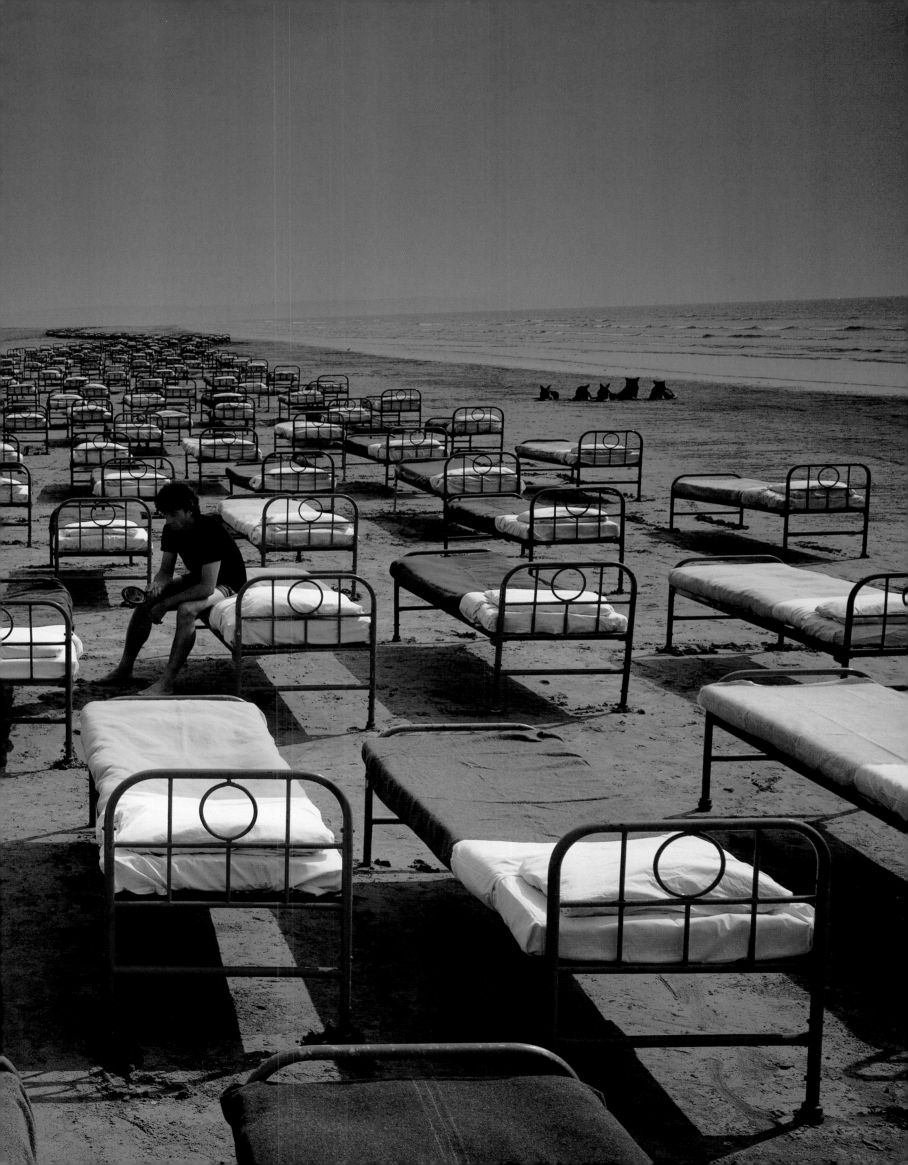

A MOMENTARY LAPSE OF REASON
P

THIS IS THE LAST CHAPTER I write of the first edition. I'm not organised enough, it seems, to do it chronologically, so I've left the most difficult to the last. Perhaps this is in unconscious sympathy with the state of Pink Floyd at the time. Difficult was hardly the word. It was traumatic. What's difficult for me here is the contradictory impulses, to say nothing or say something. It is clearly not my province to say much about Floyd music or Floyd business. I don't anyway know or understand that much. But when the state of affairs informs the imagery then it becomes more relevant to me and my rôle (so far).

There are two issues. First, I suspect that I was employed for *Momentary*, partly because my work is associated with the band, nothing necessarily to do with talent − just a historical connection. Secondly, the fundamental nature, and specific content of the *Momentary Lapse* album cover ie the beds, was a direct result, I feel, of the prevailing circumstances. Roger, it seemed to me, wanted to disband Pink Floyd. As a consequence he resigned. It also seemed to me that he hoped, if not expected, that Nick and David would also resign and Pink Floyd would simply cease to be. Otherwise why didn't he try to get rid of them? Nick and David in particular did not agree to resign and wished instead to continue Pink Floyd. If Roger wanted out that was his business: but it was not his business to tell the others what to do. He tried, it was said, to force the others to quit or bury Pink Floyd. He was unsuccessful and was obliged to make a deal. Pink Floyd continued as David and Nick despite several legal attempts by Roger to block or freeze the band's activities. They brought out a record and went on an intensive worldwide tour as Pink Floyd − *the* Pink Floyd.

This 'divorce' was marred by much bitterness and acrimony, and the aftertaste lingered for some years. It still does, in my opinion, but everyone is used to it now. Some areas of mutual business, especially in relation to the past, still exist and get seen to by 'representatives'. Other areas, ie after 1987, became the sole province of David and Nick. And the first of those was the making of a new record, *Momentary Lapse Of Reason* − a title which I had thought referred to David's personal history, but appears in hindsight more appropriate perhaps to Roger.

In 1987 David made a general decision which I think was very astute. He knew he had to be strong to attempt a record without Roger, so he sought as much support as he could. Rick Wright was brought back into the fold and Bob Ezrin was recalled to help produce the album. He also helped organise the live show, as did Robbie Williams and Marc Brickman. And I was brought back to design the cover and make some films, help give *Momentary Lapse* a Floyd look, a Floyd feeling, as much as the musicians were there to help produce a Floyd sound. I consider this action of David's not a weak or feeble procedure but one of incredible good sense and humility. It would have been a very difficult task with just him and Nick. It takes strength to acknowledge one's weaknesses.

The idea for the beds comes from two sources. The first was a lyric line from 'Yet Another Movie' which read "A vision of an empty bed". David had drawn a picture for this which I liked, but not madly, so I rearranged the words to become "a vision of empty beds" and that's it. A long line of beds stretching across the landscape as far as the eye could see. Real beds in a real place. So many that the viewer might ask how it was done as much as what it might mean. The second source was a lonely rower, or sculler, rowing himself down a dry cracked river bed. This was a reworking, I realise, of the swimmer in the dunes for *WYWH*. The beds then became arranged in a gentle curve stretching away from the camera, like a river, as in 'river bed'! And the sculler's boat was transformed into a sleek Edwardian row boat skimming down the River Cam near Cambridge for a film called *Signs Of Life* which was shown at all the concerts. It was also seen in a windswept lake in Oxfordshire for the picture on page 97 which was used as the record label. The same rower, Langley Iddens, occupied a fast moving bed for the concert film for 'On The Run' from *Dark Side*, a hospital bed like one from the cover. It all connects somehow, somewhere.

But where to get all these beds and where to put them? Obviously Los Angeles was the answer: city of dreams or visions, with great natural lighting and moody landscapes like Death Valley. This turned out to be a bad idea because they did not have the right kind of beds. I wanted Victorian,

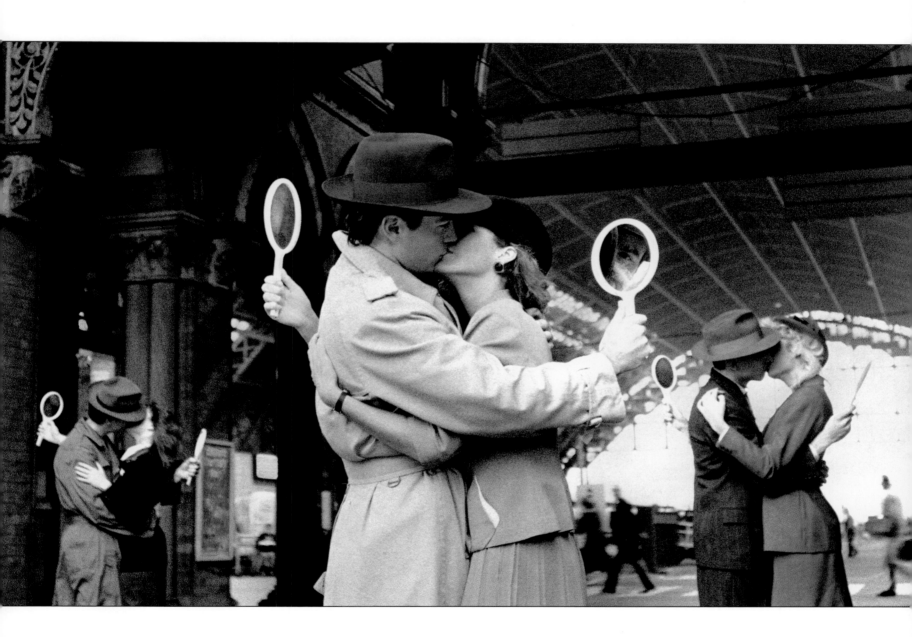

FRONT COVER 'ON THE TURNING AWAY' SINGLE 1987

wrought iron, hospital type beds for dreamers, or mad people, or even ill people. Beds to dream in, or beds to recover in, as David and Nick needed to do. Lance Williams, location manager and all round good egg, somehow laid his hands on 700 beds and accompanying sheets, blankets and pillows, plus two articulated trucks and we took the whole lot down to Saunton Sands in North Devon and began to put them on the beach – one by one.

It was a nightmare. Not at first, but later. There were three tractors with trailers, several carts, thirty helpers, dogs and dog handler, two models and two photographers, Bob Dowling

After much hectic activity we photographed exactly what you see on page 98, including the dogs and the microlite in the sky (for 'Learning To Fly'), and Langley examining his own reflection in the hand mirror. This picture is 5/4 colour transparency on wide angle with available daylight. What you get is what you see: 700 wrought iron beds all individually made up and each weighing several tons, or so it seemed by the end of the day. The photograph on page 104 is a 35mm colour transparency taken when the tide was on the turn and came rushing back, flooding all the beds in the blink of an eye. Wet dream, or what.

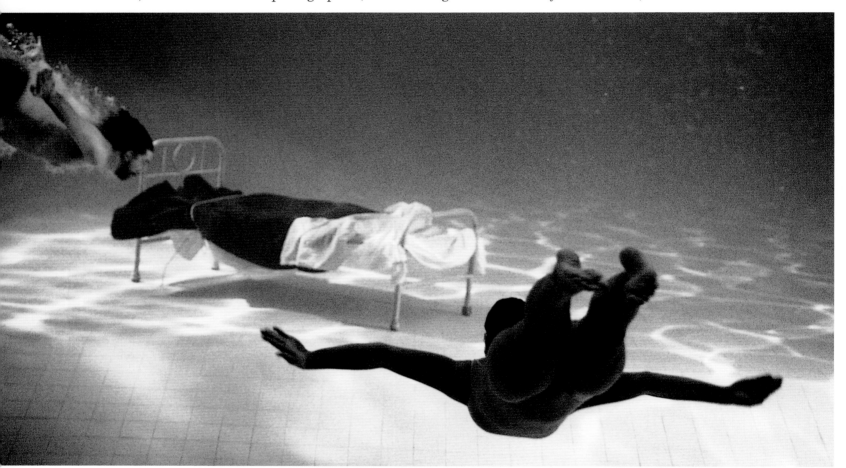

and his young assistant Tony May (so that's how he crept in), and one microlite. Unknown to me this was the same location used by Alan Parker in the *Wall* movie for the military sequences, appropriately enough. After a totally exhausting day we got everything in place and whambo, it started to rain. Not just any old rain, but the kind of English drizzle that turns everything grey and misty and limits visibility to about 50ft. We couldn't see dick, let alone the end of the line of beds. So we had to abandon ship, cancel the whole caboodle, and return two weeks later with exactly the same cast, same army of helpers, and same semi-military procedures.

The underwater bed is an illustration for the *Momentary* songbook; whilst the chap standing with the scythe in a cornfield outside Calgary in Canada (the Rockies are in the distance) is the star of a video I directed for 'Learning To Fly' which is, of course, from the album. This little film was enjoyable to make because we were in Jasper Park in the majestic Rockies, as well as in the cornfield, and it was very stimulating. We used a helicopter for much of the filming and that was very exciting. And the video won a couple of prizes, which was very gratifying. Since we're not a CD ROM I can't show it to you, which is very frustrating.

STILL FROM 'LEARNING TO FLY' VIDEO 1987

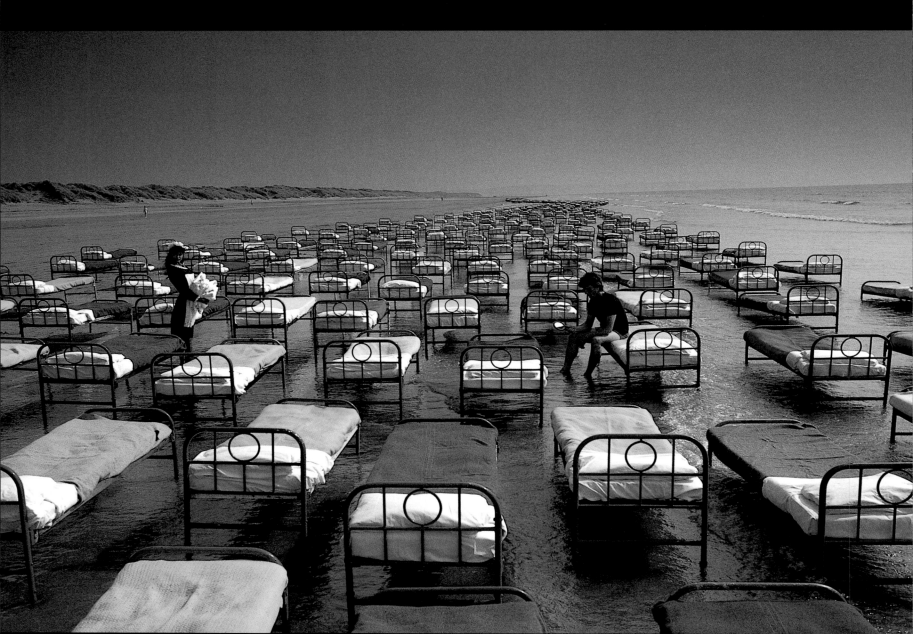

Front cover Delicate Sound Of Thunder 1988

Back cover album

OTHER PEOPLE could look at work in this book and say things like "I know where that comes from", or "I can see such and such an influence here". If they're being more brutal they might say "I know where he ripped that image from". Picasso said something like this: talent is the ability to steal and genius the ability to steal without being noticed. I don't suppose he was being very serious, though you never can tell with Pablo, can you? I have a theory, not substantiated, of course, and based mostly on my own taste, that Picasso was partly colour blind (one in eight men are, you know, that's a statistic). Shock horror, the greatest painter of the twentieth century colour blind!! Can't be. Having recently visited a major Picasso portrait exhibition in Paris at the Grand Palace and the permanent show at the Musée Picasso, I see no other way to explain his invariably horrible colours, the dearth of colour generally and the huge preponderance of no colour at all. The black and white, or grey and cream Picassos are just as good, if not better. But I digress.

Personally, I don't have an experience of 'borrowing' when working, or of being directly influenced, even though it's culturally unavoidable. It's not just that I wouldn't like to be called a plagiarist, it's also because I don't have the sensation of knowing an image of mine comes from anywhere specific. I rarely go looking in source books or reference files. I don't look at photographic books much, or visit photographic exhibitions (maybe I should). I can see, especially when pushed, that *Atom Heart* might 'come' from Warhol, *Ummagumma* might 'come' from a well-known illusion, *WYWH* from Magritte, *Saucerful* from Psychedelia, *Dark Side* from a textbook and so on, but all these designs and the others actually emerge from such a wide set of influences that specific

attribution is meaningless. Atom Heart 'comes' from chocolate box designs, and from schoolbooks on farm animals. *Dark Side* stems also from school experience, and from rainbows, from fluted bathroom windows, from glass

DELICATE SOUND OF THUNDER

paperweights and from the Floyd light show. *Collection Of Great Dance Songs* is slightly in the surreal tradition, but is not strictly Magritte-like. Images

evolve from such a vast reservoir of 'previous' material that it seems nearly irrelevant to comment on it. It is precisely this deep well of experiences and influences that one wishes to tap. It is why I don't like computers much, and why I don't bother looking at books (unless I'm stumped), because I don't want to limit the ability to explore the reservoir in my own head, and/or the one outside in the general atmosphere, which I believe, perhaps naïvely, to be available when one is focused.

But *Delicate Sound* is different. Its genealogy is more straight-forward. Due to the mediocrity of the ideas and/or to the Floyd's indecision, two complete and separate images were agreed. The one opposite 'comes' from a *National Geographic* photo of a baobab tree that I liked. Three trees for three band members. At the base of each tree a dog barking. Tony, our photographer, was obliged to go to Madagascar to find sufficient quantities of baobab, but also encountered a shortage of dogs. He went with Lance (who had located all the beds for *Momentary Lapse Of Reason*) and they decided to substitute dogs with people. The logic escaped me. Why people? I asked. Why dogs? replied Tony and Lance. Why any of it? said the Floyd later, promptly demoting it to the back cover.

The second image, ie the light bulb man on page 107,

'comes' in part from Oppenheimer's fur cup and saucer, and Dali's suit of wine glasses. It also comes from being at a gig in Detroit and thinking about how could I sum up Floyd live, how I could say visually what is predominantly, though not only, an aural experience. Being there, bathed in light and sound, some of the best light and sound ever to exist — it is the quintessential light and sound show. Ah, Mr Light meets Mr Sound. A Pink Floyd concert is where Mr Light and Mr Sound come together. Mr Light wears a suit of light bulbs (après Dali) and Mr Sound is surrounded by birds (birdsong). This apocalyptic meeting is staged like a gunfight from an archetypal Western.

The image is photographed on a Bronika 6/7 using Ektachrome and available daylight. Andy Earl, better known for his long and distinguished career as a rock band photographer, did the honours. The suit was prepared with numerous eye hooks upon which ordinary unlit light bulbs were hung. The birds were released from behind the far rock at the moment of shooting. There is minimal retouching. The location is central Spain, not far, surprisingly, from Madrid. The version of the light bulb man on page 109 was taken later, albeit

with the same suit, for the European tour. The location in Tuscany is the wonderful town of Lucca and the model is the equally wonderful Tony, demoted, or was it promoted from being behind the camera? Observant Floyd fans will notice the hospital bed in the background. Even more observant fans will know the blur is caused by movement during a slow shutter speed.

Since *Delicate* is a live album we reluctantly used some live material. I say 'reluctantly' only insofar as photographs of lights and musicians are nothing like the real event, and in a way do a small disservice to the experience. But it's the best one can do with two dimensional design, ie album packages. With that caveat in mind we tried graphically to add dynamism and spontaneity (two qualities of 'liveness') to the vinyl liner bags, which you see here. Colin Chambers deployed the elements well, using interrupted shapes, colour stabs and painterly backgrounds while maintaining an ongoing reference to the circularity of the film screen that was centre stage. This is more clearly stated in the live shot (overleaf) taken by Dimo Safari, which was used as the inner spread, and in the CD

44484/44486

LIVE

ANOTHER BRICK IN THE WALL PT II COMFORTABLY NUMB RUN LIKE HELL

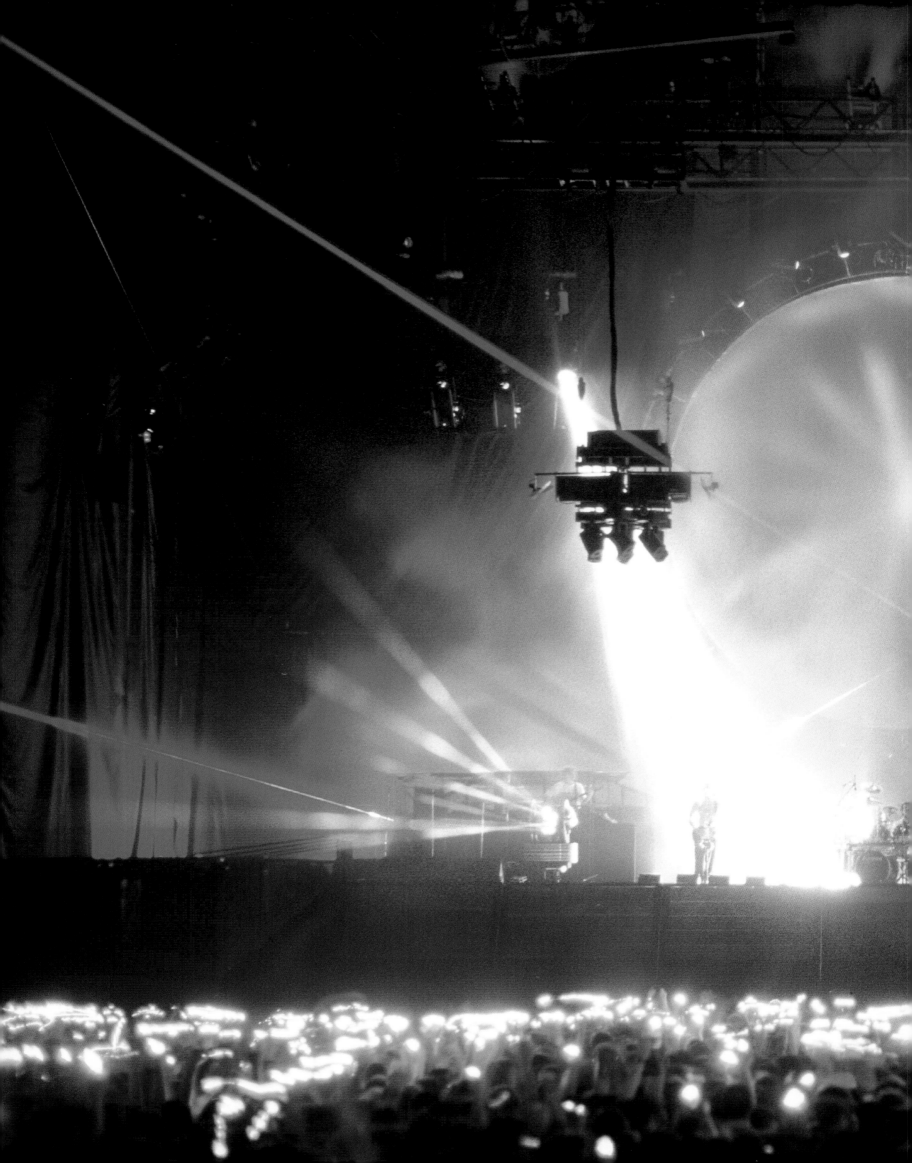

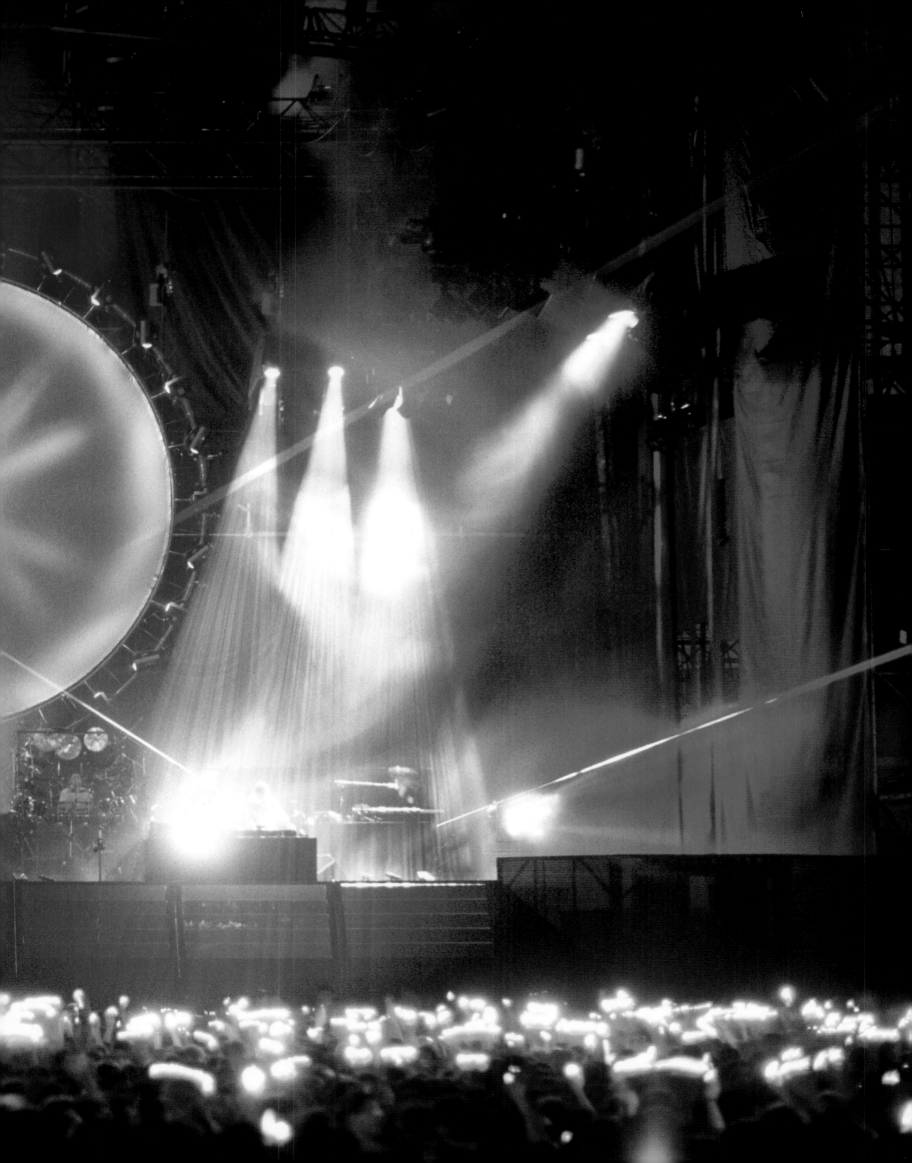

booklet. It goes a long way to capturing the uncapturable, if there is such a word.

The European leg of the *Momentary Lapse* tour in '88/'89 also required a programme, and this spawned the light bulb logo and a couple of jokes. One of these is on this page and is a relatively obvious pun on bulb, as in plant bulb. This deep and erudite interplay is not what merits inclusion so much as the photo itself. Something about bothering even to arrange the light bulbs so carefully. Or the ungainly plant pots plonked so unceremoniously on the ground. Silly really.

I note that holding up to view without much decoration or diversion is a recurring characteristic of the work. Hard to complete this book without two or three things becoming rather obvious. I won't dwell on the rampant egotism, since that would be egotistic. One of the two more pressing questions that confront me, ie the standard of the work over time, I will address later (*Division Bell* page 127), but the other comes up right now. What is, or are, the defining characteristics of my work? I can't help but notice because it's all laid out in front of me, or surrounding me, pinned like murder evidence round the walls of the room in which I write. I see that I like landscapes, fields and horizons – as a result, maybe, of growing up in East Anglia, with its flat, open spaces. A big sky country, not like Montana, but as big as we get. I like blue skies, not so much for blueness as for the sun that will light the people or objects in the landscapes. I like 3D games, illusions, perception changes, bizarre or surreal additions, and visual puns, all of which are aspects of an attempt to sabotage expectation, even my own, or to suggest greater depth and other levels, like the music of Pink Floyd. Incongruity and ambiguity are definitely there to intrigue, and to provoke further emotional and intellectual response.

Most of all I notice a sort of placed quality. A holding up to view without fancy intrusions. This tends to make the work sort of flat. Square on (as in album cover). A bit heavy handed sometimes. Static, you might say. I don't go for dynamic angles, or very dramatic lighting. I don't go (usually) for lens distortion, weird effects or short

focus. Nor is it very often that I choose to use foreground/background compositions. Objects or people are often equidistant, which is why *Delicate* is untypical. Not just because of its more obvious 'roots' but also because one figure is up front, and the other behind. *Ummagumma* and *Momentary* also use perspective, but it is a gradual or flowing perspective, rather than being stated boldly.

But even this figure arrangement for *Delicate* is not very pronounced. Other photographers might still describe it as relatively static. And I guess this is because I'm mostly interested in the idea. I want the idea to represent the music of Pink Floyd. A photo, a graphic, a film, a hologram are not enough. Two dimensions, the flat page, are certainly not enough. I want the idea to be plain to view. This is why I'm not exactly a photographer. Nor strictly a graphic designer, but a purveyor of ideas – a maker of images.

A rampant egotist, more to the point.

NINETIES
AND BEYOND

Fig.1

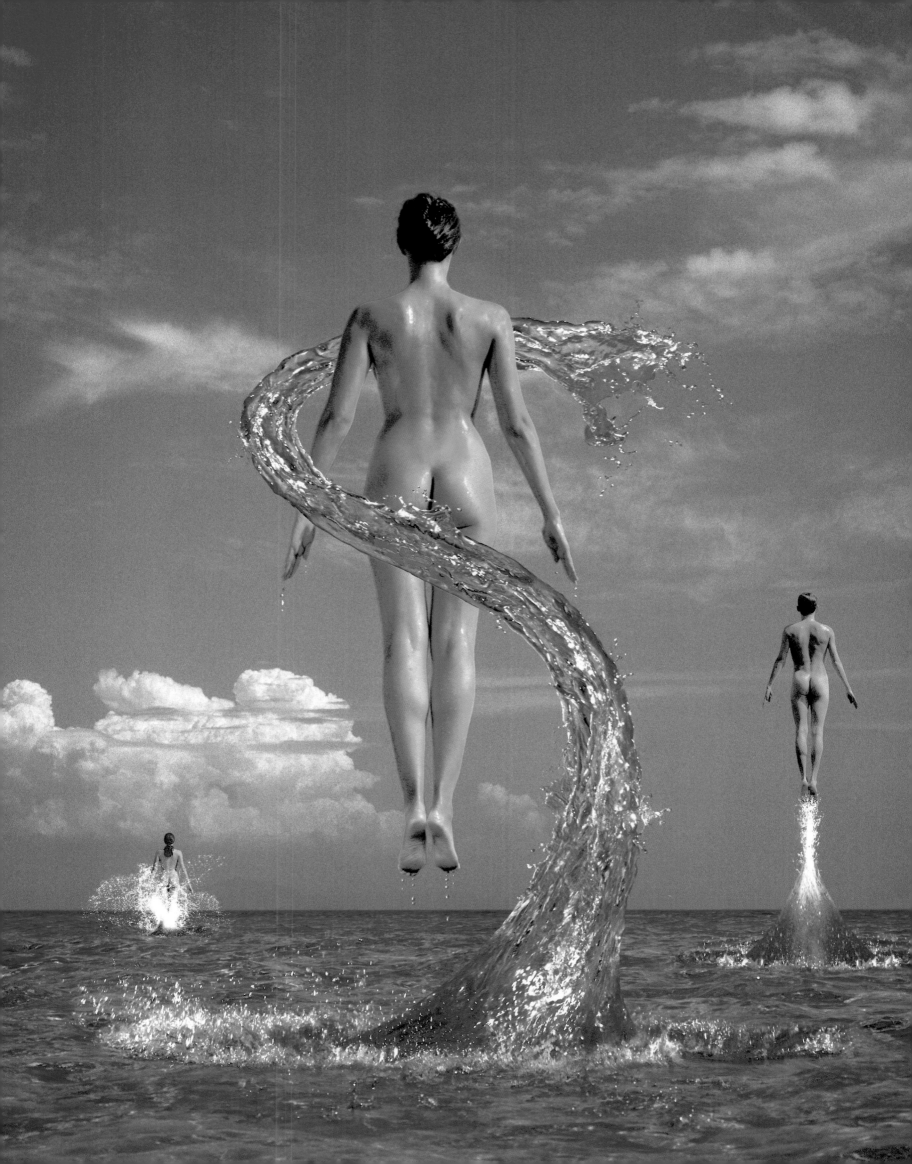

THE PACKAGE FOR SHINE ON is most definitely over the top. It is nothing like Led Zeppelin's *In Through The Out Door* in terms of design, but it is equally excessive. I remember that Robert Plant himself described *In Through* as indulgent pomp rock, but he added "all power to it anyway". Apart from six different versions available at the same time, *In Through* boasted a special black and white liner bag that turned colour after applying water or spittle, and was sold in a plain but designed brown paper bag, simply because everyone said you could sell Led Zeppelin in a brown paper bag – no need for a fancy cover. *Shine On*, however, was conceived as a fancy item from the outset. It was going to be expensive to buy (about £100), and anybody wealthy or besotted enough to afford it could have all the trimmings. Most of the interested public had probably got the albums anyway and wouldn't give a fig for it, let alone 100 hard earned smackers.

Shine On is the Floyd Box Set. It is not 'the best of' nor 'the complete works of'. Nor does it contain unreleased or rarely heard live or studio recordings. I think it was the band's collective opinion that any 'stuff in the cupboard', be they demo or alternate versions, which weren't fit to release before, were not fit to release then. Archive is one thing, scraping the barrel is another. After much debate it was decided that a box could best hold four or eight, and the eight would be as follows: *Saucerful*, *Meddle*, *Dark Side*, *WYWH*, *Animals*, *Wall (1 and 2)* plus *Momentary*. Floyd fans, aficionados and web surfers will note some interesting omissions. A little deductive reasoning will, I'm sure, provide answers, bearing in mind the historical overview, the 1992 position and who is on what album. Yet a man's gotta do what a man's gotta do, and all sixteen albums (at that time), plus unreleased recordings, would have required a small van to take it from the record shop.

In the beginning was the Word, or rather lots of words. Floyd lyrics are usually very telling and clearly needed inclusion along with sundry credits and track listing. They could all go in a book: not a small, difficult-to-extract and hard-to-read (for anybody over twenty-four) CD booklet, but a real book; a hard back cloth bound no-nonsense big enough to open book. Vinyl LP covers are not only loved for nostalgic

SHINE ON

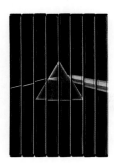

reasons, but also for big pictures and text you can see without a fucking magnifier (I must be getting old). They are also valued because the gatefold can be opened up and scrutinised while the music plays and joints are rolled upon it.

I worked with Rob O'Connor on this project and for the most part this was very enjoyable (I can imagine he'd say the same, 'for the most part'). The classic, airy, easy-to-read layout of the book was mostly him, as was the excellent idea to be 'low slung', ie text, etc, tends to sit nearer the bottom. We collaborated on the logo (page 117) only in the sense that I waffled a lot about hidden messages, inscribed in alchemical tabulations, circles within circles of Floyd history, the ripples of musical and emotional resonance, the triangle of ambition, etc etc, but Rob designed it elegantly and deftly, including secret map-like references to the eight albums…a theme he continued in the actual disc labels. Clear, architectural (Roger, Rick and Nick met in architectural college) but also romantic.

Black is invariably cool, so the sturdy box (to protect such treasured contents, of course) was black, the book was black and the CDs were black opaque jewel boxes, which then required little stuck on stamp-like covers for purposes of identification only — they didn't need to be big because in the book they were already big. The envelope that held the postcards was also black. We designed it because we just love postcards (to be used, not kept under wraps). Finally, the CD holder was also black, and it was provided in case you got bored with trying to find somewhere to put this effing great box that certainly wouldn't fit on your CD shelf. So, just about everything was black! In the beginning there was

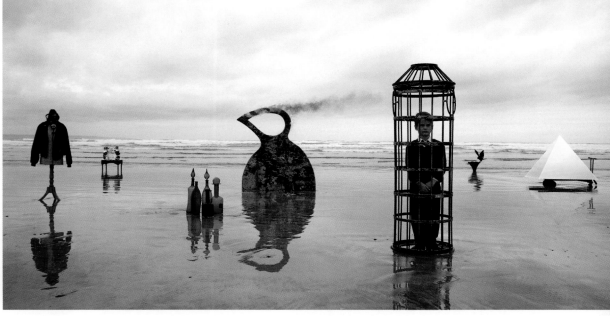

blackness, in order that the light could shine. *Shine On*.

But the crucial part had yet to emerge. What image could lead this lot? Not a light beam, no lighthouse in the ocean gloom, no portentous beacon showing us the way, shining on forever, illuminating our path through life's dark forest. No sirree. The essential element seemed to be that Floyd music takes you away, elevates you, albeit temporarily, albeit metaphorically. Floyd music shifts your perspective, raises you briefly beyond everyday ordinariness. They are by no means the only rock band to ever do this, but they are especially good at it, whether you are listening to their music in private or groovingwith the masses at a live concert. No single album or thread, in this instance, but eight different ones. The image was designed to say something about Floyd in general, hence the essential ingredient — the 'mentally' elevating experience.

Rugged Keith Breeden was on hand to assist in the actualisation of this mode of pretentious thinking. Somebody, anybody, lifted from their normal state, a figure suspended above the sea whence she came, and to which she might soon return, held by unseen forces

materialising from the ocean swell (page 119). The shapes of the uplifting water spouts reflected the different albums. The front one is an 'S' shape for *Shine On* and for *Saucerful Of Secrets*. Keen Floyd fans will, no doubt, unearth at least three more strong 'S' connections. Cynics might find a financial reference. There were two images in the end: one for the box front, one for the book front, or frontispiece. The leading figure of the second image (page 126) represents *WYWH*, inasmuch as she is lately absent, her presence defined by bubbles left behind, hanging in the air.

The photographs for these images were taken by Tony May on 120 Hasselblad using normal daylight Fujichrome working with available light and gold reflectors. We had to go to Corfu to get a warm sea and good reliable light. They say it's a tough job…The water segments, also photographed in Corfu, were simply achieved by the sophisticated chucking of water out of a bucket or bottle at a suitable angle to the sunlight and snapping it in mid air with a fast shutter. The separate elements were combined in a graphic paintbox computer system, care of Tom Woods and Richard Baker. No, that's not true. It was a realevent. A freak occurrence of nature, when an upswell of water spewed forth and lifted a nubile bather above the waves, miraculously caught in the lens of an onlooker, much like a UFO photograph.

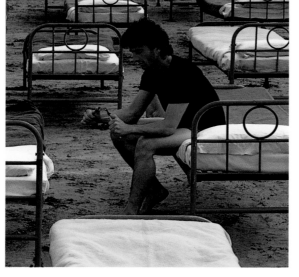

Though there are boys and girls in these images I got some family flak for putting a woman up front. A naked woman. In my defence I would like to say that the person is naked to represent two things in particular: firstly this is anybody, or everybody; there is no defined kind of person, which could be invoked by clothing, be it class, work or fashion. Secondly, the nakedness alludes to sensitivity, a person's sensitivity to life, but specifically to music.

Protective layers, such as clothing, are not necessary. The ears are naked. And it is a woman, as on *Back Catalogue* (page 156–7) and not a man, because I prefer the shape. So there.

Shine On is the only Pink Floyd box set. The vast majority of their repackaging consists of remastered and redesigned versions of the original albums. There are no compilations since '83, no 'best ofs', no 'never released before' versions, or material rescued from the vaults, or curious remixes made by DJs or obscure celebrities. By and large, they take, I think, the view that there is too much of this kind of thing in the music business. Too much flogging a dead horse and endeavouring to persuade the public to purchase numerous formats, re-issues and bogus versions.

One might argue that the public are not obliged to buy these endless re-hashes. No one forces you to buy a record: it's not food, is it? It doesn't take a financial wizard, however, to see the advantages to the record company (no origination costs). And, after all, they would argue that this is their job — to sell and distribute musical products. To make a buck. Many musicians, including the Floyd, are glad that they do. Well, most of the time. But not always. Not when it smacks of a cavalier attitude…when it smacks of milking the public, or trying to hoick the unsuspecting punter another of the same.

Constant alternate versions and re-issues inherently attempt to fool the public, take up shelf space, block the progress of new artistes, reduce funds and attention for exciting projects and consist of a lot of bullshit and unnecessary hype. It's not that I believe that there should be no box sets (after all, I've just designed one), *no* 'best of', *no* compilations, *no* alternate versions, *no* re-issues and re-mixes by the prime minister, just some moderation. I'm personally glad the Floyd don't do it too much. Though where's *Shine On* Box II, now I come to think of it?

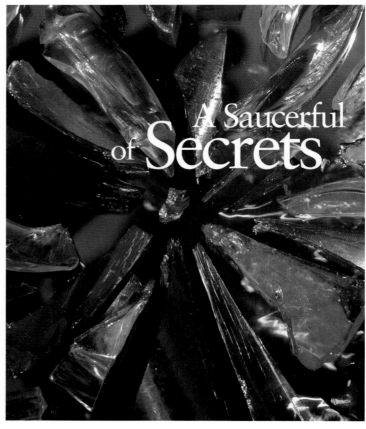

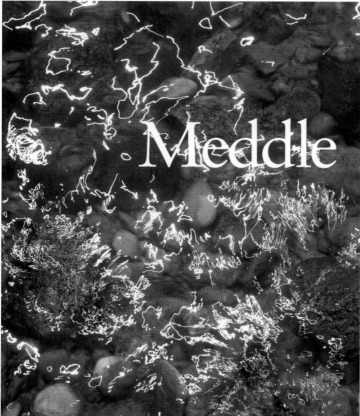

Some writers like Jack Kerouac or Cormac McCarthy seem to use very little punctuation. E E Cummings often spurned it altogether. But in a book there does seem a need to provide some degree of punctuation, some sense of a break now and then from the unremitting page after page quality. These breaks are called chapters, or rather chapter headings. The pictures on this page are the headings or chapter breaks used in the book for *Shine On*. They are intended to work in the same way as the marbling chapter breaks that you find in this book. That is, to provide a rest or change for all those tired rods and cones in the retina. Designed essentially to be different, but not jarring nor horribly dull. Some have more relevance than others, however. The page opposite is for *Animals* obviously enough, while that on the previous page is for *Momentary Lapse*. The snapping of the twig, or the mind, was an unused alternative to the hand mirror (see page 99). The images here were photographed by Tony and me on the hoof, as it were, while having a very hard time wandering round the beaches of Corfu, sifting through the debris and the sand amidst rocks and pebbles or looking down wistfully at the warm waters of the Mediterranean.

TITLE PAGE BACKGROUNDS SHINE ON BOOK

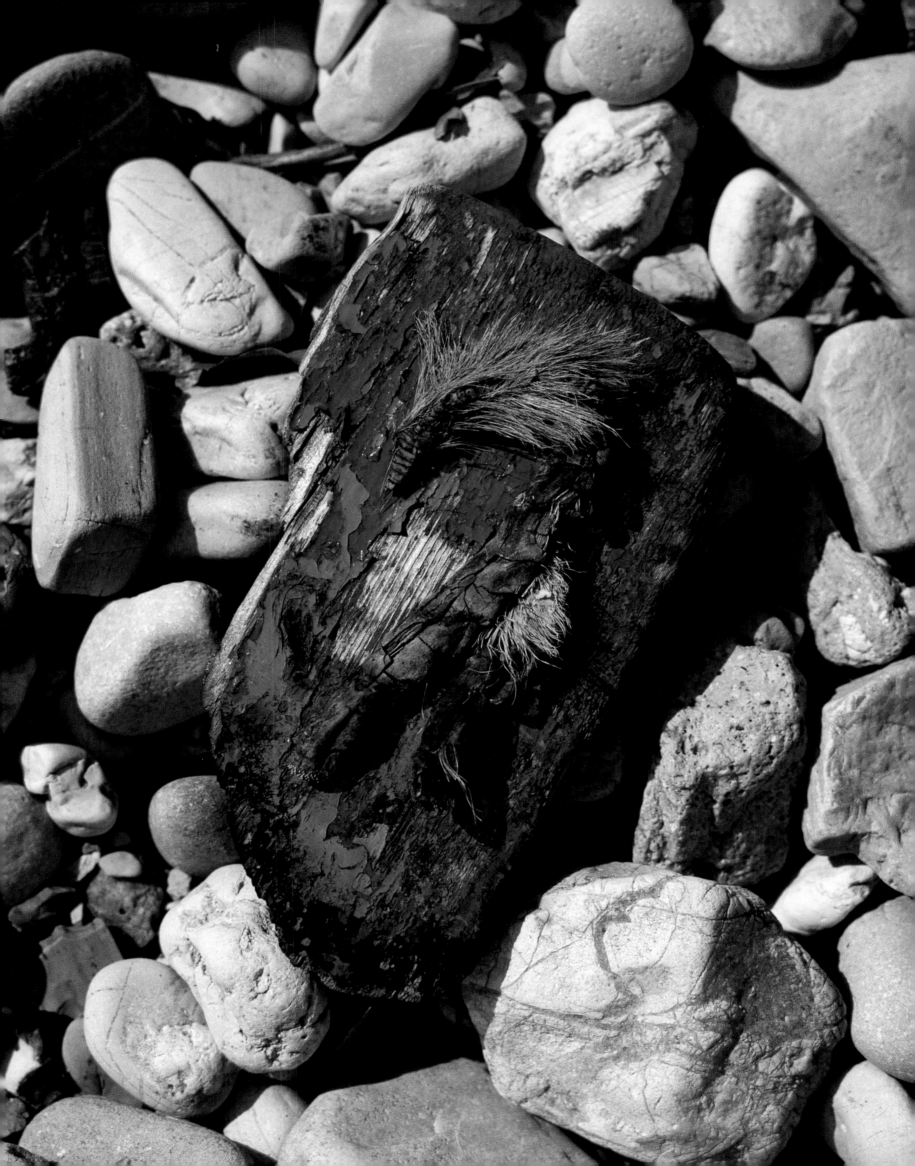

THE FLOYD EMERGED from the creative doldrums in '94 with this album, their first new studio album since *Momentary Lapse* in 1987. Not only were the public pleased to see some action, but also the majority, I think, of Floyd personnel, certainly the art department. This might account for the great splurge of images over the next few pages, starting with the front cover opposite.

The Division Bell, it seems to me, is full of historical references. Firstly in the recording approach. The band began recording by playing together in a studio, just Rick, Nick and David and for some of the time Guy Pratt, in a manner reminiscent of earlier days. A kind of jamming, an exploring of musical ideas together. Secondly, there were actual songs about the past, about Roger and, more obliquely, about Syd. Also songs about David's own childhood. There were also songs about past and present relationships. The other major theme concerned communication or, as David put it, both the distinct presence and lack of communication amongst the population at large and within specific relationships, not excluding Pink Floyd. Restricted communication, defence, isolation, ambiguity, holding opposing feelings at the same time, being unsure of the merit of decisions, not knowing or communicating what was experienced. Contradictory communication.

For example, there are bells to alarm, as in clock, and bells to celebrate, as in church. There are bells to summon, as in school meals, and bells to warn, as in bicycle. The Division Bell itself is rung to bring Members of Parliament together so that they can be not together, ie divide when voting. More contradictions.

These are the reasons for the design, or rather the background against which the music would be absorbed. The issue was how to express the contradictions. How to

THE DIVISION BELL

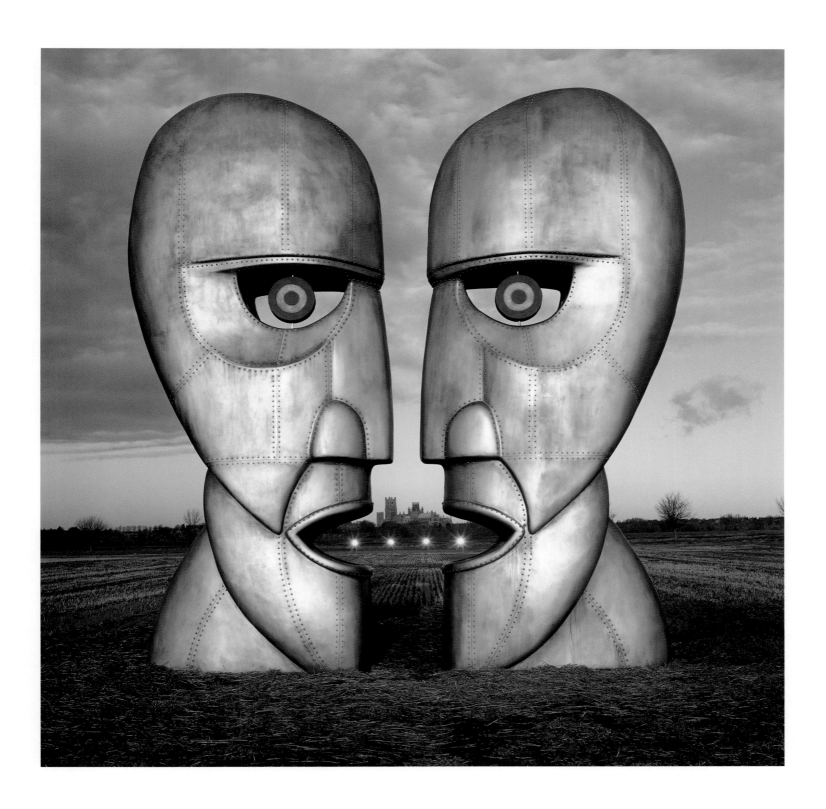

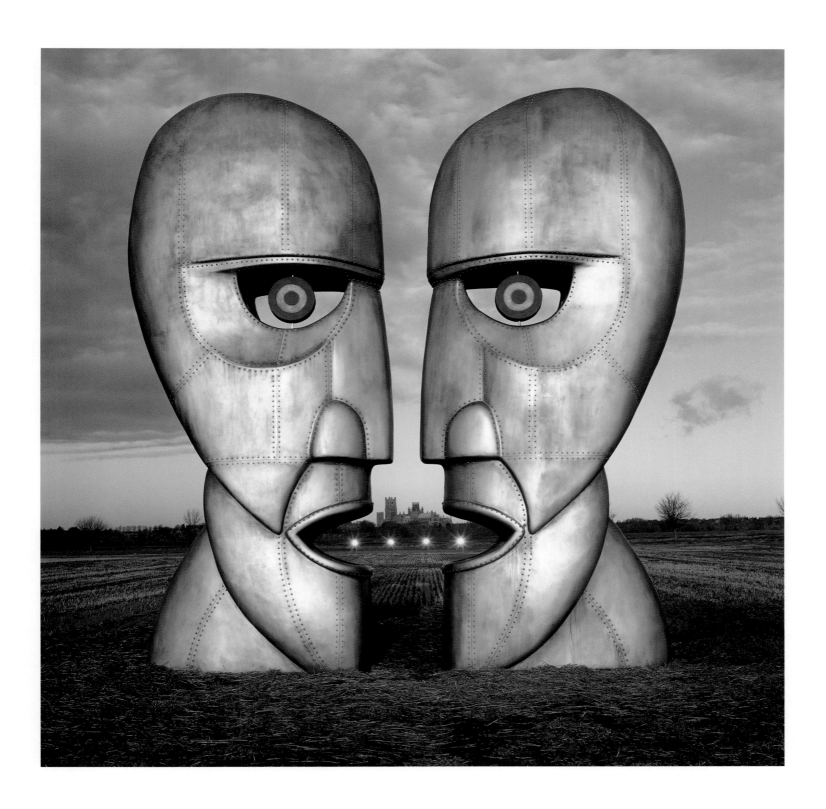

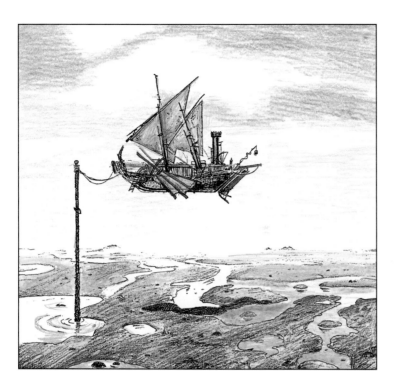

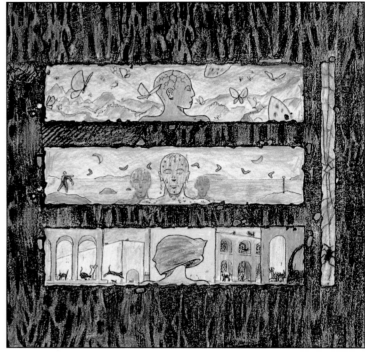

represent communication, while not communicating. As I wrestled with these weighty concepts, it struck me that I needed to disrupt the image itself. The image should try to undo itself, or get in its own way. I was reminded of those psychological line drawings that could be seen as one thing or as another, as an old lady or young lady, as two profiles or a vase, depending upon what you saw, or chose to see. You couldn't see both simultaneously. One preference would exclude the other possibility, at least temporarily.

Two heads facing, or talking to each other ('Keep Talking'), making up a third face, which would get in the way both visually and literally, seemed like a good idea. The single eyes of the two faces looking at each other become the two eyes of a single face looking at you, the viewer. It was intended that the viewer should not see both at the same time. One saw the single face, or the two profiles. If one saw both it was alternating, like an optical illusion, which was even better because it meant that the viewer was interacting, or communicating, with the image directly, viscerally.

BACK COVER THE DIVISION BELL 1994

Seemed perfect. Field tests on local inhabitants and friendly storekeepers proved the point. Half the people tested saw one facing head, the other half saw two profile heads. Luckily Keith Breeden was on hand and drew numerous examples of the idea (three initial roughs you can see on page 128). This was fantastic, because it soon became apparent that the idea worked equally well in many different styles. Or so we thought.

The Floyd, however, didn't seem so impressed. Their reaction was lukewarm. We were gutted. It took a month to encourage David that this idea was right. We had always intended to build huge sculptures (like the ones on Easter Island), and to photograph them as a real event. The drawings were simply our roughs. When we showed David the appropriate sketch, and versions of the Mexican heads (page 136) he went along with the idea. The delay must have been some problem with communication.

Other roughs which we submitted (see page 130) also attempted to represent some of the themes and ideas in *The Division Bell* and some of the feelings engendered by demos of the music. The three parallel bars referred to three band members, but also constituted a hieroglyph of some kind, probably oriental, a kind of hexagram or ideogram (not stereogram) that was communicating something in its entirety, as well as via its individual pictorial elements. A secret sign, perhaps. The magic boat floating above the receding waters of an estuary, free but tethered, afloat but not on water, suggested both in mood and in content something of the ambiguity of the album, as we understood it. This design also had local reference to the Astoria, David's riverboat studio, where much of *The Division Bell* was produced. The cosmic Bosch-like plant burr careering across the ground collecting debris on its travels, like a mind or personality collects attributes

and characteristics, fears and foibles, during its long life, refers to the mighty Floyd collecting all manner of personal and musical bits and pieces during its long and colourful history. The three scarves, not jolly long narrow flags, but fantastical 60ft long representations of typical college scarves, were made for the video of 'High Hopes', another track from the album, and were intended as fragments of a childhood memory, which is why they are very big or long (page 131). Memories of life in a university town, ie Cambridge. One of the three participants is not altogether present, though his scarf is clearly in view. The symbolism escapes me.

As I mentioned earlier, such was the enthusiasm (and relief) of getting some Floyd action after several years that perhaps the art department overdid things a bit, specifically in regard to the CD booklet. I had thought that each song should have its own personal imagery. Since each song would sit on an individual spread then they would exist separately anyway and the fact that the imagery was song specific and hence different wouldn't matter, wouldn't jar the senses. I think I was wrong. As in the design of this book, there is something satisfying about maintaining a cohesion, keeping some form of continuity whether in layout or grid terms, or in other more textural and complex terms. Design continuity is worthwhile provided that what is being continued is OK. One needs to remember that designers by and large love controlled neatness – got to keep those little poo piles in place.

I'm being over critical thanks to the luxury of retrospection. The CD booklet is fine, but the whole is not greater than its parts. Some of the individual song illustrations are excellent, such as the monkey design for 'Keep Talking', which is the handiwork of Ian Wright. A monkey face made out of monkeys, communicating to

each other and to you, the viewer. I liked the use of tails, and the brushstroke style. Very swishy, yet rough and ready. Peter Curzon has deftly rearranged them for this book. The CD label, also by Ian, is a strange concoction: a line drawing of mask-like apparitions and ethnic markings, primitive representations of animalistic gods. A maze whose embedded shapes communicate some wild and dangerous message, a warning from the spirits. Ian drew half of it only, then folded over to imprint a mirror image of the other half next to it. The original is in black and white and then printed in specified colours. It works well on the label, I think, because it's a graphic pattern and the centre hole does not intrude (see previous page).

Although the main image of *The Division Bell* is intended to get across the themes we thought were

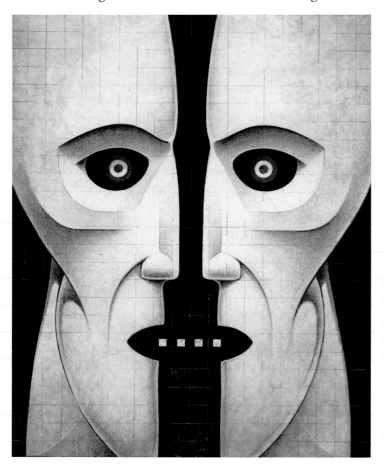

informing the actual album, the most important aspect is the feelings that are engendered in the viewer. The elements that conspire to do this include clearly the idea of two heads or one head, as discussed earlier. Or a third head. Is this the ghost of Floyd? Just as important are the elegant shapes of the sculptures themselves. Not being a sculptor I needed to know a man who was. Keith Breeden designed the shape and form of the heads to suit the idea but also to suit the material used to build them. He first designed a pair of heads in metal, like the metal plates that are welded together to make aeroplanes. This is the cover of the CD and page 129 of this book. He also designed a pair of heads to be carved out of stone, which were noticeably different, more elegant in some ways. Keith and I did this partly because we were unsure ourselves which would work better, stone or metal, but also because we liked both. When the Floyd saw them they agreed and said to hell with it, let's build both sets. Such daring. Such luxury.

Such good sense, as it turned out, because we were able to make widespread use of both metal and stone heads. Keith made the scale drawing (shown here) and then oversaw the making of a maquette, which is a 3ft model. When that had been OK'd the real statues were constructed in proportion but now the height of a double decker bus. Metal heads were built by John Robertson and the stone heads by Adrian Smith, both under the beady eye of Keith Breeden, and myself lurking in the background, like the third head of the finished design.

The statues weighed a ton. They were taken by flat bed lorry to a field on the edge of Cambridge, nearer to Ely, in the heart of the Fens. The stone heads started at one location but were then moved to stand alongside the metal heads. Two sets of heads, standing mute and imposing, eerie sentinels of the Floyd, the size of a small house, like the giant Aku Aku totems on Easter Island. They looked majestic, and spooky as hell, especially when the weather changed and dramatic clouds banked up high behind them. We left them standing for two weeks in freezing January under personal security guard, camouflage netting and fairly constant attention from Tony, our embattled photographer, and his long suffering

SCALE DRAWING OF STONE HEADS WITH FINISHED ARTICLE
OPPOSITE USED IN 1994 TOUR BROCHURE

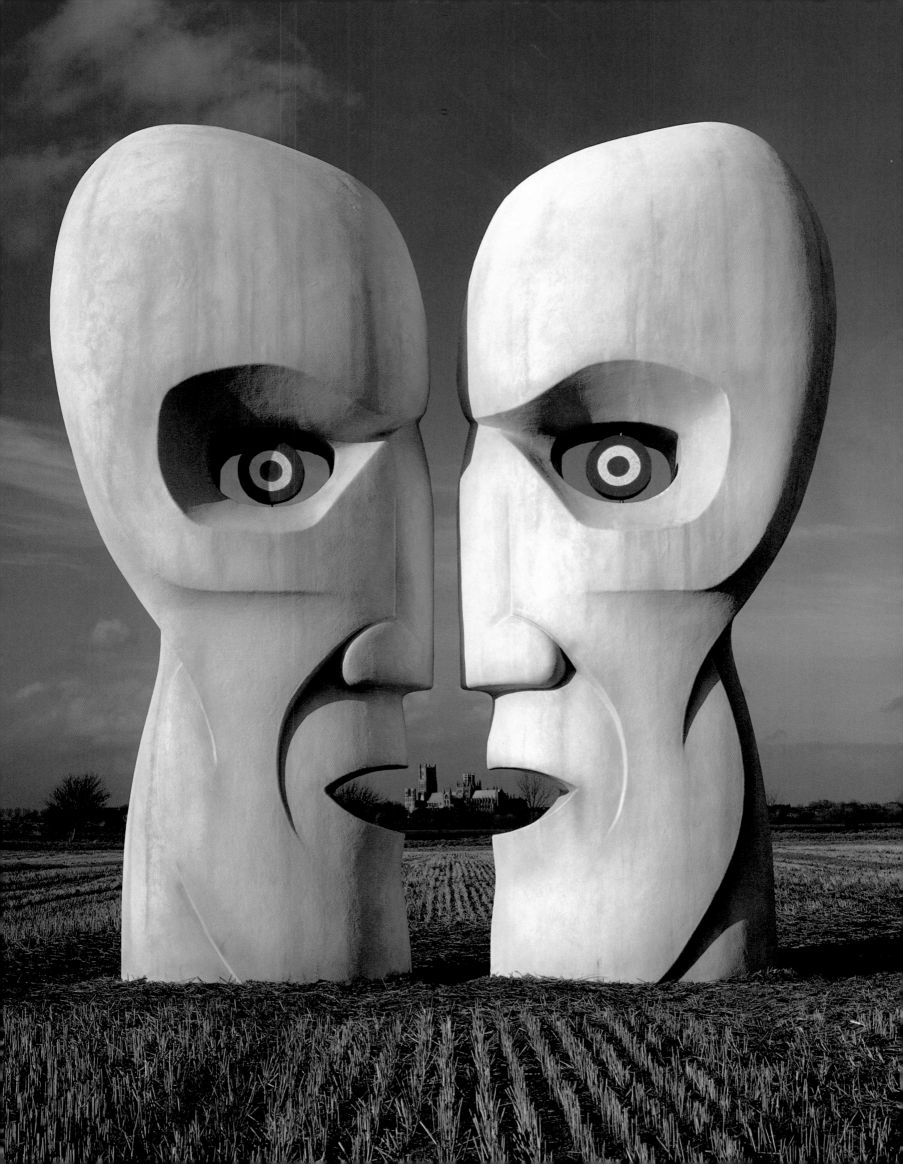

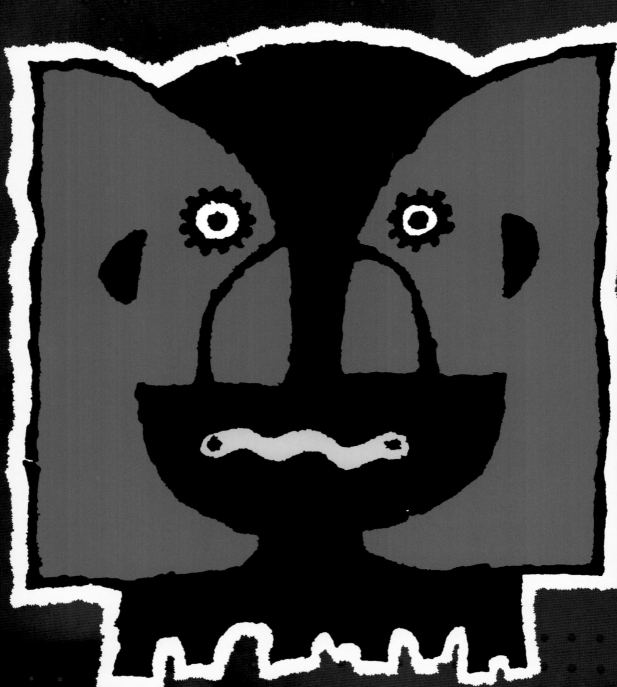

assistant Rupert Truman. On one occasion terrible winds, gale force six, raged across the Fens and actually blew down the metal heads even though they weighed half a ton each and were tied down. Echoes of the escaping pig at Battersea Power Station, for *Animals* (see page 84).

But, god, it was worth it. Despite freezing our nuts and getting crazy bored waiting for the weather to improve and the sun to come out, the end results were creamy. And the car lights or red flags used to indicate the lines of communication, the talking of profile head to profile head worked well, as did the positioning of the distant cathedral. And the lighting was wonderful despite the time of year. The cloudscapes above the Fens were most effective, as you can see in the different versions. There is no faking here. It is all very real. Despite some comments that it could have been computer manipulated, and that the statues were actually quite small, just a few feet high, the anguish, endurance and money involved in making these images real, real statues in a real place, paid off handsomely. As it did for the beds of *Momentary Lapse Of Reason*, and the pig and the burning man.

When I showed David a 5 x4 transparency he thought it was excellent. Better than expected. Steve O'Rourke, the band's manager, was equally fulsome in his praise. He said it was fantastic and that I was a fucking genius. I think this was a compliment. Nick never had any doubts and thought both sets of heads worked equally well. So the metal heads went on the CD and stone heads on the cassette. Huge street posters were made of both sets and Steve, I think, had them pasted all over town, not that he would ever admit to it publicly.

Since the Floyd were on tour as well, it meant that

head variations could be deployed in all manner of ways. The most graphic representation, which Keith also illustrated, is on the page opposite, and became known to us as the 'Mexican heads', partly because of the hot colours, but also because of the sun eyes and runic snake, the poisoned tongue of communication — you speak with forked tongue. These Mexican heads were used on banners, on T-shirts and hats and in the concert programme. The front profile heads possess a mad jester-like quality, cackling to each other, while the third or back head feels to me a bit medieval, like an executioner's mask, made of black cloth. By way of contrast, and as evidence of the effectiveness and universality of the idea, the version on this page has an altogether softer quality. Two whale-like creatures, symbolically represented, face each other. What can they do, made of sand, marooned sadly on the beach out of water? This is a photograph of a sand sculpture that was designed by Ian Wright and delicately crafted by our friend John Whiteley (of marbling fame). As an aside, John was responsible for the original front running title for this album namely *Pow Wow*, which I have to confess I disliked for its Red Indian association that I felt was inappropriate for many reasons but especially for the heads. Polynesian maybe, Apache no.

MAROONED
Music: Wright/Gilmour

On the following page are a set of images that are thankfully a departure from *The Division Bell* heads that came to dominate my life, and these pages. These other images come from the film made for 'High Hopes', projected at the live concerts, which was in part about memories of childhood. Everything is oversized because children are small and see everything as taller and bigger, naturally and metaphorically. The black cape or gown was 60ft of black

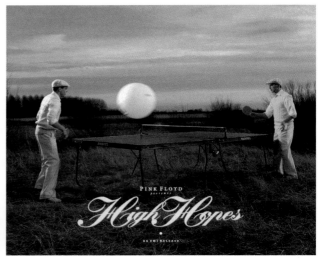

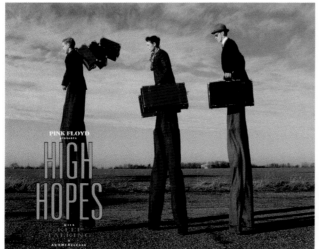

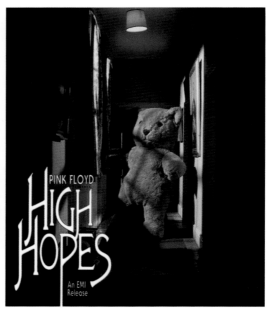

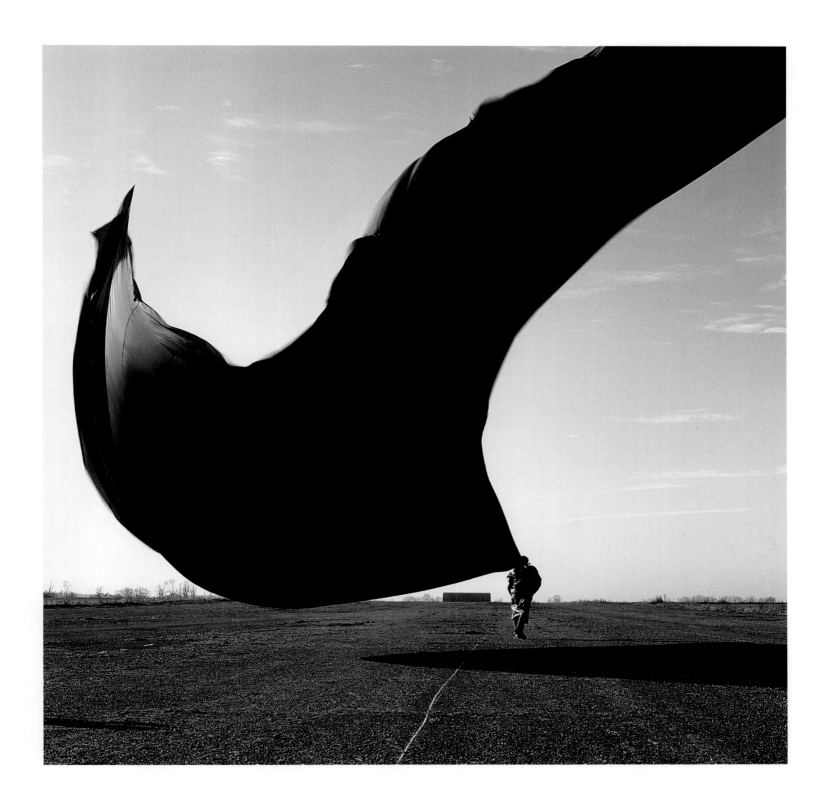

STILLS FROM 'HIGH HOPES' FILM AS USED IN SINGLE PACKAGE 1994

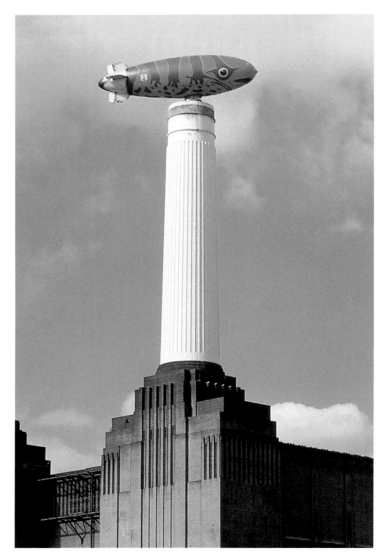

silk sewn together, flapping like some great bird of death in the wind, and truly was an awesome sight. And an awesome sound.

I write this surrounded by hundreds of images from the past and the present and I ask myself what am I doing? Heading inexorably towards the great design studio in the sky. Do I like my work? Do I think it's progressing, getting any better? Despite the doubts that afflict me, and most artists, I think it probably is. I feel this most clearly in relation to the heads that were designed for *The Division Bell*, which is why they were, of course, on the cover of the first edition, and in the background of this edition. They're also on the airships shown here. Pete and I have never designed an airship before, and might never do so again. Not that many rock bands or their record companies can afford it. Paul Rappaport from Sony in New York commissioned us and kindly brushed aside our trepidation with his enthusiasm and flattery. "You can do it," he said, adding philosophically, "after all you can only fuck up." The real difficulties were two-fold: the design had to be effective

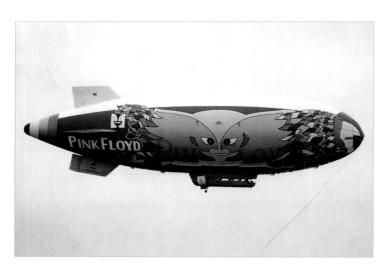

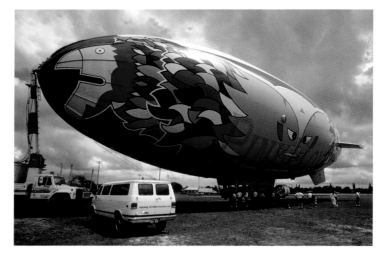

from different angles (side, front and varying degrees of belowness) and it must make the airship a surreal entity, ie not a normal airship, because a Floyd ship would not be normal. A fish perhaps. A flying fish. Bingo.

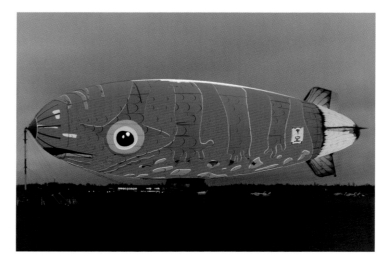

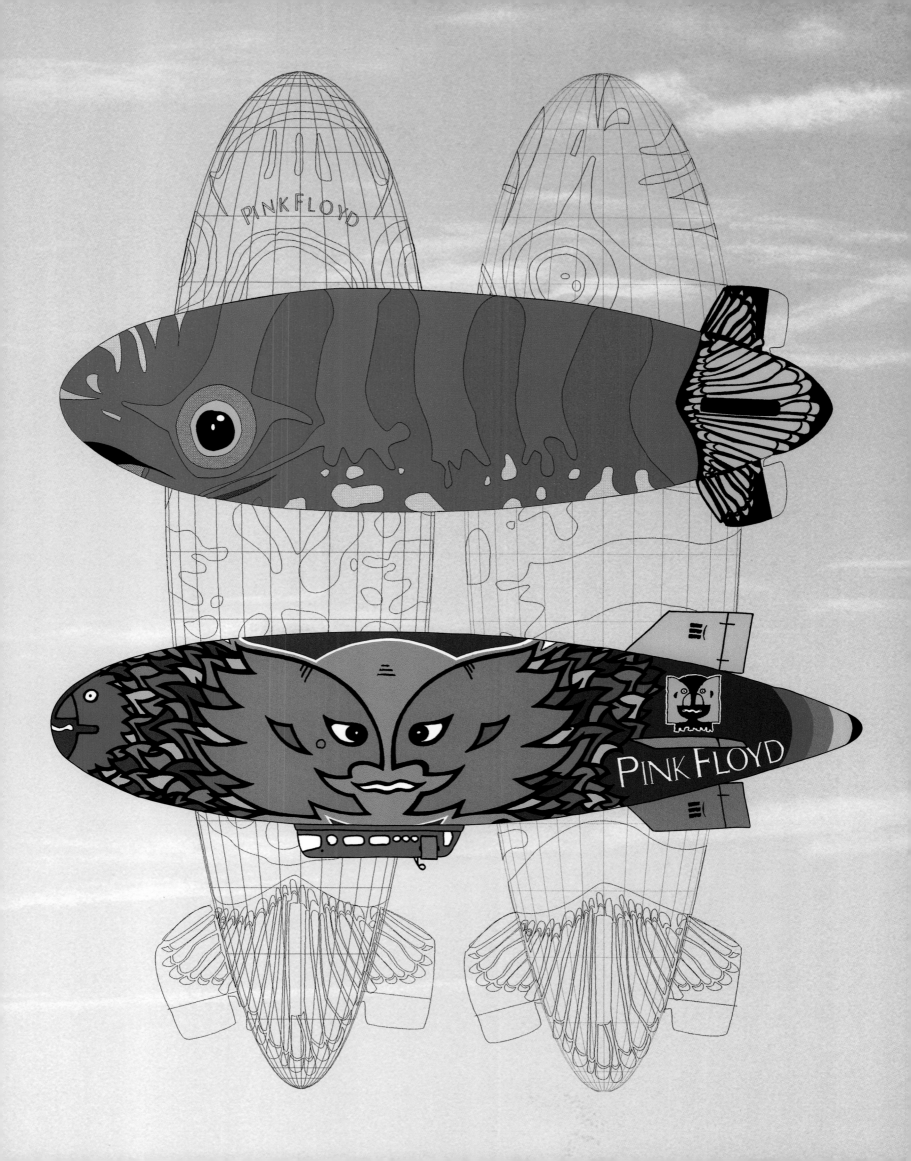

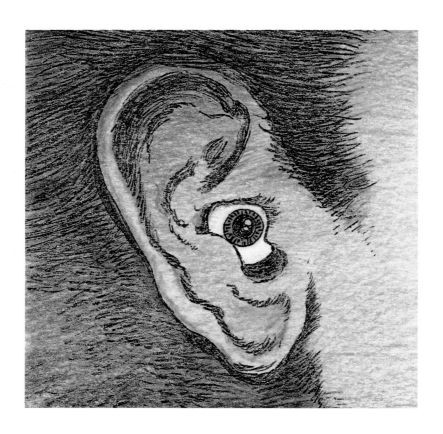

PF LIVE • 2CD • 2MC • 4LP • 5 / 95

P · U · L · S · E

ONE OF THE FRUSTRATING THINGS about talking to you in this book is that I can't show you the pulsing red light. The first two or three million European CDs for the *Pulse* double live album came in a specially constructed box which had 'a secret' compartment in the back of the spine. Inside was a complex and cunning device comprising battery, capacitor, chip and red LED. This hidden contraption provided a pulsing or flashing red light seen on the outside of the spine of the box. It was intended to last for a year, pulsing away in your living room, saying "Hello, I'm here", communicating with you better than I am on this page.

This red light was supposed to make the package feel like a live event, like the music. It was also about light itself, which is a particular feature of Floyd concerts. It pulsed at the rate of an average heartbeat, like the beginning of *Dark Side*. It also identified itself loud and clear, and removed any neck craning or eye squinting caused by struggling to read CD spines. It was basically for fun, though a terrible headache to achieve. I rarely thank record companies, regarding them usually with caution, mistrust or complete loathing. This was different.

It was not, however, the main event. It was an extra. What mattered was the central image, the design for the actual cover. On this very page you will see several of the rough designs initially submitted to the band. The giant armchair, the Floyd patterned chair, was liked but rejected because it was another large thing, like the statues for *Division Bell*. Same went for the gigantic pink cardigan or twin set – which I liked because it was, after all, a double album. The receding windows, echoing *Ummagumma*, but made of real rooms and real alleyways, came third. The suspended man was the preferred choice of both Nick and David. The eye in fact came second. I suggested that we use both designs for what was essentially two albums, either as the fronts of separate booklets or, as was the case, the front of the LED box and the front of the hardback book contained within. This book held two CDs, one at either end, and displayed a set of live photos taken at several concerts and selected from about 5,000 shots – a job that did our heads in, I can tell you.

I campaigned for the eye on the front of the CD because I thought it more simply represented the live Floyd experience, in spite of its obvious complexity. It is comprised of about thirty-six separate photographs moulded and vignetted together in a computer paintbox. Not only did the design reflect, in the punter's actual eye, elements of the live show, it was stylistically a mixture of old semi-psychedelic ideas and modern technology.

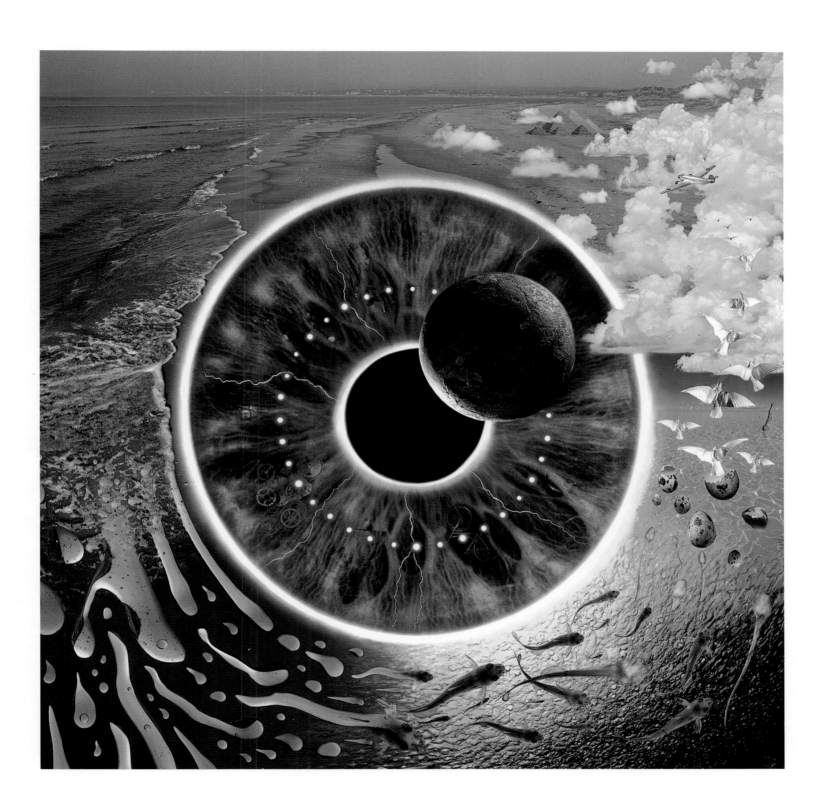

It would have been difficult, if not impossible, to manipulate photos in this way before computers. Like a Floyd concert, the design was old and new at the same time. Old songs and new songs, presented with old and new state-of-the-art technology. Well, that's what we told the band anyway. I still get letters (or E-mail) asking me the significance of various elements only lately discovered by the correspondent. Look more deeply and you will find further Floyd connections, some we never even intended.

The second principal design used for *Pulse* is known as the 'hanging man' and is on the page opposite. The V-shaped light beams emanate from robotic stage lights or from imaginary aerial craft. They are supposed to represent the lights at a Floyd gig, and are in fact directly based on some of the actual lights that are visible round the inside perimeter of the semi circular dome, to be seen on pages 152 and 153, amidst the billowing clouds of smoke and radiating beams. These imaginary flying craft are both illuminating the arcing figure with arms spread wide and supporting him, as if bearing him aloft. This romanticised image was intended to represent any member of the audience who would hopefully be borne away, albeit metaphorically, on the waves of Pink Floyd music. I imagined that these lights were those of numerous flying craft, small UFOs even, that were elevating someone to a rendezvous with a larger mother craft. The nakedness was again supposed to suggest that this could be anybody – no class, no job, no fashion victim this, but any member of a Floyd audience – and to represent the sensuality of being borne aloft, or of alien abduction experiences. At least this time, for a change, it was a bloke and not a woman. And this 'anybody' was floating in the air suspended high within an interior, not an exterior, partially because concerts are usually indoors, but also because I was fed up with using landscapes. The prototype for the small flying craft was designed in conjunction with Finlay Cowan and is here illustrated as a real object, which of course it was, photographed by Tony May, who was fortunate enough to catch it before it zoomed off into the starry heavens.

The rough for the hanging man had been drawn as a woman, as you can see, but otherwise bears some clear similarity to the finished article. As does the eye on the previous page. The dynamics of producing roughs is central to the whole business of designing images for the Floyd and, by extension, most other bands. The drawing has only to be figurative enough to be easily recognised. The colouring can be rudimentary yet naturalistic.

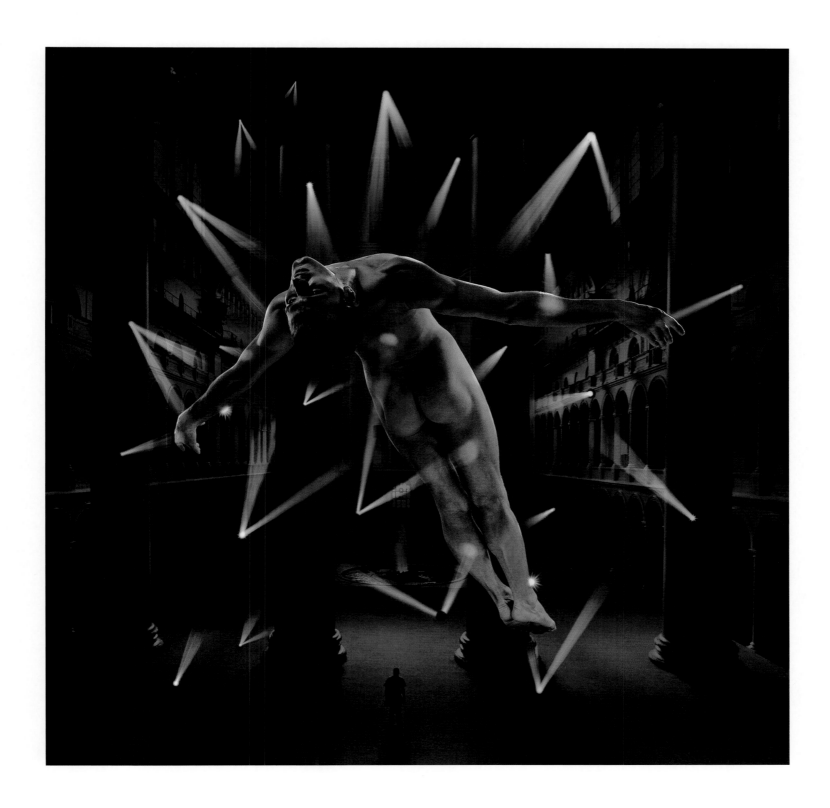

Front cover Pulse book

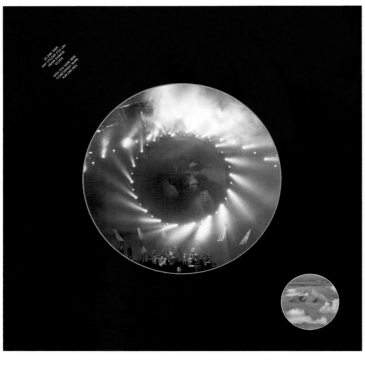

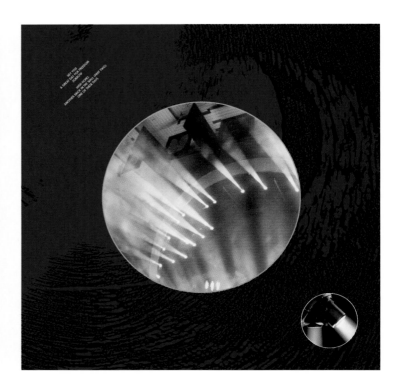

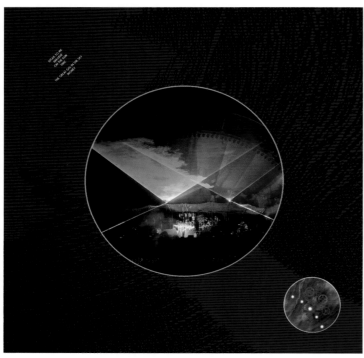

The composition is more crucial because the photograph for the finished piece is often based fairly precisely upon it. By following this composition, over which a lot of time and effort had already been invested, we set about shifting the units of reality to fit our imagination, which is invariably better than reality itself – certainly better for expressing the idea. *Mind Over Matter.*

The hanging man motif was carried through to the label designs for the actual CDs. Finlay Cowan illustrated a blend of our own design, Da Vinci and the Voyager tablet, with some architectural plans of the imaginary craft for one of the discs, and an evolving fish/worm from the eye design for the other. The Floyd were not enamoured with these, nor alternatives involving the high contrast blurred lights that

form the backgrounds of the vinyl liner bags opposite. They preferred instead the photographic details enlarged from the front eye design and reproduced as coloured tints rather than in four (or full) colour. All this to and fro highlights the difficulty in designing CD labels. Either it's the frigging hole in the centre that sabotages any attempts at integrated design, or I'm just too selfish to want my image to have any part of it removed – by force, not by choice. Imagine telling a musician: hey, here's a really nice song, except that the middle verse and chorus are replaced by thirty seconds of silence!

Circles I don't mind. The circularity of the eye, the circularity of the film screen at a Floyd concert, the circularity of the back of the box, even the circularity of time embodied in the wide range of songs on *Pulse* – all

WHAT DO YOU WANT FROM ME PINK FLOYD

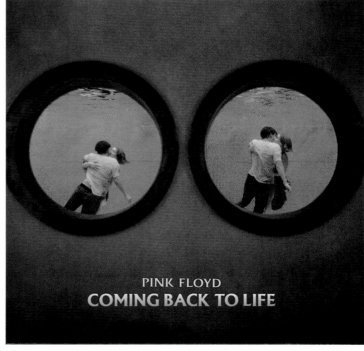

PINK FLOYD
COMING BACK TO LIFE

1. *wish you were here* 2. *coming back to life* 3. *keep talking*

Produced by James Guthrie and David Gilmour. Recorded and mixed by James Guthrie
Assistant engineer Sean O'Dwyer. Recorded live in Europe and U.K. with Le Voyageur II Mobile
Mixed at Astoria in Q Sound. Mastered by Doug Sax and Ron Lewter at The Mastering Lab

All tracks taken from the album PULSE

Under exclusive licence to EMI Records Ltd
Pink Floyd (1987) Ltd under exclusive licence to EMI Records Ltd. © 1995 Pink Floyd (1987) Ltd
Pink Floyd Music Publishers Ltd. ℗ 1995 The copyright in this sound recording is owned by
Cover design by Storm Thorgerson and Peter Curzon. Photography by Tony May

entire design, including the advertisements (on page 143) and the liner bags (on page 148). Such design continuity is considered laudable by many other designers though I remain unconvinced. Design continuity is not a lot of fun if what is being continued is either mediocre or a pile of shite. Design continuity is not necessarily a virtue in itself, is what I think.

Jon Crossland and Peter Curzon were heavily involved in designing all these *Pulse* bits and pieces, from the eye on the front of the box to the graphics on the labels, to the American singles bags you see on these pages. The theme of two circles derives from the front eye design being flipped and then collaged, forming an image reminiscent of an owl, which in turn became a real owl, and then two portholes for 'Coming Back To Life', a veiled reference to emotional life saving, and then onwards to two circular fish bowls for the 'Wish You Were Here' live single "Two lost souls swimming in a fish bowl". A dour couple, their faces trapped in a world of their own, confined within the fish bowls, intense and distorted in their separateness. No retouching here, no clever tricks, no pretence. Like the words of the song.

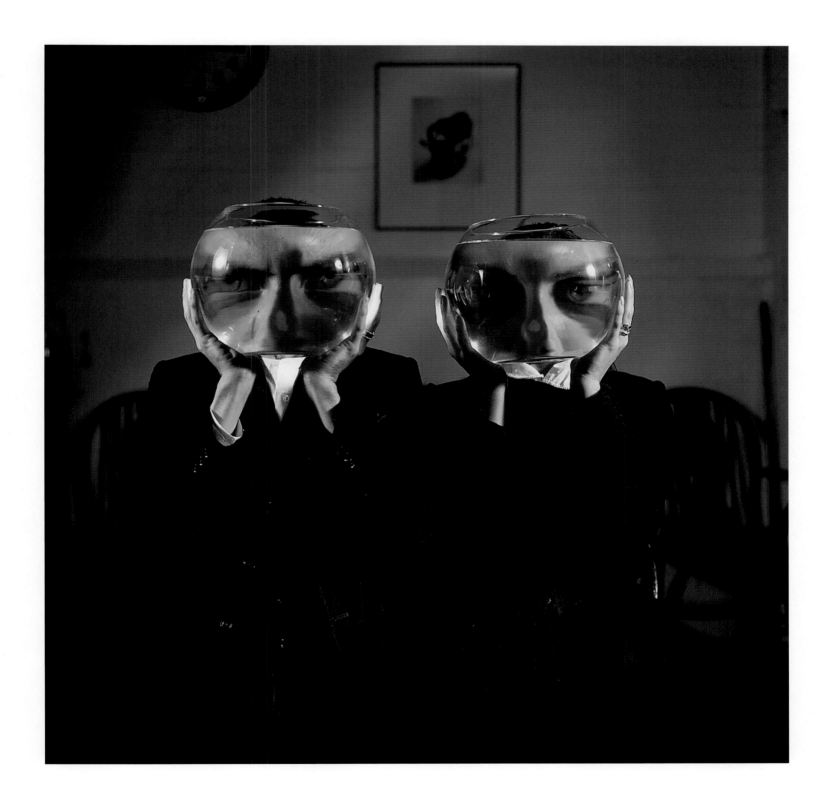

FRONT COVER 'WISH YOU WERE HERE (LIVE)' SINGLE

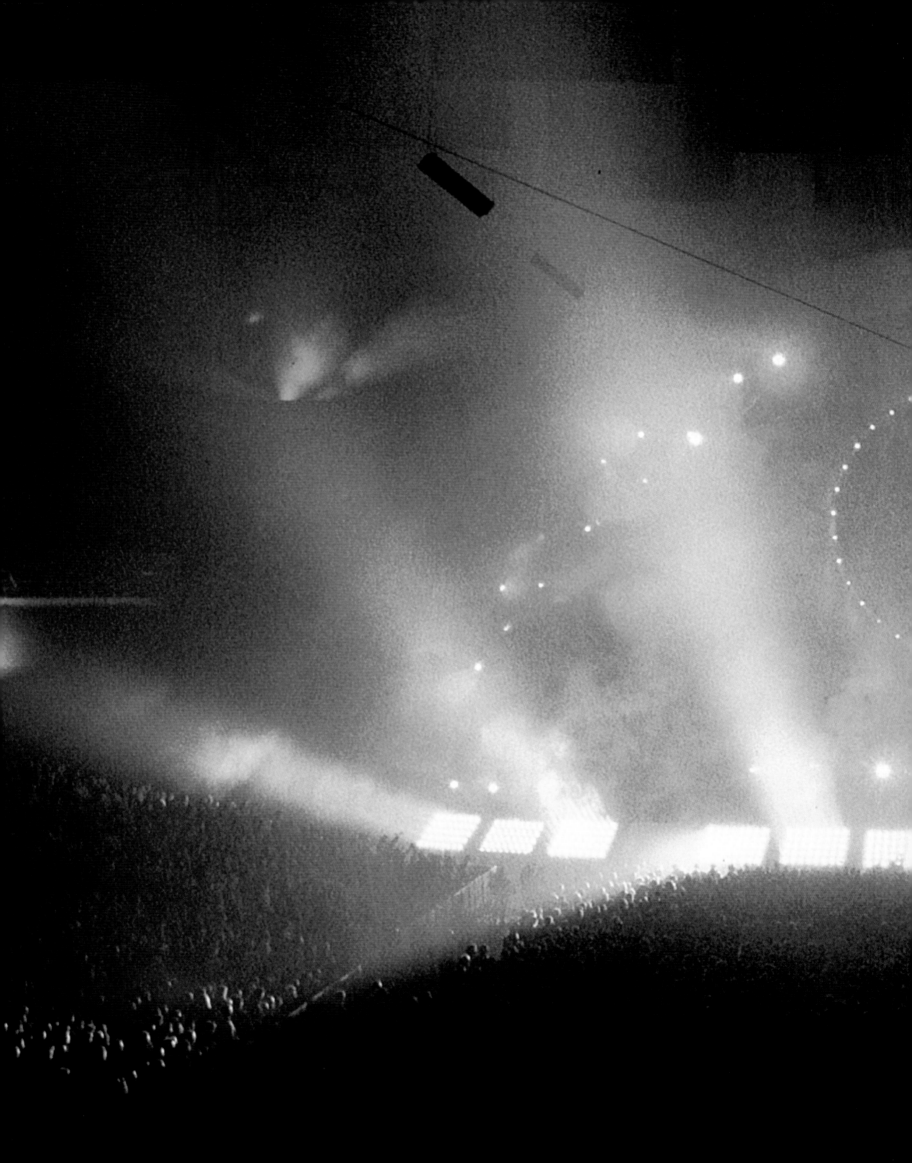

EVENTUALLY ALL VINYL RECORDS of Pink Floyd were remastered and repackaged for CD. This was not initiated until after *Shine On* in '93, ten whole years after CDs were first introduced. As an aside, there are cynics who claim that CDs were invented and foisted on the public so that record companies could make their money all over again. You, poor consumer, had it on vinyl, now you feel compelled to get it on CD. It's the same music, of course, but buy it again, why don't you. And to think CDs are unbelievably cheap to make, 2p each! The packaging is another 20p and you pay twelve quid. The great CD rip-off, except for the fact, which record companies know only too well, that music is good relative value; twelve pounds gets you one meal, half a pair of pants, into the cinema twice, etc etc. But what a scam! And do CDs sound better? Is the packaging better? It's a good deal smaller, that's for sure, but don't get me started.

The entire Floyd CD makeover was completed in '95. Firstly, all the music was carefully remastered from the original master tapes. Secondly, we set about refurbishing all the packaging. As another aside, record companies, in the early days, simply adapted the original vinyl sleeve design for the initial CDs and 'squeezed' it unceremoniously into a two- or four-page booklet. Sacrilege! But it was our own fault (and the manager's of course), because we didn't pay attention. Didn't realise it was happening. Too many internal band problems '83–'86, and revamping the packaging was low on the priority list. So, better late than never, we designed proper CD booklets with full lyrics, carefully scaled down original art, and further embroidery and photos where desired (or necessary).

Come '96 and the UK record company wanted to publicise and promote the Floyd back catalogue en masse by means of television advertising. We wrote five alternative scripts for this promotion, one of which consisted of no music at all, and no English dialogue. It was called *The Art Gallery* and showed foreign art lovers commenting on Floyd covers, just like you see in this book, but hung instead like paintings in a gallery. The dialogue was incomprehensible, unless you were fluent in Icelandic, Japanese, Hindi and Italian. More given to slagging off record companies than complimenting them, I must point out how adventurous EMI were to run with this obscure idea.

A second script involved a slow side track across a group of naked boys and girls sitting chatting on the edge of a swimming pool. Upon their backs were paintedfacsimile copies of selected Floyd covers from the catalogue, the 'back' catalogue (now that's what I call humour!). The designs were not projected nor computer manipulated, directly painted so as to follow body curves and reflect the lighting,

BACK CATALOGUE

as if really there — which they were, courtesy of the brilliant Phyllis Cohen. Body painting has a long tradition from Aborigines to Red Indians, and has its own fetish-like surreal properties. Tony Harlow at the record company preferred this idea and suggested its use as a poster. But why containing only women? Not Tony's decision, but mine. That old misogyny appearing again? Men and women were in the rough drawings (page 158), but I felt that this was wrong. The backs represented album covers and should therefore be the same generically. All men or all women. After much deliberation I chose women. Their shape is more elegant and more sensitive, I feel, but is this the whole story?

Finlay Cowan, designer and 'gate' keeper, executed the storyboards for *Art Gallery* and other scripts for the *Back Catalogue* commercial. He was largely responsible for this particular idea. Tony May enhanced the design with some very good 'pre-Raphælite' location lighting, and the women were just wonderful to work with, creating a very charming, friendly, and gentle atmosphere.

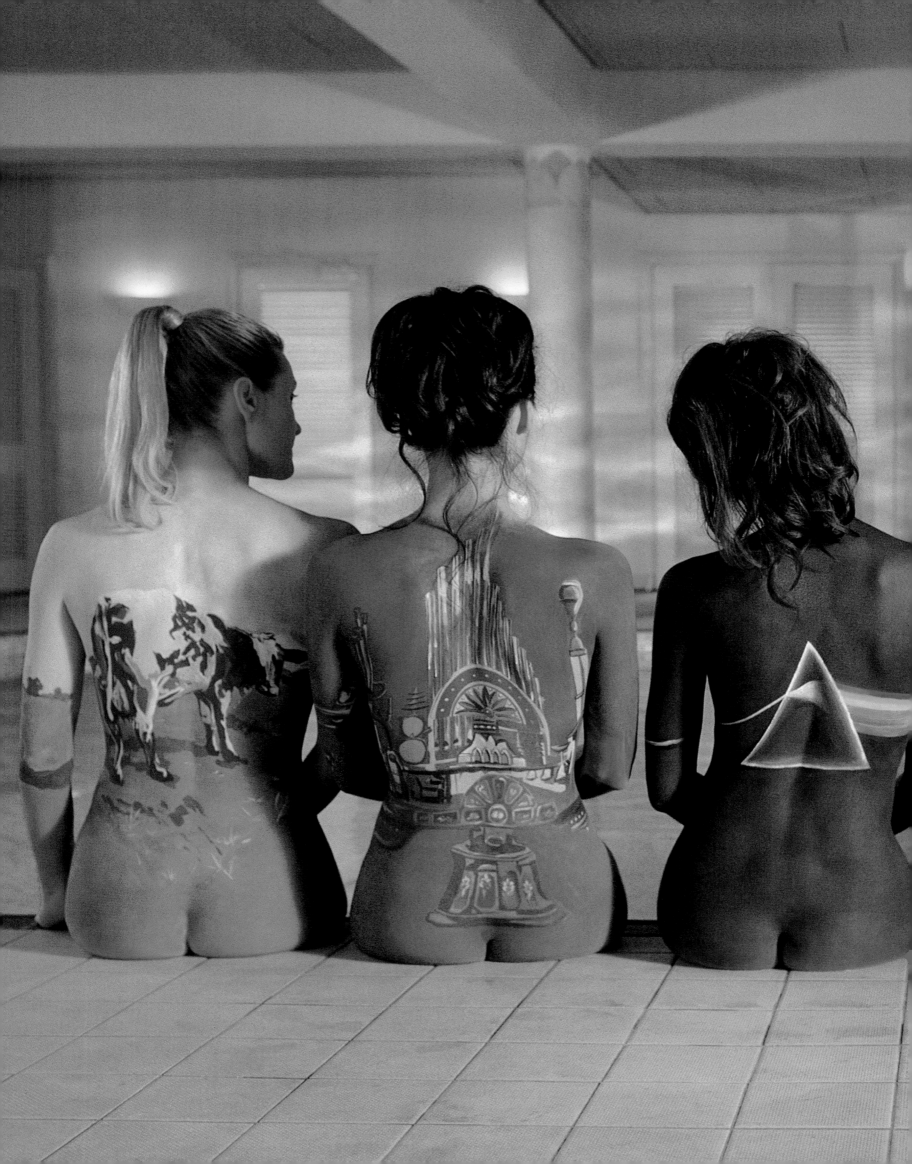

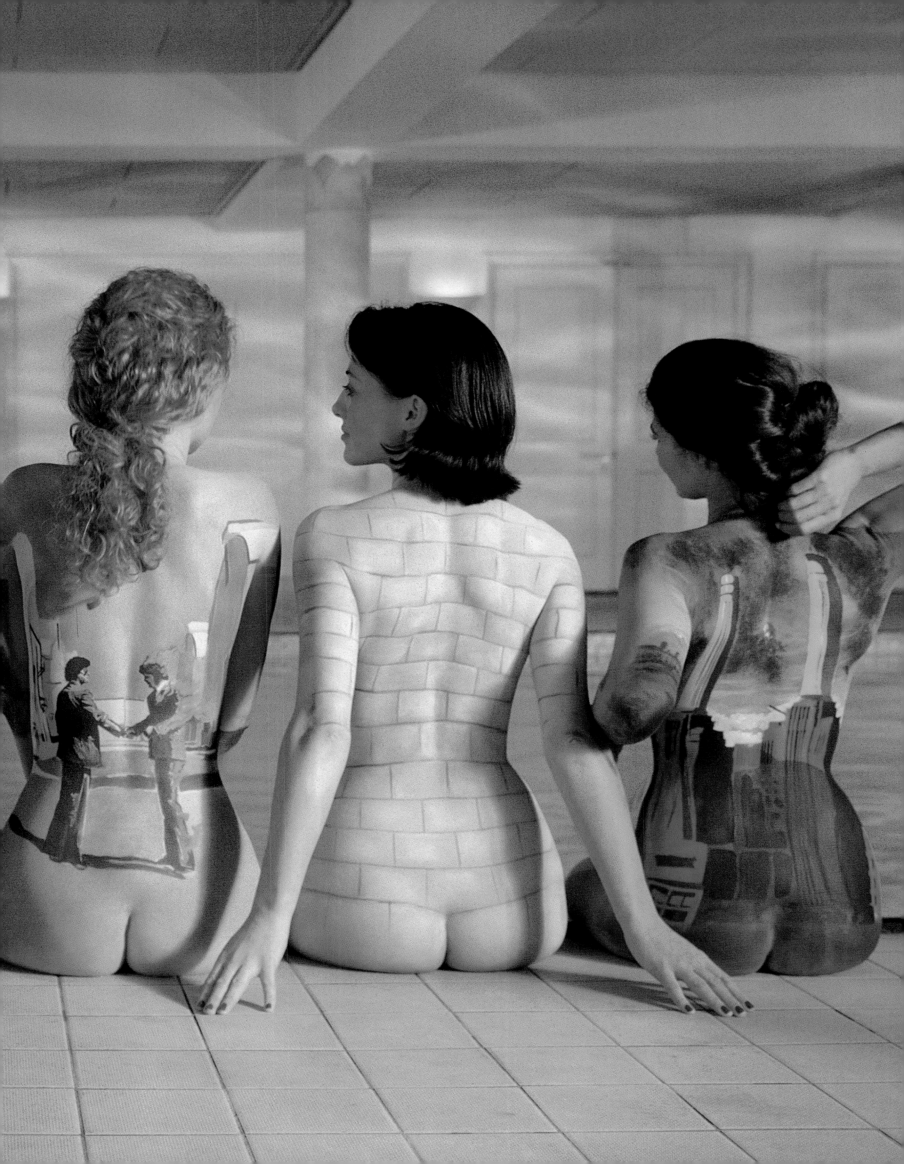

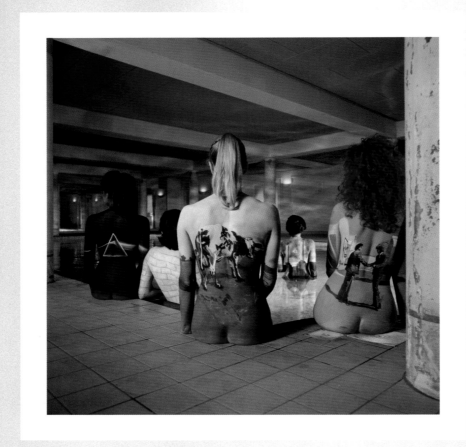

I HAVE TO ADMIT I'M NOT MUCH GOOD at making TV commercials. I really can't maintain what they call 'product focus'. The idea that I need to admire and believe in a product, in a can of beer for instance, is beyond me. And if I don't believe, I find it hard to do a good job: can't pretend and collect the money, worse luck — some kind of character defect, I suppose. Maybe I'm not professional or talented enough for the medium, not capable of realising, in the most eye-catching and polished manner, someone else's — ie the agency's or the client's — ideas. The advertising world is no place for integrity because directors (and everyone else) are expected to believe in the superiority of the product, or at least behave outwardly as if they do, irrespective of the truth. Imagine, all that endeavour, skill and money vested in a very short and succinct film, on a subject that you don't really give a shit about and might well consider deleterious or irrelevant. Redundant superlatives, massaged statistics, lies and hypocrisy — that's the norm, isn't it, in the shiftless world of advertising?

But not, hopefully, in the world of Pink Floyd. At the very least the product is specific and not like others. Arguably it is among the best, or it is certainly possible (for me) to believe it to be. And for them I can write my own idea and not be obliged to use someone else's, perhaps even divesting myself temporarily of product focus — I don't even have to show or play the music. I don't have to be obvious and can, on occasion, be very obscure.

This was the case for the *Art Gallery* commercial we did for the Floyd back catalogue in '96: no music, no product description, let alone any direct promotion, or indeed many words you could understand at all, not unless you knew, as I said on page 155, Icelandic, Gugurati, Japanese and/or Italian. There was a throwaway one-liner in English at the very end but the relevance was very obscure. The general idea consisted of people visiting an art gallery and commenting on the merits, or not, of the pictures on view. These were in fact huge blow-ups of Pink Floyd covers. An Icelandic couple discussed the politics of *The Wall*, a Hindi woman was curious about *Atom Heart Mother*, three Japanese trendies were alarmed by the burning man from *Wish You Were Here* and two attractive Italian boys admired the pig over Battersea Power Station. Though there was a working script in English we could not understand a word of it when spoken in foreign tongues; hard to direct, familiar with neither vocabulary nor expression. It sounded incomprehensible however it was acted.

TELEVISION ADVERTISEMENTS

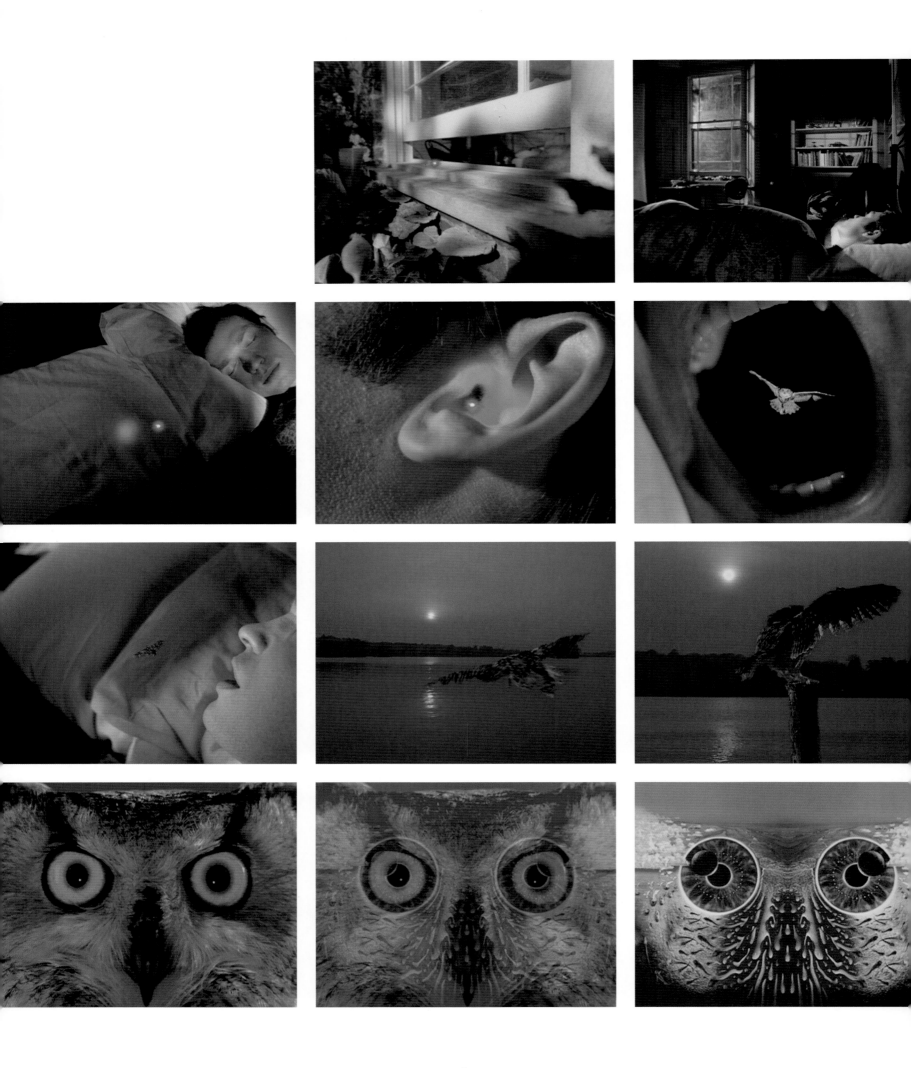

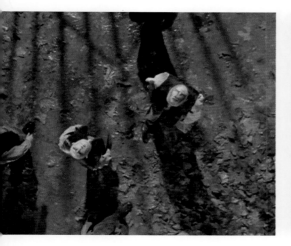
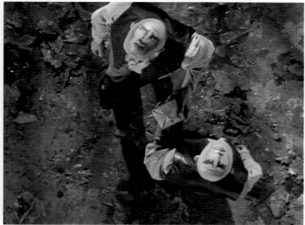

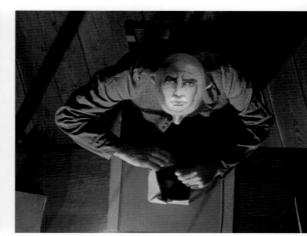

Kind of absurd really: only die-hard fans had any clue what was going on and they didn't need to be 'targeted'. The general public out there in consumer-land might not understand it, and would probably just ignore it or get angry. We thought it well funny from our sequestered viewpoint. It was definitely at odds with all the other ads on TV that would always, however belatedly or ironically, show and/or mention the product, or at least would be intelligible to an English audience. Our ad was not even that. Not gobbledygook exactly, but pretty damn close, especially for xenophobic Brits.

The other commercials shown here are more straight-forward but not without character (or so I'd like to think). *Pulse*, opposite, was a set of images vaguely connected by the red pulsing light (see page 144) that, like a firefly at night, drifts into the bedroom of a sleeping figure, floats across the pillows and enters his ear, literally, like the music.

He turns in his bed and opens his mouth as if to yawn and, out of the blackness within, emerges an owl that flies over the pillows and out across a moonlit lake. It turns its head towards the camera and its eyes become twin *Pulse* cover designs, also viewable on page 150 as the back of a single bag. A music track was specially prepared by a Mr J Guthrie, nifty producer and current Floyd sound magician.

Last but not least is *Baldheads* – a tribe of bald-headed gentlemen upon each of whose pate is painted a face that 'shares' the real ears with the real face, but looking up now, not straight ahead. The narrative, such as it was, consisted of two sets of these 'Baldheads' walking towards each other in slow motion to a soundtrack of 'Shine On You Crazy Diamond'. One of them discreetly hands a package to another approaching Baldhead, who takes it back to his house, goes upstairs, enters a garret with wooden floors and one table, sits down and opens said package to find – wait for it – Pink Floyd CDs, repackaged and remastered. Each shot in the commercial is taken from above so that one sees the 'heads' looking up with resolute, fixed expressions, moving woodenly, surreal, especially when turning away, the painted head rotating like a robot. The expressions of these painted heads were all the same, painted in the same style, mask- or clown-like, and very dour until opening the Floyd CDs at the end, when the face is then seen in smiley mode, as one might expect.

All very enjoyable and elegant to view. A simple idea, told slowly, all shot from some aerial viewpoint with appropriate music soundtrack. The idea worked so well that I developed it later and used it for a CD cover in 1997 for a band called Ragga, where different faces were painted on bald heads, including dolls and animals and even cracked eggs, winding staircases and wooden trapdoors. Whatever next?

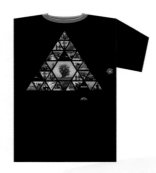

MILLENNIUM T-SHIRTS

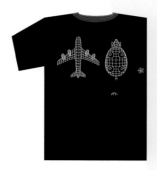

I HATE TO BE LEFT OUT or excluded. I remember as a teenager being most upset when I was not invited to parties or evening arrangements. And for many years as a working man, I'd dislike it if I were not included in band activities, or 'jollies', or meetings where I thought I ought to be. Just an ordinary old paranoid, that's me. And I didn't want to be left out of Millennium celebration-type stuff either, even if it was all a bit overblown (and technically incorrect, if you know your Gregorian calendar).

A range of Millennium Floyd T-shirts beckoned: one for each album, but not quite all of them, due to the divorce with Roger who retained *The Wall*. An incomplete range, in fact, celebrating a Millennium that is a year early; and designed by somebody who knows nothing about fashion (that's me). Should be good. I was keen to do it, however, attracted in effect by all the incongruities. I listened again to the albums, like I had many moons ago. I reread all the lyrics and attempted to redesign the covers, adapting the ideas to T-shirts, and using some imagery we already had, especially where I couldn't think of new shit so easily. The designs were obviously slightly less involved, less expensive to produce, and more graphic orientated as befits printing on fabrics.

Jon Crossland helped do *Meddle*, the mudman for *Obscured* and the psychedelic pixellated image of Syd for *Piper*. (His first effort, a psychedelic cockerel, a dawn piper no less, was excellent, but was rejected by the band.) Peter Curzon designed the intercommunicating tablets for *Division Bell*, and the graph-like plane and pig for *Animals*, and also the actual Millennium T-shirt, made up of sections of Floyd covers in a clever triangular pattern resonant of *Dark Side*. *Dark Side* itself echoed themes in the lyrics — missed opportunity, madness and ambition, to name but a few, whilst *Momentary Lapse* referred to Langley the mystic rower from the Signs Of Life film. *WYWH* was about *WYWH* and the number 'four' (see page 172). And so on.

I have to say that the band were lukewarm about the project, caring little for the T-shirts in general, and even less for our designs. Perhaps they were right in the Grand Scheme Of Things. But I badly wanted a set of T-shirts that I really liked, and so was quite happy to persevere. I especially enjoyed *Saucerful Of Secrets*, comprising overlapping aliens, standard grey model, sharing one eye apiece, like the comic/tragic masks of theatre-land. One representing sadly the departing Syd Barrett, and the other happily the arriving David Gilmour; overlapping heads of yellow and blue, forming green in-between, the green of *Saucerful Of Secrets*, the green of peace.

JUST IN CASE, dear reader, you didn't know, 1997 was the 30th anniversary of Pink Floyd. Sony, their US record company at the time, wanted to do a big autumn push on the back catalogue — well, the six albums they had. We were commissioned to come up with an image to spearhead the campaign. No problem, or so we told Sony. In fact we couldn't at first think of anything. Any one album cover is difficult enough: so hard to offer up a single design against all that music. One is always falling short, since

30TH ANNIVERSARY

the music is so complex — so many different feelings and ideas. A design for each song would be more manageable, but several albums for a campaign? So we panicked. And then procrastinated. We looked through some old stuff and came up with the giant chair (see overleaf) and the window in a window idea (see here), which is in itself a reworking of *Ummagumma* (see page 29), but at least provides possibilities for reference to many albums. Thirty objects, one for each year, seemed suitable and even more interesting when drawn out. There were three or four versions, one of old hats which I liked a lot but nobody else did, finding the humour unfunny, or too close to the bone. Thirty aliens (see here) was a front runner for a while, but Sony didn't see the connection. They

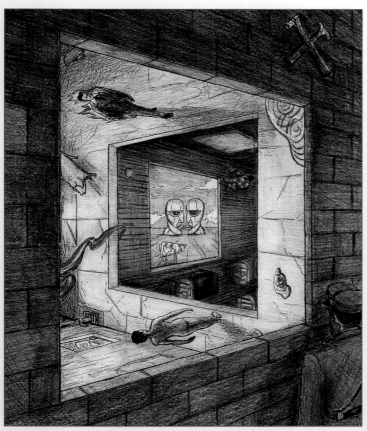

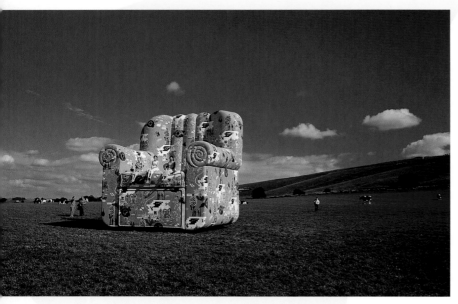

Easter Island heads for *Division Bell* and this enormous armchair were not – that's NOT – assembled in a computer. They are real, physical objects; real physical events. In order to accentuate the reality of this Floyd chair we included human figures for scale, but this didn't stop the sceptics who simply felt that the figures were part of the same computer process. Well I CAN TELL YOU that this baby here is as real as a Dutchman's helmet, as the day is long, and we should know, because we spent a long day shooting the bastard.

The location (in mystic Wiltshire) was excellent, the weather absolutely perfect, and the enormous chair truly a sight to behold, sitting there huge, placid and incongruous in the middle of the British countryside. But shortly afterwards things didn't work out quite so well. The chair itself became the centre of a squabble about dismantling between the modellers, the scaffolders (who erected it), the photographers (ourselves) and the unfortunate farmer upon whose property it rested. Nobody wanted to take it down. The poor chair was abandoned, left to rot before being carted away as rubbish. We never spoke again to the model maker, and his scaffolding cronies disappeared.

To cap it all the final image was never published. Owing to a monumental cock-up over remastering the music, the records didn't get released on time and the campaign died, our beloved chair along with it.

And, as you can readily imagine, this whole exercise was not cheap! Lots of money was squandered, as well as much time and effort. It just had to appear somewhere after all we went through, so here it is. The final (artistic) irony is I'm not entirely sure if it really works that well. I like it. I like the idea of a Floyd chair which will transport you in your room, as it were, to anywhere in your head. Listen to the music, sit back in your Floyd chair, and be 'transported'. I like the photography and the location, but something irritates me. Is the Floyd pattern painted on the chair too bold and clean? Not enough of a background pattern, for it's the chair that should be the focus of attention. That it's a Floyd chair is only a secondary consideration. Then again I could be wrong. I have been before. Once in '87, I believe, twice in '93 and once again in '96.

rejected 30 pink objects as being too silly. Fancy that. The band favoured the window idea but accepted Sony's preference for the giant chair, since the chair had been a strong contender for *Pulse* a couple of years previously. Sony surprised me by choosing something not only contrary to the band's wishes, but also the most expensive. Very unlike a record company, though that's not why it all went pear-shaped in the end (that's pear- not chair-shaped).

It's jolly frustrating in these modern digital times to have to explain that certain images were not constructed in the dreaded computer. The beds for *Momentary Lapse*, the

PINK FLOYD

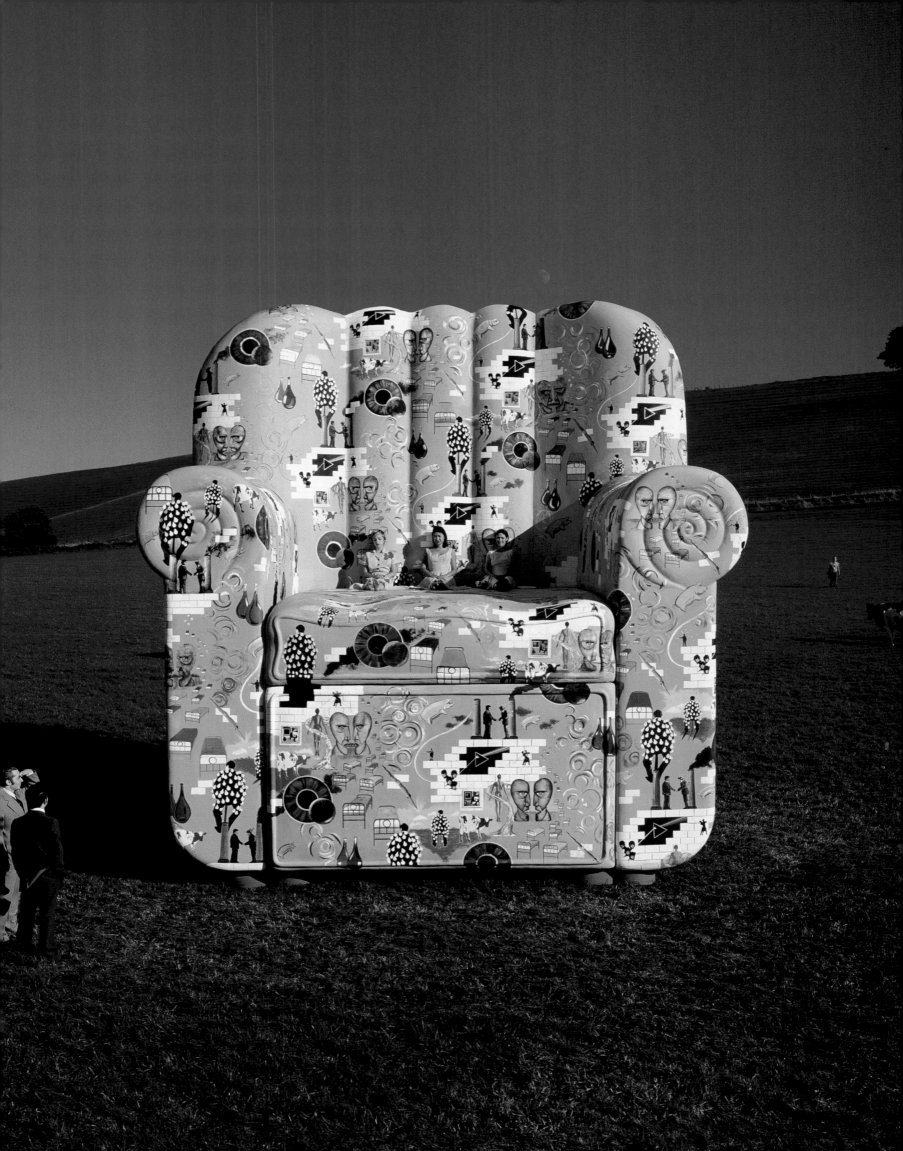

SOME PARTS OF THE DIGITAL EXPLOSION are more impressive than others, in my not so humble opinion, such as computers themselves and especially the printers. I watched mine print a colour photo today and was amazed – how does it know what to do? And the quality was really good, lots of detail and bright colour. How does a computer remember everything anyway? And store layers, or keep files, and possess such a variety of tools and devices, for games or for work? Extraordinary. But digital TV I could do without. Lots more stations, lots more programmes, lots more crap. It is supposed to look better, provide better reception and so on, but does one care? Better looking crap is still crap. And the internet is pretty weird if you really think about it. All those connections, all that information at your fingertips, available so quickly, and yet the sense of amazement is dulled by how much shopping is done, how much chatting, and how much the technology is driven and fuelled by commerce and pornography. Friends swear by e-mail, but I like faxes and phone calls. Mobile phones lessen the internal horizons but are good for stranded daughters. CDs are all right, convenient, but not better sounding, while CD-ROMs are a disappointment. I remember David Gilmour being singularly unimpressed, as were market forces. Mini Discs you can keep, and downloading MP3s or whatever is not to be mentioned, as it might well put the likes of me out of a job. But DVDs, on the other hand, are great.

The Digital Versatile Disc is basically a CD. Looks exactly like an audio CD but contains six to ten times the amount of digital space or information. It can reproduce feature length movies easily with excellent picture quality but, more spectacularly, with excellent surround sound, called 5.1, for those who need to know. Watching a DVD will make VHS a thing of the past, thank God. But of course you gotta buy the gear...a new DVD player and some kind of top box, possibly a new wide screen TV and naturally your 5.1 surround sound system. And all sorts of add-on and luxury items for those affluent collecting obsessives out there in consumer-land. (A further drawback is that recordable DVD players are currently extremely expensive, though I'm sure that'll

change soon.) DVDs are great for movies, natural history programmes and rock 'n' roll concerts.

DVDs actually contain extra space so that one can include other ingredients in addition to the movie itself. A commentary, perhaps, or different language subtitles; photographs and illustrations: a trailer, or a documentary even. The user has choices to make – he or she can view different items at different times, or some in combination. A DVD therefore has a menu, an interface and a means by which to make the choice, namely a handset controller. But digital space is limited, and hence the choices are limited. A DVD is not a CD-ROM, and the controller is not a mouse (although you can play DVDs on a computer, which is not such a great idea as regards to screen quality and speaker system).

Choices are made step by step, not click by click.

THE WALL DVD

James Guthrie, genial Floyd producer, was asked by Roger Waters to produce a DVD of *The Wall* movie. He had firstly to remix the sound (mostly music and songs) for surround sound (and stereo for those who didn't have the 5.1 system). He persuaded Roger's manager, Mark Fenwick, to consider using me to help in the design of the DVD menus and interfaces, devise the graphics and help select the contents. I suspect that Roger was not overly keen on the idea (see page 100), but Mark persuaded him anyway.

First we designed the packaging as you can see opposite, which was OK, keeping as it did within the bounds of what had been done previously for the VHS, but different enough since it was a very different product. We also designed a poster (see overleaf) – an 'inducement' Sony called it, a freebie for punters who bought the DVD, which allowed us greater freedom to represent the movie, the intrinsic nature of DVD itself and the powerful illustrations of Gerald Scarfe. I particularly enjoy the border, which at first sight seems pretty and decorative, but shows, in fact, rows of screaming faces, like a macabre psychedelic edging to wallpaper.

The four horizontal inset panels, containing film stills, indicate the basic interface structure of the DVD. Each menu has four selections (see adjacent), partly because

the handset controller has only four buttons, left, right, up and down, and that's all. The user can make one of four selections, not step round the menu, as one does with most DVDs. Rather than three or four menus of several choices *The Wall* DVD has several menus of only four choices, interconnected like a branching tree. Each menu allows you two items, plus one 'return' and one 'next menu'.

This system, involving ten or so menus, looks complicated at first, but is designed for simple operation, saving the bother of a separate 'entry' button, since each choice corresponds to each button, but also ergonomically reflecting in your hand what is on the screen.

No longer necessary to locate choices, count out and step round, instead one unconsciously knows where one is. One can select 'spatially'. Very sophisticated, or so we thought, but will anyone notice, I ask you, or even care? In case they didn't, we also designed custom menus with moving graphics, set against slow motion filmic backgrounds, accompanied by specially edited Floyd soundbites orchestrated by James Guthrie. The movie itself was cleaned up, regraded from original interneg and made wide screen, while the soundtrack was remixed from original master tapes. We located unseen footage, namely 'Hey You', and a video of 'Another Brick'. We found an old documentary, shot and edited a brand new one, provided advice on how to get the best from your DVD and so on. What a feast! We even had secret rogue buttons with surprise icons that appeared every now and then, but I can't tell you about those 'cause they're secret.

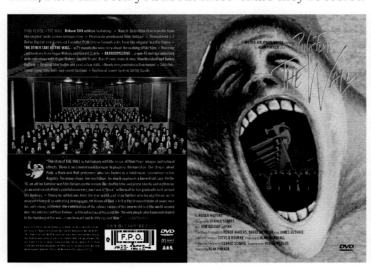

FRONT COVER, MENUS AND, OVERLEAF, POSTER THE WALL DVD 1999

IS THERE ANYBODY OUT THERE?

THE GREAT CIRCLE is nearly completed. I get to work on *The Wall* and you, dear reader, get to the end of the third edition. Not *The Wall* studio album but a live album, deftly compiled by that digital wizard Mrs James Guthrie from the 1980 and '81 gigs at Earls Court, London.

If you're a Floyd fan or music aficionado several questions might spring to mind: like why now? Why this and not a new studio album? Why something from the vaults? Would anybody buy such a thing? Who was behind it? Was Roger top man since it was largely his creation? Or was David since it was a Pink Floyd project and Roger is no longer officially in the band, though he was very much so back then? If you need a job to pay the rent, like me, then you don't ask too many of these question out loud. But February 2000 marks the 20th anniversary of the first Wall concert, so that must be it. Any fool knows that.

It was a great show, I hasten to add, so perhaps *The Wall* live album, *Is There Anybody Out There?*, would be great and, more particularly, different from the studio album despite the precision — the show was so complex and diverse, you see, so crammed full of lights, effects, films, puppets, surrogate band, pig, crashing aeroplanes not to mention a fucking great wall, erected slowly then brought down in a tumultuous finale, that it had to be timed to perfection to play in the correct order and be properly synchronised. It was a minor if not a major feat of technology and organisation, let alone of art, that it took place at all, and indeed ran efficiently for several nights in four different cities. All of this splendour would, of course, be available on film or DVD, but what we had here was a record, an audio product, a CD disc or rather two CDs, since *The Wall* concert was too long to put on one disc.

As stage designer Mark Fisher, sound producer James Guthrie and stalwart drummer Nick Mason intimated, the primary objective of the packaging, in their view, was to reflect the scale and the enormity of the show itself. No ordinary concert this, but a theatrical operatic mother of a rock show. In this instance, Nick said with a knowing wink, size mattered.

So I started to design not so much from the feeling or ideas in the music as from the scale of things. The package needed to be large, larger than usual, yet capable of automated production. We took a standard four-CD book pack which was twice CD size, and which provided much greater variation in page layout and picture cropping, had the CD

VISUALS FOR IS THERE ANYBODY OUT THERE? 2000

pocket altered at either end to take only one disc (two in total) and then removed the plastic trays. God, I hate all that plastic, especially in clam shells – double CD jewel boxes to you. We created a handsome casement bound book of humongous length (64 pages) made up of three different papers, and including a dye cut, which was then inserted in a snug and durable slip case for protection. All in all a tight little package.

Are you still with me? This physical specification stuff may not sound very exciting but it is to the likes of us. The tactile nature of a book is a vital ingredient, especially with picture books, be it for *The Wall* live album or this very book you hold in your hand. My belief is that books are objects to keep and treasure, and that their feel is nearly as relevant as the design and individual graphics. So there, that's what I believe.

The oversize book displays a great set of photographs of *The Wall* show (Earls Court 1980) plus some excellent back-stage pre-concert pictures and new interviews with the band and other leading contributors to the event. The end papers comprised patterns made up of Gerald Scarfe illustrations and a sort of Laura Ashley-type wallpaper (get it?), violent in its cosiness. The elegant upright shape of the book determined much of the graphic layout vis à vis title page (page 170) and the book cover itself (opposite). The other leading design imperative was the number 'four' as you can see, because there were then four members in the band and four letters in 'Wall', in 'Live' and even in 'Pink', the leading

character of *The Wall* story. Too many coincidences to be ignored. An ascending stack of four items also suited the portrait shape well, so effortlessly that, at least for me, this settled matters.

What was not so easy to settle, of course, was the politics. Roger was the progenitor, the author, and therefore his opinions were very important. He was not, however, in charge and could be outvoted if David and Nick decided to do so. But David and Nick were respectful of Roger's authorship, but not if it turned to dictatorship. Roger refused to talk with any of the others, but agreed that the record be released. He reluctantly accepted that I put the whole thing together, but wouldn't talk to me either. The respective managers (Mark Fenwick and Steve O'Rourke) did talk, but usually through expediency. Roger wanted pal Nick Sedgwick to organise the text (this was OK), wanted Gerald Scarfe involved (partially OK) and wanted credit listing like the concert programme (not OK). Would reason prevail?

More diplomacy than design perhaps. Things were eventually agreed, but not before the album release was delayed. There was a rumour that this was due in fact to difficulties in the mixing department, but I discounted this as mere hearsay.

The cover of the slip case proved more awkward in so much as neither Roger nor David liked what I suggested (the swines). However David did not want what Roger wanted and vice versa. I really liked two of our suggestions:

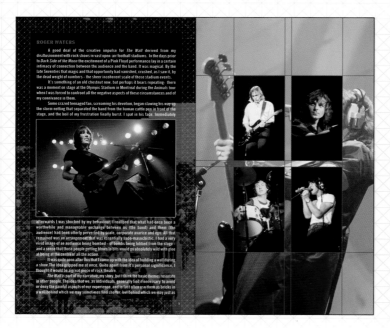

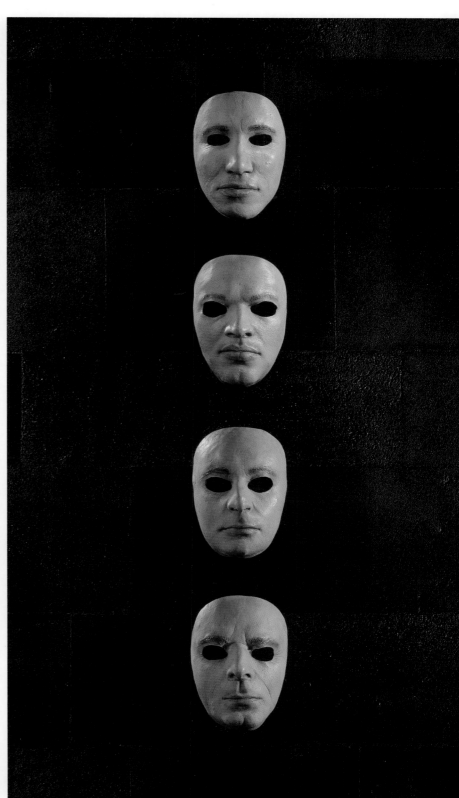

BOOK COVER AND BOX FRONT IS THERE ANYBODY OUT THERE? 1999

namely the mother and baby made of metal bars/wire (page 171), like an iron skeleton, like much of the scaffolding used in the show, and representing the idea of a cage which both protects and imprisons, like the defensive bricks in Roger's wall; and also the dead horse hanging like a carcass, done as a Scarfe-type photo, reminiscent of his dramatic imagery, but with a self knowing touch of irony, as in 'flogging a dead horse'. Oh, there was also the Scarfe-illustrated Russian doll (doll within a doll within a doll), which again I thought was very appropriate, but David and Roger didn't like this either. They may not have been talking to each other directly, but it didn't stop them agreeing about certain things. I felt they were being conservative. It seemed they might settle for live pictures, or were inclined to retain ties with the past by using variations of drawn bricks or scratchy lettering as per studio album. They were persuaded that this live album was a different album, a new album, and therefore needed a different kind of design. Finally Roger agreed to the life masks which David and Nick already liked and which were used in the actual show by the surrogate band pretending to be Pink Floyd. These masks (on page 173) are the actual items, re-photographed and dropped in against a wall from

a Cambridge College (seeing as the band came from Cambridge), not cut-out faces, but real prosthetic life masks from 1980. I think they're a bit creepy but I like that. A little edge, a little irony – life masks which look dead for a live album from a 'dead' band. The rumours will spread.

Peter Curzon and Richard Evans should be thanked for their graphic input and Sam Brooks and Finlay Cowan for help with the ideas.

While sifting through hundreds of slides and watching a VHS of the whole show, it became apparent that *The Wall* really was a great show. Spectacular and moving. Surreal and scary. Not to mention some excellent music like 'Mother', 'Hey You' and 'Comfortably Numb', dramatic stuff like 'The Trial', and straight rock 'n' roll like 'Run Like Hell'.

I may not have worked on the show but it was a pleasure, despite the politics, to work on the live album, and get re-introduced to the music. I do remember being there back in 1980, feeling a bit of an outcast, not having designed the studio album cover, but being blown away by the concert itself. "We don't need no education," intoned Roger, in the unlikeliest and only Number One single of their career.

And we don't need no more text, for now.

PRIMER SINGLE AND ART POSTER IS THERE ANYBODY OUT THERE? 2000

PINK FLOYD
WISH YOU WERE HERE

Special Limited Edition
25th Anniversary Issue

Reproducing in CD form
the original vinyl artwork
including black wrap

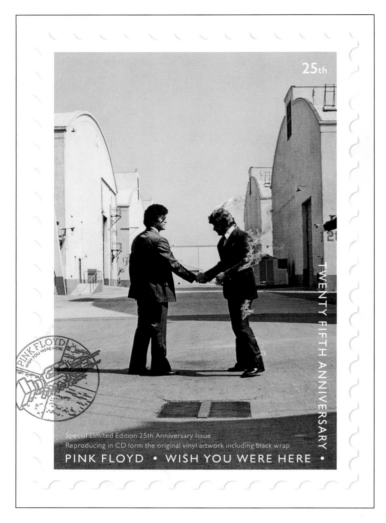

HOW TIME FLIES. When 2000 appeared it was, amongst other (possibly superior) events, the 25th anniversary of the release of a phonographic album entitled *Wish You Were Here*, modestly performed by Pink Floyd. EMI records wanted a commemorative poster and we duly obliged.

Now, I am kind of neutral about anniversaries. . Perhaps marginally in favour — especially if it involves a knees up, a splendid meal paid for by somebody else or celebrates my own birthday. There are others, however, who are in general very keen to mark events, honour birthdays and celebrate anniversaries, for a whole range of authentic reasons, but then there are record companies who do it for money. Not that I blame them particularly; they've got a capitalistic job to do. I blame them for doing their job badly, for making marketing claims that obstruct creativity. I blame them for not having sustainable faith, for not enthusiastically fostering new talent etc etc, things for which they criticise themselves, I'm sure but let's not go there. EMI's job, in this instance, was to market and distribute Pink Floyd product efficiently and with taste, vigour and innovation. Now there's a thought.

More to the point is whether the item being commemorated is worth it, and *Wish You Were Here* certainly is. Some folks think it contains Floyd's best song — 'Shine On You Crazy Diamond'. It sports, moreover, one of my favourite images — namely the man on fire. And another of my favourite images, the diving man. And the swimmer in the desert going nowhere fast. (OK, yeah, I'm biased. You gotta like just some of your work, for it is too easy for an artist to be paranoid, and forever doubt his own ability.)

So, the 'burning' question was, what to design to celebrate a great album with, dare I say, great imagery. I thought long and hard, but despite being always keen to do new things I simply could not think of anything better or more appropriate. But, should I choose one of the old images or use all of them? Did I have a preference? Would using all the images make them too small, or too cluttered?

WISH YOU WERE HERE 25TH

Then I recalled that one feature of *Wish You Were Here* 25 years previously was 'four-ness' — four faces of the vinyl cover, four band members, four words in the title, four elements (earth, air, fire and water) and there you have it; a poster, or rectangle, divided into four quadrants for the four images: then a centre circle for the sticker (see page 75), and a narrow decorative border made up of repeat alternate reverses of the swimmer in the desert. Neat border, I thought, affirming the long tradition that a repeated mirror pattern works wonders, especially when not composed of merely shapes or geometrical elements, but of a whole image instead.

And as I did this Peter van Curzon had started his own design — a single image, which was made large in the poster and given a serrated edge like a postage stamp. He then added a 'postmark' to ensure it was totally like a stamp, in honour of the postcard aspect, actual and metaphorical, of the original. And he'd chosen the burning man — independently, I assure you. But the result was that we now had two different but equally valued designs, so which one should we go with? The answer was so easy it took the record company to think of it — use both. Print a doublesided poster, which I am usually against as you can't see both sides but on this occasion I was happy to, since I hated to lose either of the designs. Which just goes to show…just goes to show that…I've forgotten what aphoristic titbit of wisdom I had in mind… *Wish It Were Here*, so to speak, close at hand.

TALKING OF *WISH YOU WERE HERE* reminds me that we also devised a six-minute film for Capitol Records to celebrate the album's anniversary. It was made specifically for the internet, technically and creatively, and was posted on the Shockwave site for several months, available to all...well, all who were connected that is, especially if broadband connected.

This webfilm was designed in seven or eight separate parts, which were to be joined at the end of the project. This division allowed us to work on separate pieces at the same time. It also permitted substitution in case one piece was disliked by either Pink Floyd, Capitol or our good selves. A music edit, or cutdown (shock horror), was required since the 40 or so minutes of the actual album was clearly too long for the web to handle easily. Despite such 'sacrilege' the assembly would consist of noticeably different sections for the different songs on the original, or not be fully representative. In addition the Floyd asked that the film be referential to the original imagery of the album cover – the man on fire, the diving man, red veil, faceless business man, swimmer, the four elements etc.

James Guthrie, long-time producer and Floyd sound wizard, reluctantly begun the necessary music surgery while we embarked on the filming. The borders were the first idea to materialise, echoing the use of borders on the album cover (where they were white). In my mind they could be less quality conscious, even defocused or looped, since viewers' eyes would not examine them closely, and so save on digital space and at the same time make the frame/video window seem bigger.

The opening section derived from the sound of wind, from the veil image and from the sand through which the swimmer in the desert was struggling. The next section – the flying hands for 'Welcome To The Machine' – was based on a set of black and white drawings that described how the shaking hands from the album sticker might have come to meet. The illustrations, foreground and background, were scanned and animated in Flash. The next section for 'Have A Cigar' consisted of a short sequence about masks, particularly the inside-out mask that seemed to suit the lyrics well. This was filmed on DVC, converted to vector graphics and imported into Flash, where every frame was hand-optimised. The title track was represented by a short illustrative montage composed as a mandala to save on digital space as well as appearing attractive. Tilting the camera 45 degrees was the key. The four-way quality also reflected the 'fourness' of the entire album package – four elements, four cover sides, four band members, four words in the title and so on.

Mark from Bluish kindly gave me some understanding of how Flash worked so that the jetty sequence for the beginning of 'Shine On You Crazy Diamond' was filmed soley with this in mind, i.e. shot for Flash by using fixed

camera, silhouette type compositions and graphic action. Worked a treat both for the music and the original album imagery, or so we felt. The geometric sequence for a 'Shine On' verse was executed directly in Flash, again to save space but also to utilise the computer in a different but suitable fashion, and to look diamond-like.

The burning picture of the man on fire was our little head joke, but was also easy to shoot, and interesting to see what happened when transferred straight from video to Flash. The last part of the webfilm was about Syd Barrett. It was meant to be a graphic piece, another kind of visual approach, but mostly it needed to echo the sad haunting music. James Guthrie and I had always agreed that the actual end of the original album would also be the actual end of the webfilm cutdown. *Wish You Were Here* Syd.

WHAT A SONG AND DANCE!

You wouldn't have thought that affairs could get more complicated in le Monde du Floyd since it was by now 2002 and they were clearly not going to make a new record and were even less likely to go on tour. And they were obviously older and wiser too…

Don't you believe it. The record company, struggling to make its money back from the rumoured advance on a new ten year deal but no new product, suggested a Best of Floyd release. A 'Best of'? Cries of "Heresy!" were heard across the land. Floyd don't do 'Best ofs', surely. A 'Best of', or 'Greatest Hits' album may be well known in the trade, and even amongst the great public at large; a tried and tested format, very applicable to many recording artists from Elton John to Celine Dion, from Beach Boys to Boyzone. But not the Floyd! You can't be serious! For a kick off, they don't have any hits, well, a couple perhaps, they don't trade in singles, or ordinary songs that much, but rather in experiences — long meandering tracks that sometimes seem to lose their way. They also don't usually conjure any catchy lines except, of course, 'We Don't Need No Education' from 'Another Brick', which was therefore first in everybody's list of contents for this project. Put simply, Pink Floyd are not the kind of band you can make a 'Best of'; the concept simply does not suit their music, nor their image.

There ensued a collective indifference. David went further and denounced it as a very stupid idea and would have nothing to do with it. Nick said it was all old stuff anyway, but could see why the record company might want

to do it. Rick thought it unedifying. Roger was off touring somewhere. I confess I thought it a bit silly myself, unless one could muck about with the concept, change the idea of a 'Best of' and do it in a Floyd way, whatever that was. I didn't know what I meant, but it sounded good.

Thus began the saga. EMI sent a list of proposed contents to Steve (Floyd's manager) and to Mark (Roger's manager) beginning, I think, in January 2001 (if not November 2000); and the lists were sent back with comments, and then returned. And then refined. Back and forth. These lists were chronological in order and the selection was predictable, if not a trifle pedestrian. This exchange began to take on a greater purpose round about April or May when demos were made and the cover design initiated. James Guthrie was underwhelmed by the track lists he'd seen so set about making his own demo. "You have to hear it" he announced grandly, "not read a fucking list!" He agreed that a non-chronological order was more stimulating and that some edits might be necessary. David was disinterested still, attending to his own concert appearance in June. Roger was becoming more interested, but preferred chronology, probably because post-Roger material would be at the end and kind of 'separable'. Nick wasn't consulted much at first, and Rick was on his boat somewhere.

Now, the defining feature of a 'Best of' is presumably the track selection. Which tracks comprise the best ones? What does 'best' mean? If there were sufficient singles releases then it could be settled by the simple procedure of including the best

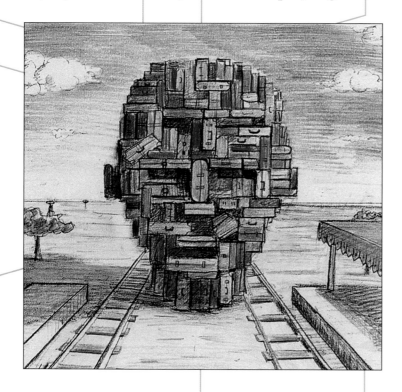

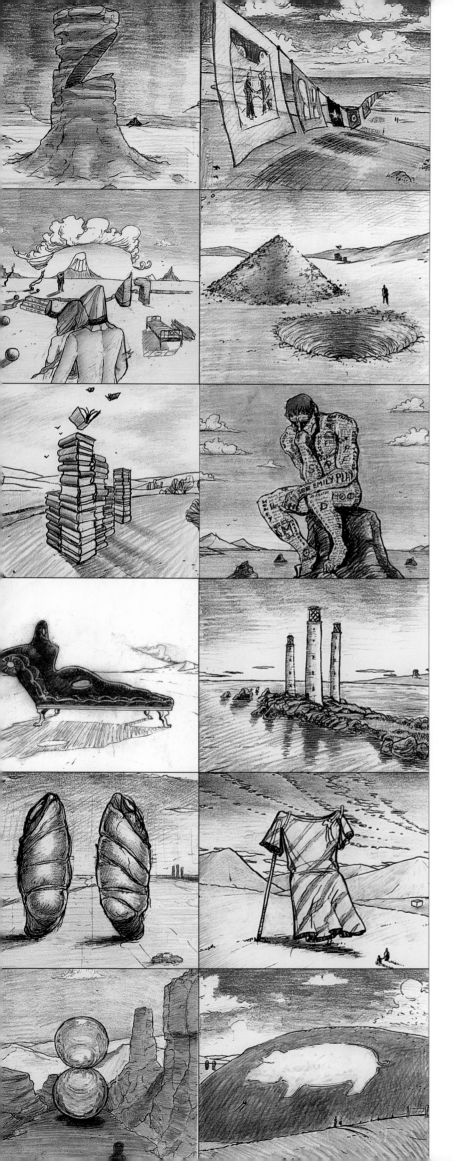

sellers, or the greatest hits by chart position. Since Floyd don't have many hits (two or three perhaps) – and not many singles at that, not enough to make an album, let alone a double album which was EMI's preferred option – the question became more complex. What precisely goes on the album, in what form and who is going to decide? It soon became apparent, organically rather than by deliberation, that the Floyd rather than any third party were going to do the choosing.

All straightforward in theory. The Floyd decide, say, by some ordinary internal voting procedure, what does or does not go on the album. No problem. However at this point, by now August, their maturity deserted them and argumentation set in. Roger and David communicated mostly via James Guthrie, and could have decided it between them, but in practice they couldn't, despite endless phone calls and test discs. David preferred a non-chronological order, Roger didn't. Roger wanted such and such, David didn't. David was keen on 'Fat Old Sun' and Roger wasn't. Would it be 'Great Gig' or 'Us and Them' from *Dark Side*? And so on and so forth. The release date was fast approaching but the disagreements continued. James Guthrie, as the man in the middle, was accused of misrepresenting peoples' opinions and, like any man in the middle, was blamed for anything and everything, and accused even of 'betrayal', and was therefore beheaded (only kidding). Come September furious faxes were addressed to all and sundry, and Rick and Nick brought some sense and proportion to the whole issue by casting their votes, as it were, counter to both David and Roger. No extra *Final Cut* tracks,

ECHOES *The Best of Pink Floyd*

a non-chronological order, no 'Fat Old Sun', in fact nothing from AHM, both 'Great Gig' and 'Us and Them' from *Dark Side* and so on. Agreement of tracks was thus reached, but, lo and behold, not the running order. James sent all of them different running orders on disc but they could not agree. The record company was going spare, as their Christmas release date was fast becoming untenable – without a running order we couldn't complete any artwork, or finalise any text, not to mention mastering the record itself. In their final frustration, or wisdom, EMI set Floyd a deadline – agree a running order or forget the release, perhaps for a year, if not indefinitely. Strong stuff! 10am on Friday October 12th was the hour. James Guthrie rang at 9.59 precisely and spoke to a leading EMI executive pretending not to have a running order, but he did really. What a cad! We spent the weekend re-organising all the artwork into correct page order, amending the credits and checking all the text, and worked late into the night. Or was it the morning? Or the next night?

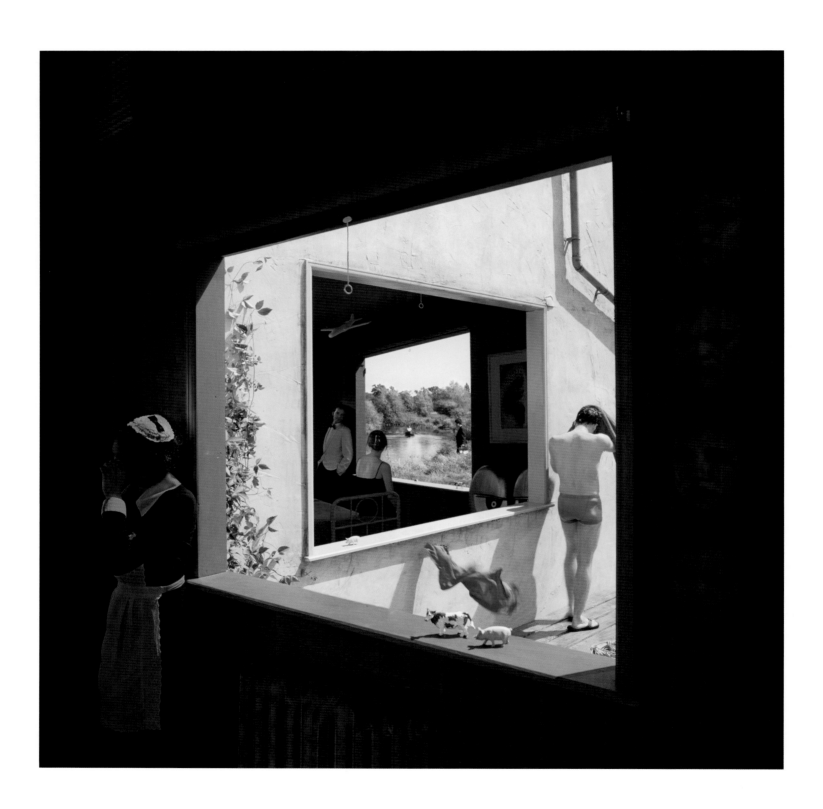

ECHOES

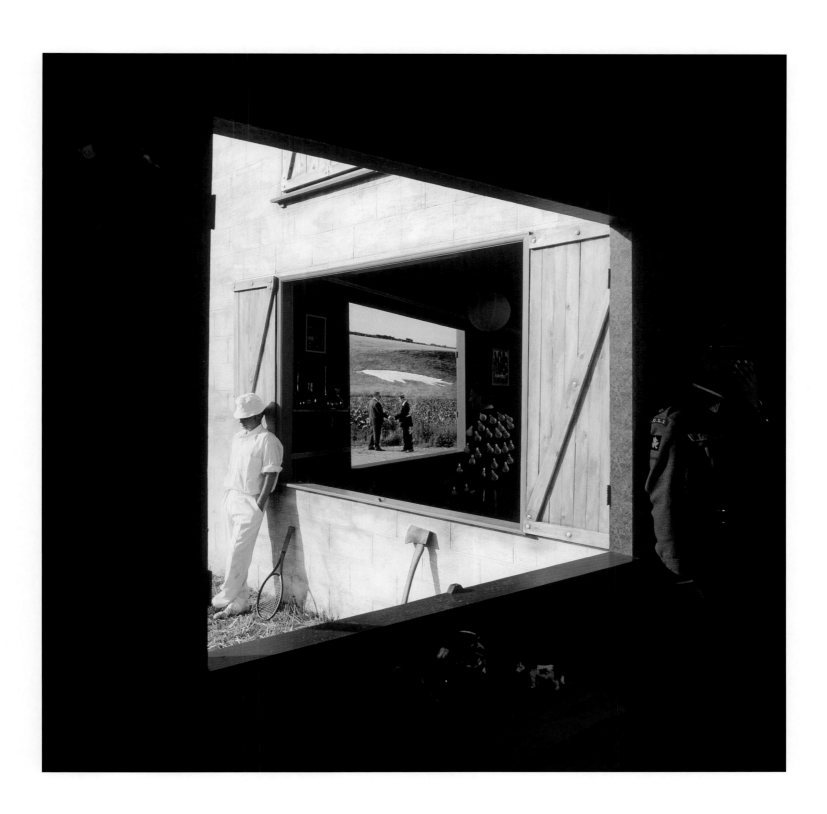

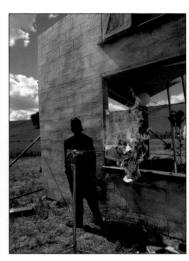

I admit, reading this story is not so very gripping. The events themselves were even less so. Remarkable that things should take so long, be so acrimonious, a relatively simple task becoming more complex than tax returns, given the writing was on the wall more than six months earlier. EMI had been told that the big problem was going to be track selection. Not exactly a revelation, but still a crucial observation. Even more of a problem when none of the band were on genuine speaking terms, and still more of a problem when assessing whose songs were 'best', a contentious subject at the best of times. Cup your ear and you can readily imagine voices in disagreement, "mine is best", "no, *mine* is!" Inherent danger, I suppose, in having the authors themselves decide what tracks constitute the 'Best of', but I still think that this was a better way than having a third party decide, because it makes the selection more authentic for the public, who had been spared all the childish infighting. No knowledgeable third party, no record company consensus, no cold statistics could do the same job; had to be the Floyd themselves, however lugubrious the task.

Not only was James on hand to help finalise the tracks but also to join them if possible; if segues were not feasible then to choose an order that worked musically. All with Floyd guidance, of course. He also had to edit some tracks,

like 'Echoes', which could not get on the album if kept in original long form. Purists might object, but it seems to me that if an artist revisits his own work then makes alterations, that's OK. If I like Picasso in the first instance then why would I not like his reworking? It's like having two Picassos rather than one. Twice the value, twice the fun. If Floyd themselves were happy to have tracks edited, I was happy to hear them. So there.

The cover was far less arduous, though not without its problems; the central one of which was – is this a new or an old project? A new twist on an old tale, a fresh project or just a sophisticated rehash? EMI said they wanted something of 'genius', something 'just brilliant', as if obtainable off a peg. 'Very Floydian' they intoned. Well, at least they were being flattering, unlike the Floyd who were disinterested. Working in the dark is hard enough, working without motivation is even darker. But a man's gotta eat.

Firstly we did stuff with old imagery in mind, i.e. references to the album titles, or to previous designs, a visual counterpart to the tracks on the album. New variations on an old theme, illustrated lettering, lyrics painted on bodies (as in 'Body of Work'), enlarged album covers hanging on a washing line like big sheets stretching into the distance, a window through

Previous page front cover Echoes 2001

ECHOES
THE BEST OF PINK FLOYD

Vinyl box front Echoes 2001

a window set peppered with Floyd objects, a reworking of an old idea (page 163) and then a really ambitious landscape series which was both old and new — a series of landmarks stretching across the countryside, one always in view of another, forming a line of protection like old Martello Towers or coastal forts. A set of landmarks in the great Floyd landscape, as the songs were a set of soundmarks in the great Floyd soundscape. We selected what we thought were the nine most likely songs to be included (even though they hadn't been yet), and interpreted/represented them as buildings, sculptures, land art or totems etc. Some of these ideas were obscure, some simple, some surreal, varying as you can see on page 179 from lighthouses to heaps of earth, from glass sculptures to massive incisions in the rock. We chose nine songs for nine sculptures — as in nine letters of Pink Floyd — in order to limit the cost (and number of roughs), the whole idea being already costly enough to frighten off a small country, let alone twenty-six sculptures for the actual number of songs on the final double album. Now, *that* would be expensive.

Secondly we designed some new things, ideas that attempted to represent the whole Pink Floyd oeuvre, something fresh, not seen before, relating to their history not in terms of recognisable icons but in terms of a general overview, summing up the Floyd in the same way as a 'Best of' collection might sum up their output, clearly incomplete, but saying something at least, a sort of audio or visual precis, (see page 178). I was, nay, I am, particularly fond of two of this lot, namely the bust of suitcases, a huge head fashioned literally from stacked suitcases, old and battered cases, the Floyd being well travelled folk. And the tilted ring — a giant sculpture of glass or perspex, tinted in iridescent colours, enormous but elegant, about to fall, balanced precariously on its edge. Spacey, ethereal but clearly grounded. Beautiful and geometric, but not without a little humour — a giant frisbee or the rings of Saturn, but no Saturn: heartfelt but no heart. The great head of suitcases on the other hand had a strong retro feeling, or so I thought, looking theatrical and dreamlike, yet heavy and real because it would be made out of actual suitcases: busy in parts, but simple in its wholeness — parts of the sum or the sum of its parts? A head of cases, a headcase, more likely a hard case. Or a nut case, on the loose, just arrived at a Delvaux like station, not urban but in the forlorn and dusty landscape of Spain or Arizona.

David was not, I think, terribly impressed by any of these roughs, or still not greatly motivated by the project — not unfriendly, just not very enthusiastic. Either way he decided by a reverse process of elimination on the 'windows through windows' idea constructed as a real 'building', see page 180. It was after all an idea he'd liked before. Nick was OK with this and Roger made no comment, fearing I suspect that he

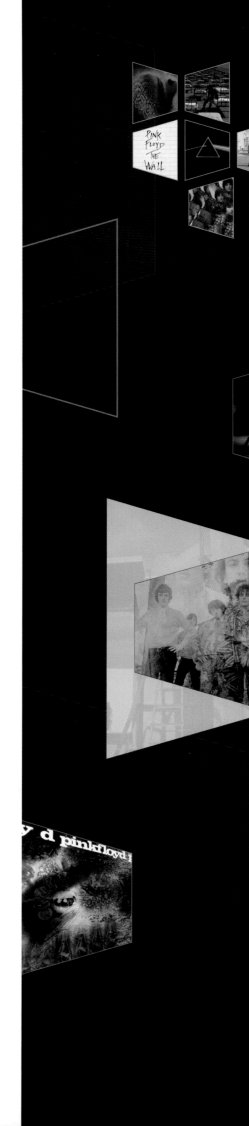

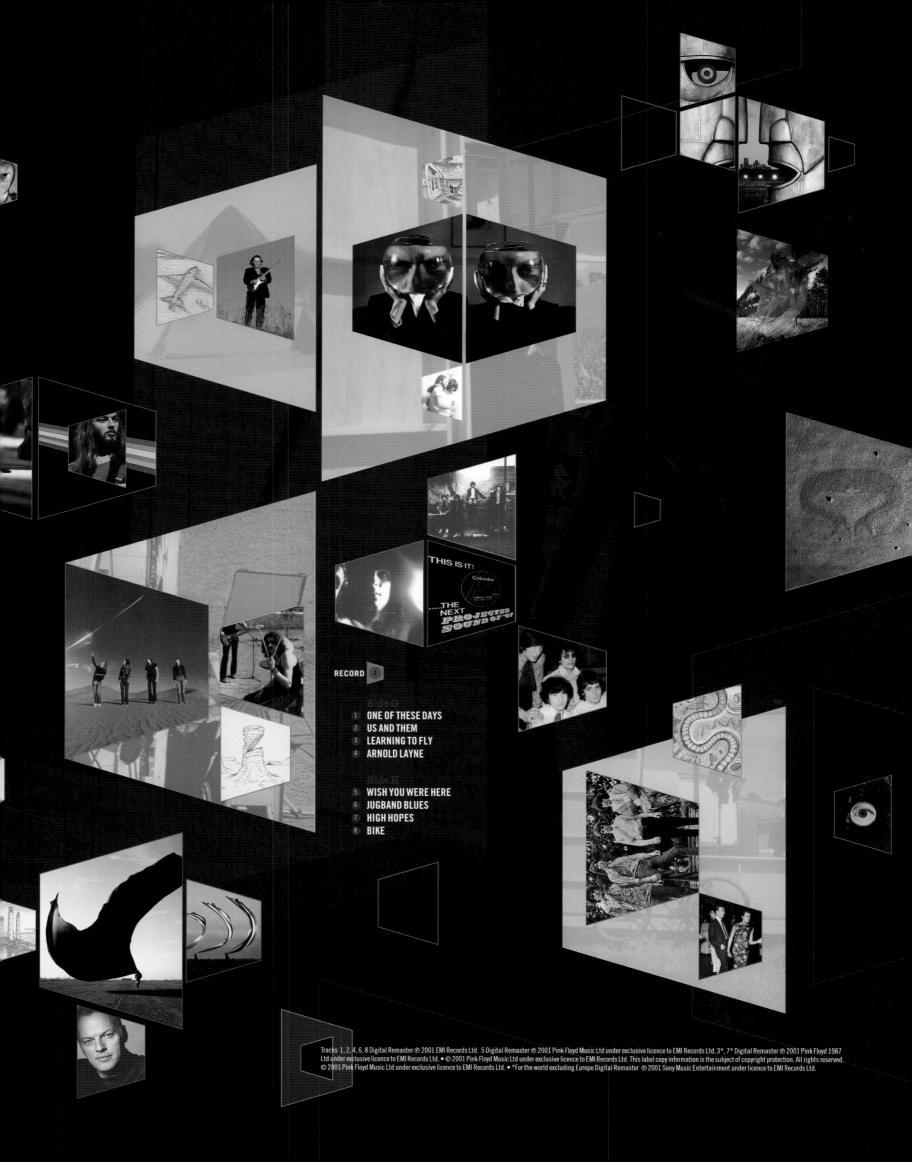

RECORD 4

Side G
1 ONE OF THESE DAYS
2 US AND THEM
3 LEARNING TO FLY
4 ARNOLD LAYNE

Side H
5 WISH YOU WERE HERE
6 JUGBAND BLUES
7 HIGH HOPES
8 BIKE

would be 'outvoted' whatever his opinion. (Later reports suggested that he quite liked it, oh wondrous thing!). Rick was on his boat.

Inside or outside was the first practical dilemma. Since the idea was about looking out of a room across an alley into another room and out again into the distance, it was composed essentially of opposite lighting, interior and exterior – so, should I shoot in a studio for the interiors and blast light into the exterior parts? Or film outside, by natural light, shielding the interiors from daylight and even adding a bit of tungsten light? I did not want to do both, or strip parts together, fearing it would look false. I opted for the latter as the lesser of two evils but had reason to regret this decision, though not at first.

We had the set built in three sections for the three windows by the indomitable Hothouse, model makers extraordinaire, having photographed test shots with pieces of polystyrene lashed together. We built two complete sets for the two discs and in order to have enough room for the many references to Floyd's visual past. They were of different colour and texture, walls of brick and stucco, interiors painted or wall papered, shutters and blinds for the window (no glass or frames that would impede the graphic eye), differing shelves and props. Though the shapes were the same and the graphics/geometry remained very similar it was in effect two designs, two designs in one – same essence, different trimmings. Constructing the set in three parts (or walls) allowed us to easily alter the angle and size of windows and align them correctly to camera (through which one experienced large dramatic changes with the slightest shift of either camera or set).

The first set was then erected on Grantchester meadows, *the* Grantchester Meadows, looking out down the river Cam near Cambridge – literal echoes of Floyd youth – and the weather was stupendous. A cloudless summer's day. Perfect. The set looked fab and very much like the original conception but so much better for being life-size, solid and real, parked incongruously by the river. One soon became very aware of moving shadows, of how window edges were lit (or not) and how much light entered the rooms. And also the colour, how the wall outside became warmer, pinker, as the afternoon wore on, and the sun got lower. The whole experience confirmed the decision to shoot outside, on location, as if it were a real three-dimensional building, which of course it was, despite us taking it there.

Don't count your chickens. Whatever we thought from the first shoot was blown away on the second shoot. We had chosen a small green field valley between rolling hills, very English and very adaptable. I had learnt from the first shoot that we should turn the set around 90° at 1 or 2 o'clock so as to make better use of the sun. But the weather was unpredictable. So we waited. And waited. Everyone was on standby, impatient for a break in the weather. Pressure of delivery obliged us to take the first opportunity, so I made a call based on a previous evening's weather forecast. Not so clever. Next day we headed out of London very early in the morning and as we hit the motorway south there was an almighty cloudburst. Torrential rain. Buckets of it. Apart from the danger of driving in atrocious conditions, we were too far gone to turn back. When we arrived on location it was knee deep in puddles, muddy as hell, grey and overcast. We stood forlornly in the middle of our little valley, knowing the game was up, but reluctant to surrender. (Turned out later to have been the heaviest hour's rainfall for 30 years.) The intrepid articulated lorry arrived anyway and backed into the field along the muddy dirt track. The driver jumped out and said cheekily, "OK, what now?" Come rain or shine, he'd be there.

We decided to unload the three sets, wrap them in plastic and leave them overnight...they were, after all, too heavy to steal. The next day was better, so we all returned, put up the set and photographed as before, easier now we had routine. The pig looked great, made of white sheets cut out to an enlarged stencil, and laid across the ground, held down by stones, looking from a distance like a giant chalk figure, reminiscent of the White Horse of Wiltshire or the Long Man of Wilmington. We even had the luxury of leaving the set for another night so that we could return and photograph the cricketer (see page 181), the next day.

A cricketer? Neither cosmic nor fashionable, one might think, but nonetheless a reference to the halcyon days of a sporty past, when Floyd boasted a football and a cricket team, and as featured on the Nice Pair cover (see page 63). And there is a model cow (from *AHM*), the swimmer (from *WYWH*) and the maid from *Momentary Lapse*. And if one looks closely there are at least twenty references in each picture, some fairly obvious, others well hidden, like clues to a puzzle, whose answer is probably forty-two. A teasing collection of visual icons, Floyd icons, the best of Floyd's visual past, mirroring the

Above liner bag, opposite 6 sheet poster Echoes 2001

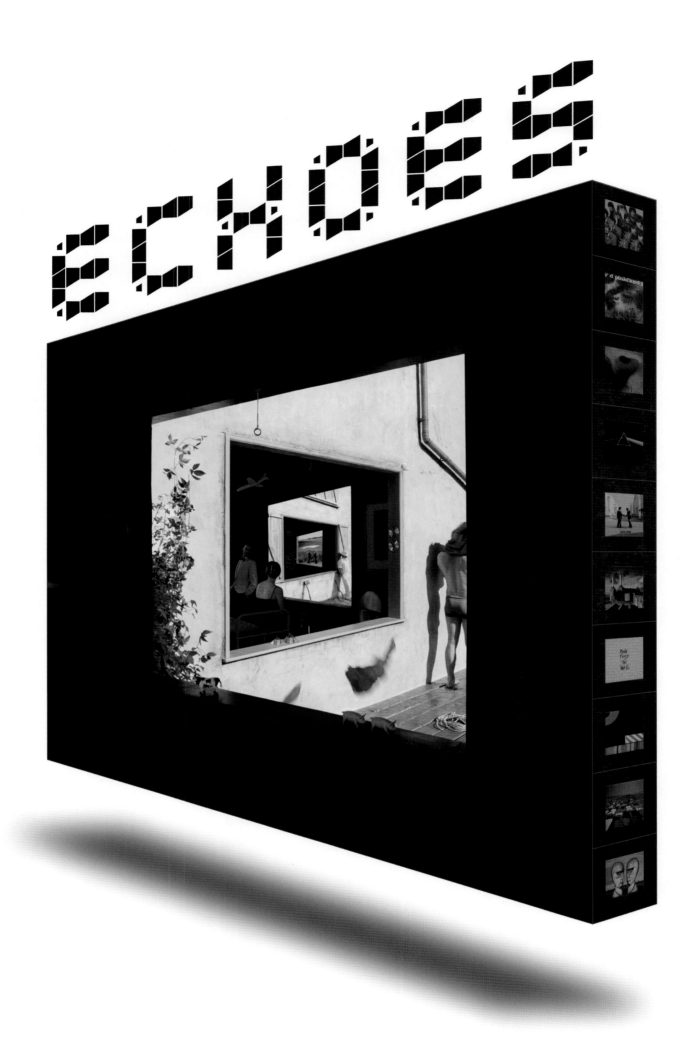

best of Floyd's aural past on the album, the whole collection 'housed' naturally within rooms of a building and also in the spaces between. The entire structure echoes through its 'windows in windows' perspective an early cover for *Ummagumma* in 1969 (see page 29), which had no representative of course on the finished album. What do you expect?

An energetic campaign by the record company enabled us to explore some interesting variations. There was firstly the vinyl box, page 183, housing four separate vinyl LPs each needing covers, liner bags and labels. The front of the box makes dynamic use of the trapezoid shapes and deftly deploys computer super imposition, care of handsome Peter van Curzon (as an aside I sometimes think that text box positioning and Photoshop layering nearly justify the all-pervading computer on their own, but then I remember motion blur and feel my distrust returning, and then I'm all right). The six sheet poster on page 187 was derived from a previous print ad that cheated the number of receding rooms to make them seem further away, to lengthen and deepen what you are looking into and then contrarily making the whole thing a block or slab with a finite thickness to lessen, in effect, the depth. Very perverse. Not to mention the inclusion of appropriate old album covers down the side, adding further three-dimensional thickness, making it in turn even more slab-like. And then in addition to all this 'finite thickness but infinite depth business' the slab also hovers just above the ground, floating ominously, like PF music.

We also enjoyed designing two other sets of posters, purposefully not featuring the *Echoes* cover or its graphic properties. One set featured old album covers, each with a bold and telling caption. I particularly like 'Everyone has a Dark Side' for its double meaning, referring both to psychic baggage and also to the retail business and the large numbers of the albums shifted over the years. Must be 40 million by now. Step aside Michael. Secondly, I thought the eye tester was a neat idea (see page 189), courtesy of dashing Dan Abbot. The incomplete words mean nonsense unless you look more closely,

which, in a way, you might feel obliged to because of the Stroop effect and because you are curious, if not down right nosy, and looking more closely is precisely what we want you to do. This poster was also an internal ageist joke about the Floyd themselves and 'moi', all old enough now to need glasses.

Echoes was a great pleasure to do but long and heavy going. One of the feelings left at the end of the day was that the design was appropriate, not wholly original, but a new and interesting arrangement of old stuff, eminently suitable for the album. Graphic yet reality based, neatly inside out, conceptually pleasing in its regressing infinity, windows beyond windows, worlds within worlds (wheels within wheels perhaps). Another feeling was that the design was safe. Its very appropriateness was lessening, unlike *DSOM* where the iconic nature, the utter simplicity, saved it from banality. In *Echoes* I detected, personally speaking of course, a conservatism. Though the idea was consciously about 'revisiting', about having been there before, it was not as elegant as the rings of Saturn, nor as dramatic as the head of cases and not as ambitious as the series of landmarks stretching across the countryside. I would rather be new, or even 'newish', than 'oldish', notwithstanding that the work might look like previous work (most artists' output is recognisable), so long as it is not too much the same. Don't get me wrong, I like the *Echoes* design, I just think that we should have done something new. Even if just to avoid creeping conservatism, which was creeping hand in hand with age. But there is a hint of conservatism here, and it can set in unnoticed. Let's hope it doesn't do so in their future projects. Once experimental, Pink Floyd were darlings of the underground, the scourge of newspapers; they wrote subversive lyrics, attempted grand opuses, they endured madness and breakdown, and even the taint of drugs; former princes of the avant garde, now fading away beneath a veneer of conservatism – I hope not.

I hope not.

I hope not.

 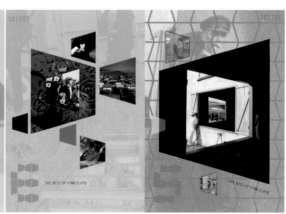

PIN
K F L O
Y D E C H
O E S T H
E B E S T
O F 2 6 T
R A C K S 2
C D 4 L P 2
M C O 5 1 1 0 1

BACK TO THE PAST, LITERALLY.

Back to the past, in the dearth of a present.

Back to the Roman past, never mind Pinkus Floydium.

Since the VHS is one of the worst inventions spawned on this earth it is not inappropriate to replace it with a DVD, altogether a more attractive item (they even work well). But the *Live at Pompeii* film/TV programme/VHS/DVD has had more outings than a gay priest. But there again maybe that's OK, for there is a strange charm to the film. Roger called it a very expensive and laborious home movie. Nick cannot recall why they did it in the first place nor why it has numerous incarnations, never sure if it's even finished, as other bits get tacked on, or intercut with existing footage. More 'rare' interviews are uncovered, or is it more of the same 'interview'? Further illustrations, culled from libraries as much as from the director's fridge, or cutting room floor, have been added at various times. And yet its elusive charm survives all. A rare mixture of naïve filming, inelegant cutting, lifeless location, disparate content and an unnerving sense of not knowing where it's going singly fail to sabotage this enterprise. The

the proportions (from 4:3 to 16:9). This is greatly facilitated by the superb video equipment that is currently available, which effects the enlargement required with hardly any discernable loss of quality. What you lose is some of the top to bottom of frame since the 16:9 proportions are relatively narrow. You can choose how best to reframe easily, i.e. whether you take it either up or down or both. This is called 'racking' and is not a serious problem, but it can be awkward if the film in question features big close ups of faces, and also a huge number of shots where every shot may need individual adjustment. Guess which film had both.

The project had fallen into Roger's court, not technically nor legally, but by default and lack of band interest. The first hurdle was working for Roger without him knowing directly. Well, he knew, but dealt with it at a distance, through his manager, the urbane and extremely wealthy Mark Fenwick. For the second time, in fact, in two years, we redesigned the package. I was well happy with a couple of roughs (see opposite) particularly the floating black slab over the rectangular trench — has the slab emerged from its hole in the

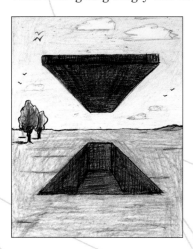
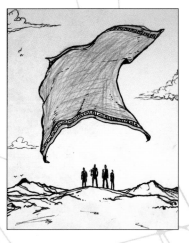

original film survives these criticisms, survives perhaps because of them. One hates, but sort of loves it for the same reasons. It's clearly a mystery, which is why it endures I guess.

The director, Adrian Maben, has now completed the director's cut, or so I am told at the time of writing. The DVD shown here is for the said director's cut and features the cover for the package and various widescreen menu designs on the disc itself.

One of the issues with DVDs is whether or not to have widescreen or 16:9 as it's technically known. The old or normal screen proportions, the aspect ratio, is 4 wide by 3 high or 4:3 as it is more commonly described. There's a surprise. 16:9 is a more trendy, more modern and is actually more satisfying in many ways, especially for land- and cityscapes, and also for rock and roll line ups on the stage or even on the dry and dusty earth of the amphitheatre at Pompeii. But back in the good old days when Adrian made the original film there was no widescreen, well, no easy practical widescreen camera and no call for it in the market place. Now that there is, it seems preferable to alter

ground (its hideaway or its grave) or is it about to fill it? Out and about on mischief or returning for a rest? Something vague and incongruous, heavy yet floating, seemed ideal for the music. It was also derived from the graphic representation of two volcano shapes, one inverted, and this becomes clearer if you squint or half shut your eyes. I was also fond of the floating Victorian Zeppelin hovering above the volcano, as if peering into hidden depths, the explorers, (the band), on some fearless and intrepid journey, much like the journey of the making of the film itself. Not to mention the flying 'toga of despair', deep red, fringed with a Roman border, about to engulf the diminutive figures of Pink Floyd, who are dressed in black, etched against the grey and moody sky in barren volcanic landscape. Roger was not impressed and returned to the graphic design submitted two years previously now updated, recoloured, extended, improved etc etc, care of the inflappable Peter Curzon who neatly interwove Pompeii references (amphitheatre and volcano) with iconic references to the Floyd albums represented, all encircling a silhouette of Roger

PINK FLOYD
Live at POMPEII
The Director's Cut

DVD package
LIVE AT POMPEII 2003

LIVE AT POMPEII

doing his Rank Films impersonation and beating the gong with dramatic flourish. And a lot of wellie (see previous page).

Since *Live at Pompeii* seemed just such a peculiar idea – performing to no audience, dark music in a sunny place, very live music in a very dead place – it felt relevant, nay imperative, to interview the director to understand what the hell was going on, which then became part of the contents or additional material so characteristic of a DVD. Other items to be included were old promotional material, radio adverts, previous covers, bootlegs, album graphics, Pompeii stuff and the first original version of *Live at Pompeii* circa 1971. to be included were old promotional material, radio adverts, previous covers, bootlegs, album graphics, Pompeii stuff and the first original version of *Live at Pompeii* circa 1971. Roger was not keen on any current band participation… no new interview… history should stay historical and needed no modern intrusion or Floyd overview… so what was this Director's Cut all about then? Mustn't carp, at the least some additional material would be of interest to the customer and give our good selves some menus to design.

And menus are like food to us designers.

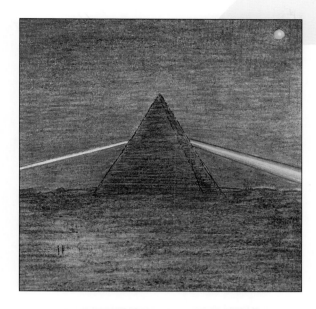

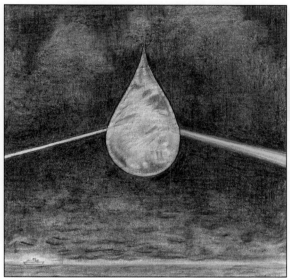

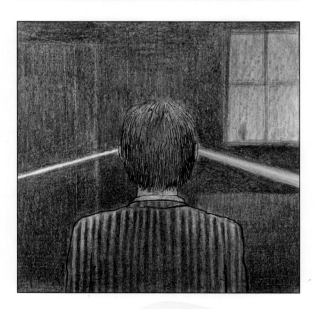

BELIEVE YOU ME, I am not a superstitious man, touch wood, nor indeed a marketing man, but the 'coincidences' and cosmic connections in history of *The Dark Side Of The Moon* are amazing. Get a load of this:

This year 2003 was the 30th anniversary of the release of *The Dark Side Of The Moon.* The date of the initial release in 1973 was in March, the third month. It so happens that EMI's usual release date is the first Monday of the month. In 2003 in March that will be the third. In effect the anniversary will fall on the third day of the third month of the third year of the new century. Written digitally, as is the modern way, the 30th anniversary of *The Dark Side Of The Moon* is 03 03 03, which is 3 x 30 backwards. Bingo! Planetary alignment or what! Open the portal to the other worlds!

There's more...the cover design for *The Dark Side Of The Moon* is...wait for it...a prism, a triangular three-sided and three-angled figure, not four-sided or no -sided or many-sided, but a three-sided shape. And Pink Floyd has nine letters, not ten or eight, but nine, which is three x three. And the title *DSOM* has two x three, ie six words, which in turn has three 'O's and three 'E's. And an E written backwards or in reverse could be a '3', and with the O makes 30, and x three backwards is 03 03 03.

Knock me down with a feather. The most inventive marketing person could never match this neat and attractive set of connections, and its all natural folks. On top of this we have a truly great record here, an item clearly worth commemorating even without any cosmic nonsense.

However the Floyd themselves were once more indifferent. "Its history" they say dismissively. Please no more *Dark Side* releases for it insults the public and milks the fans — as if punters have no will and discretion of their own to ignore what they don't want, roundly reject what is superfluous and simply not purchase what they might already have. And what was *Shine On?* Or *Dance Collection?* Perhaps the good folks 'out there' haven't in fact all got *DSOM*, especially the younger ones, who might enjoy exposure to what is arguably one of the world's three greatest albums. Anyway, we are trying to mark the anniversary even if they and the record company are not, so there.

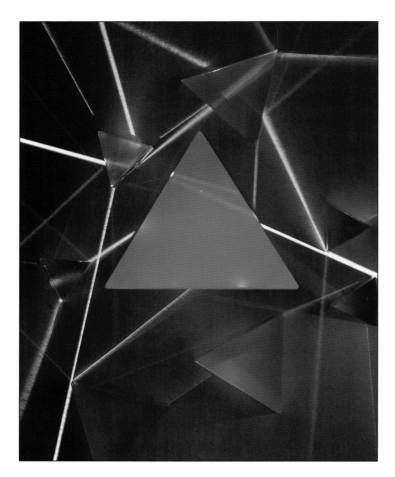

Firstly there is this book, the updated edition, which is edition number three. Really it is. No connivance here, only coincidence. And on the previous page are three album cover variations for possible DVD, remastered CD and SACD, though none of these may actually appear (such is le Monde du Floyd). These roughs reflect the initial design by maintaining the white light to spectrum motif but altering the object, previously the prism, placed in between and playfully using, I thought, a man's head, a teardrop (makes a rainbow naturally) and a pyramid, appropriately enough.

On page 201, is the 30th anniversary poster of triangles, being 30 triangles in all, one for each year. The design was experienced at inception like a flash, like a vision, lurking in the subconscious, leaping easily into the forebrain, clear and fully formed, radiant in the sunshine (I thought of it on a beach). Lots of work in the doing, of course, but you can't have everything – inherently suitable, albeit inherently arduous, with so many different pics to photograph or illustrate. The Floyd prism, you see, is reflected in many forms, in all sizes, in all dimensions and at all times. The essence of Floyd, as effortlessly represented by said triangular shape, can be found everywhere. If one but looks one can detect it across the universe. Just another extraordinary cosmic coincidence? Or part of a plan? A larger plan no doubt.

And last but not least, on this page are three fine-art prints that we published in 2003, one of which is 20th anniversary photographic version (see page 53), another is a pyramid design using the first published pyramid picture made for the original press playback at the London Planetarium in 1973 and the third, overleaf, is a collage of 9 'Dark Side' images laid out after the manner of the original stickers. The three fine-art prints are limited in number and can only be acquired as a threesome, of course, not as a twosome nor a foursome. They are housed in a special custom 0303 box which is black all over. And this is because black is cool, black is beautiful but, above all, because black is fitting.

Black is also the end, which is where we are now, textually speaking being at the finish of MoM third edition.

But hang on a mo', black is also deceptive, regularly described as a color by many people when it is, in fact, an absence of color or of light rather than an actual color in itself. So this is not the end of text after all; it carries on as MoM fourth edition.

THE
DARK SIDE
OF THE MOON SACD

THE WONDERS OF TECHNOLOGY - or is that the perils of technology? - inexorably involve improvement. The experts tell us that it's all part of the march of progress, leading us to a better life. How true is this? Sometimes my skeptical self imagines the worst... more sophisticated ways of conducting warfare, but let's stick to music. First there was mono, then stereo, then quad, and now 5.1 surround sound, wherein one is surrounded by six speakers, or is that five speakers and a woofer (sounds like a political hustings). I have to say that even to my untutored ears surround sound is pretty damn effective. In order to make a 5.1 disk or SACD (a proprietary acronym in fact), the music has to be remixed to take full advantage. Golden Ears Guthrie, the Floyd's sound man, was given the original tapes of *The Dark Side Of The Moon* and asked to remix for 5.1. It was then our job to do the same to the cover, i.e. the prism and its refracted spectrum, and to present it in a similar but different form and to make it as pristine and radiant as the new sound. It was the same music, but refreshed, enhanced and amplified by the wonders of the technology I mentioned earlier.

I don't really know how other artists feel about re-working old material, whether or not they find it a challenging or a just a tedious exercise? Alternately is it more a case of Northern philosophy? - If nowt broken, don't fix. Hmmm. I was reluctant at first, until I had an idea and realised that, selfishly, I didn't want someone else messing with my parts (would you?). This is the story:

A policeman from Virginia, America, paid a visit to my studio and gave me a present of a small stained glass rendition of my logo in return, it seemed, for letting him use one of our images for an anti-drug campaign for kids in Virginia. Stained glass was his hobby and it was such a thoughtful gift, and so it hung for some time on our patio window door. It must have dawned on me eventually that rendering the prism design as a stained glass window might work just fine...what better than using a medium, glass, dependent on light, to represent the most splendid characteristic of light, namely a prism refracting a beam of white light into a rainbow. Pure, radiant and succinct. All we needed to do was find a man who could

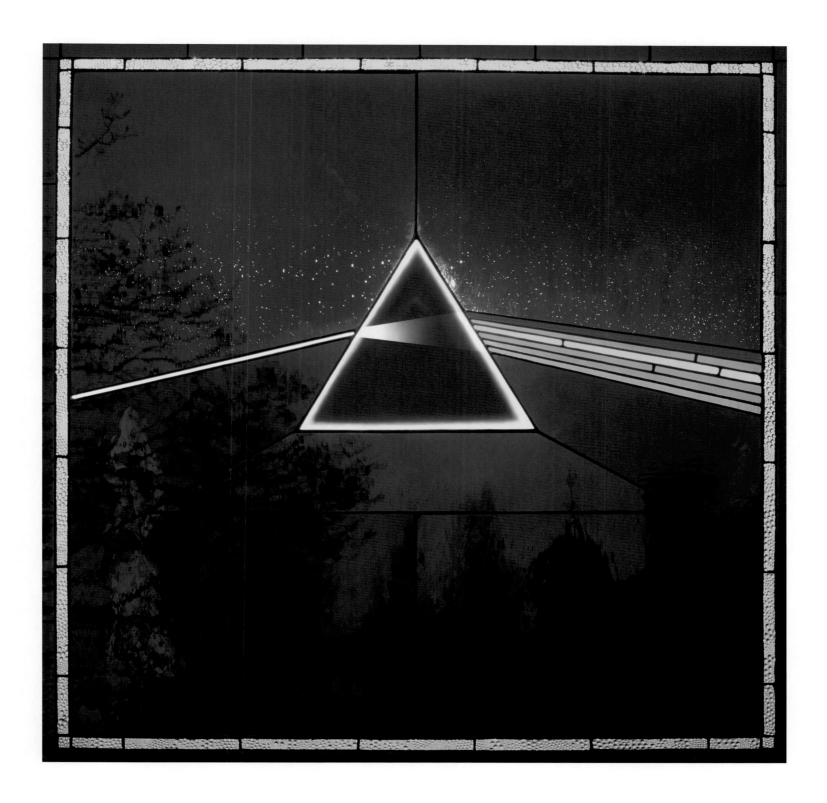

FRONT COVER THIRTIETH ANNIVERSARY SACD BOOKLET 2003

16. Roger circa 1973,
from songbook

17. Postcard picture from
20th Anniversary edition,
1993

18. Rayogram from 20th
Anniversary edition, 1993

19. Russian vinyl front cover

1. Daytime sticker
original cover, 1973

2. Poster supplied with
original album, 1973

1.	SPEAK TO ME (Mason)
2.	BREATHE (Waters, Gilmour, Wright)
3.	ON THE RUN (Gilmour, Waters)
4.	TIME (Mason, Waters, Wright, Gilmour)
5.	THE GREAT GIG IN THE SKY (Wright)
6.	MONEY (Waters)
7.	US AND THEM (Waters, Wright)
8.	ANY COLOUR YOU LIKE (Gilmour, Mason, Wright)
9.	BRAIN DAMAGE (Waters)
10.	ECLIPSE (Waters)

David Gilmour: Vocals, Guitars, VCS3
Nick Mason: Percussion, Tape Effects
Richard Wright: Keyboards, Vocals, VCS3
Roger Waters: Bass Guitar, Vocals, VCS3, Tape Effects

Produced by PINK FLOYD
Recorded at Abbey Road Studios, London
between June 1972 and January 1973
Engineer Alan Parsons
Assistant Peter James
Mixing supervised by Chris Thomas
Saxophone on 'Us And Them' and 'Money' by Dick Parry
Vocals on 'The Great Gig In The Sky' by Clare Torry
Backing vocals by Doris Troy, Leslie Duncan,
Liza Strike, Barry St John

build a stained glass window to the exact specifications of the original *The Dark Side Of The Moon* and this turned out to be Mark from Led And Light, just down the road from our studio. I think the band was wary of the whole procedure, both audio and visual, until they heard James' mix and gave it the thumbs up and told me to proceed. Mark built a window of approximately one metre square, the black background was replaced by a blue-purple background in order to let some light through (or you wouldn't see it), and we decided that it was in keeping with stained glass window tradition to add a holding border of white stiple glass, which we could crop out of the final design if we didn't like it.

We then photographed it in the studio with back-lighting and a shadow of a figure behind and a reflection or two in front, but David was very unconvinced, finding it a bit lacklustre and asked us to shoot it outside. So we shot it in various conditions and locations, including Nick Mason's back garden, against a wintry sun, and it worked much better, the sun lending an incandescent quality, highlighting the imperfections and making star bursts in the stipple border. It was truly a Beautiful Thang. In the flesh it was radiant, gorgeous colour, nearly transcendental, if not religious. It would look good in your private chapel. But it looks pretty good when reproduced as a photo, or a print or an album cover, or so I'd like to think.

In case this window didn't work from a technical point of view, due to the complex leading and the possible weakness or stress points which might occur, we constructed a more robust version which was used on the CD inlay and was made of rectangles, see opposite. In accordance with the occasional touches of satire that we like to add to our humble designs, we also photographed a version of the stained glass window which was intended to reflect the intricate politics and creative dynamics behind the making of the *The Dark Side Of The Moon* album.

Because the SACD was released thirty years after the original, it seemed natural to put thirty images in the CD booklet, each image connected to the prism design. I particularly like the painted van and café in Jamaica.

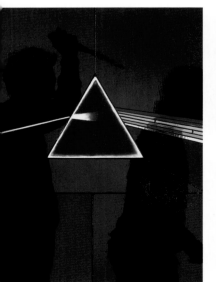

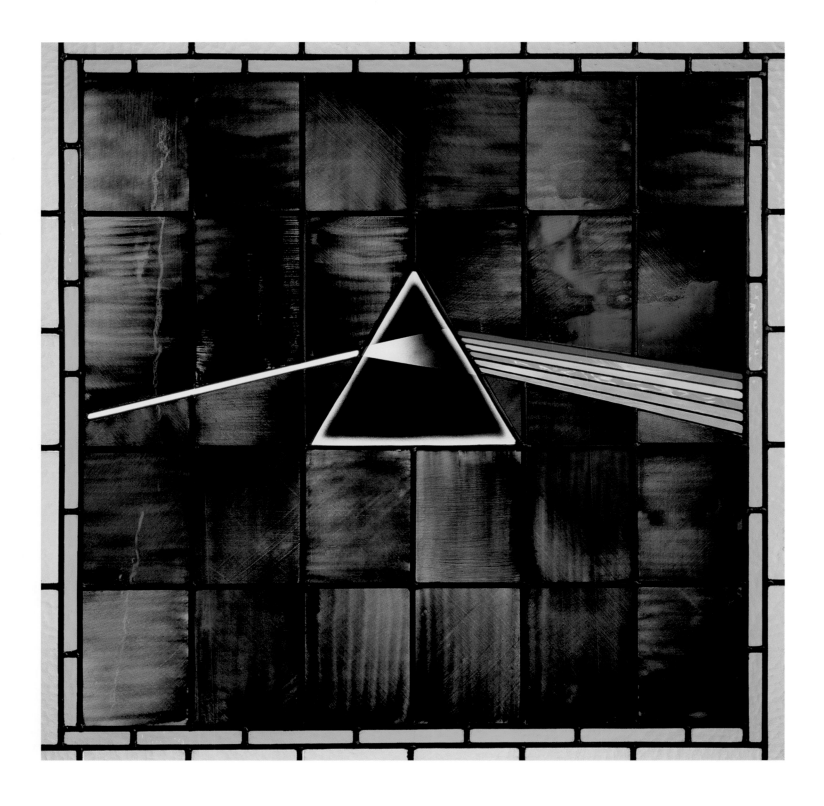

INLAY REVERSE THIRTIETH ANNIVERSARY SACD 2003

Opposite USA DSoM 30th Triangles poster

INTERSTELLAR

THERE IS A MUSEUM in Paris dedicated to music called Le Cite De La Musique. It is a place which celebrates the playing, teaching, and history of music of all kinds. They have a permanent exhibition and a space for temporary exhibitions, and every now and then they hold an exhibition of rock music. In 2002 they presented one on Jimi Hendrix, and the following year decided to mount a Pink Floyd exhibition. Somehow I got involved - kinda strange since I was not an exhibition designer, but not so strange as I have worked with the Floyd now and then.

Mon Dieu! It was a tortuous affair.

I believe the exhibition was very successful, but I'd suffered an accident on the day of opening and was out of commission for a few months and never saw the damn thing in action. One of the many dilemmas was how to cram the Floyd's long history and huge creative output into a small space. We tried to persuade the French that contrary to the Renault advert, size matters, and advocated painting the entire building in Floyd graphics, visible from the air and surrounding suburbs. They declined (because the architect refused to allow any temporary defacing). We also advocated the use of huge scrolls or massive window transfers to display many of the lyrics. They declined (because it is against French law to display non-French language in a public space). We also requested the presence of large sculptures,

and they agreed to a couple and also that they provide an exit door to the main exhibition room to allow through flow, which they did eventually, after prolonged negotiation. We also requested the display of actual album covers, framed artwork and the use of fine art prints, done by our good selves, which they refused, thinking it better to incorporate imagery in the wall paper. This last item struck me very forcibly as bad PR, since they were saddled with me and it was my stuff they were declining.

I don't wholly blame them, for they were caught betwixt their own desires, to run their own show in their own premises at their own cost (understandable), and the wishes of Pink Floyd which were Floyd related, and not of course, museum related, and the Floyd tend to do things their own way, as you know. And since the exhibition was about them, it seemed only reasonable, if not true, and yet I was the poor fucker caught in the middle. I later heard they had 72,000 visitors over three months, which seems a helluva lot for a museum, but what do I know? Out of commission, and probably out of mind.

There were, however, some redeeming features. One of them was the exhibition plan - a sort of reverse time tunnel, which snaked down the centre of the space, and through which you walked from the present day back to 1967 and the beginnings of the Floyd, passing dates and 'sound rings'

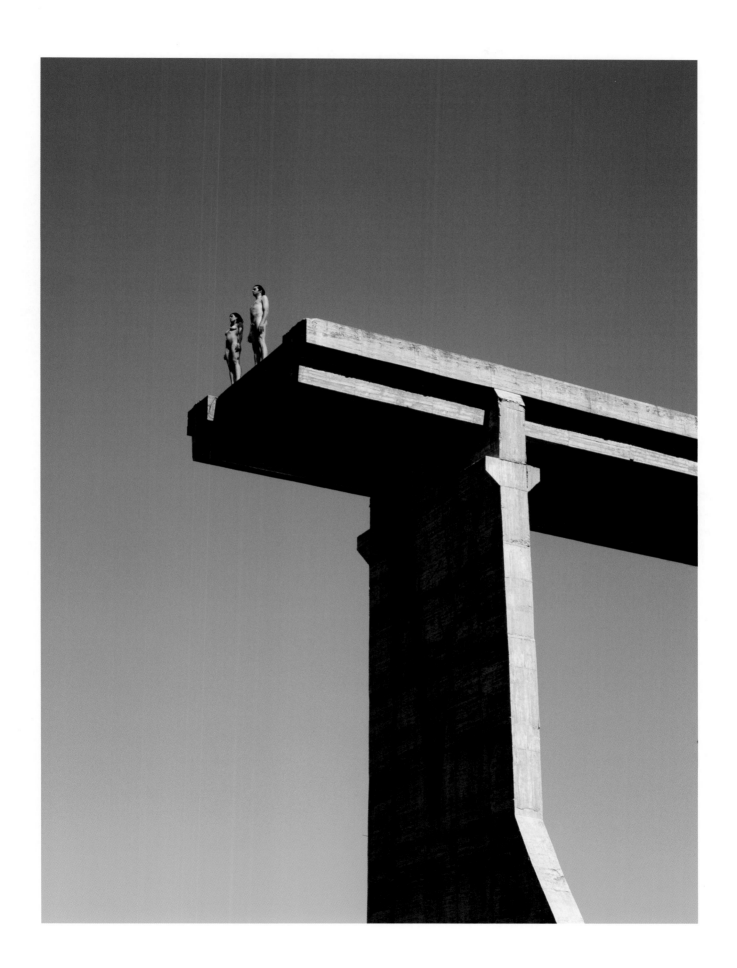

as you went, and you then walked back through several rooms bordering the tunnel, which returned you chronologically to the present day, each room devoted to an album, displaying photos and artifacts and showing films. The second redeeming feature for us was designing two posters, one of which was a couple at the end of the road, literally perched high up on an uncompleted motorway in Spain, since the Floyd were nearing the end of their long and illustrious road. The other consisted of two mirror balls, perched upon each other, sitting serenely on the banks of the river Cam in Cambridge, in Granchester Meadows to be precise. This design reflected Interstellar, the title of the exhibition, in turn, taken from 'Interstellar Overdrive'. The idea is derived from a mixture of the eyeballs from Pulse DVD (see page 213) and the sculptures of Anish Kapoor seen at the Tate Modern in London. We had Perspex hemispheres electroplated with mirror, which provided for perfect reflection - no distortions, or unwanted irregularities. One hemisphere viewed flat on will look like a ball, or a sphere as one cannot see the reverse side. These 'mirror balls' were taken to Granchester Meadows and were photographed on location and were truly magical in the bright sunlight, highly reflective, perfect mirrors, attracting kids from around, who deserted their picnics to peer into the shiny depths of the mirror - it was one of those unforgettable sunny days of summer.

One 'ball' is balanced upon another to provide a pleasing sculpture, but more particularly to reflect the adjacent mirror, which in turn reflects the mirror above, and so on, providing for an infinite set of reflections, an infinite set of layers (to the music), like the infinite number of miles between the stars, as in 'Interstellar'. Turn your head sideways and the two balls are reminiscent of the sign for infinity. I fancifully imagined that the secret of the Floyd was contained therein, and had intended to build a peephole exhibit through which people could quizically peep and spy two silver boules, since we were in France, perched atop each other, and labelled it Le Secret de Floyd. I thought it cosmic and silly at the same time, and therefore, wholly appropriate, but the French didn't agree.

Eh bien, on ne peut pas gagner tous.

CALENDARS

THE ONE GREAT THING about designing calendars is, of course, that they come round every year (gissa job, gissa job), the one bad thing is the plethora of dates, always the effing dates - how does one incorporate said dates, plus space to write notes, in a new and interesting way? We have recently produced three calendars for Pink Floyd: the first including album covers and using the big chair on the front (see pg 165), and the third was a veritable rampage of band shots, live mostly, executed as a grid-based collage, much more archival in nature and more dynamically arranged on the page, but in both instances the dates were laid out in a straightforward manner.

However the second calendar was much more interesting and was fashioned to mark the anniversary of *Wish You Were Here*, so all the images were from that period. The layout of dates was quite dramatic, executed in a spiral shape, heading concentrically towards the middle as the month progressed - so hats off to Josh and Peter for imbuing the affair with panache.

But voices were raised in criticism that such a radical arrangement was not user friendly and that a calendar ought, of course, to be designed as a functional entity, and we should not forget that dates need to be clearly indicated, naughty boys, with white spaces to make jottings, naughty boys. But putting function before form for us would require brain surgery because in some ways, as visual artists (ahem ahem), we always put first how something looks, so here's a picture of a date to prove the point.

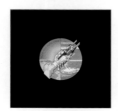

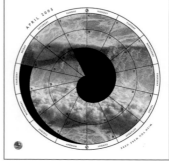

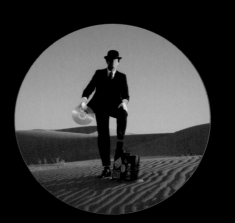

1967

THE
PINK
FLOYD

POP DANCE · With Fantastic Effects.
All Saints Hall, Powis Gardens W.11.
OCTOBER 14th & 21st. 8pm. 3s.-6s.

'February' 2007 Calendar

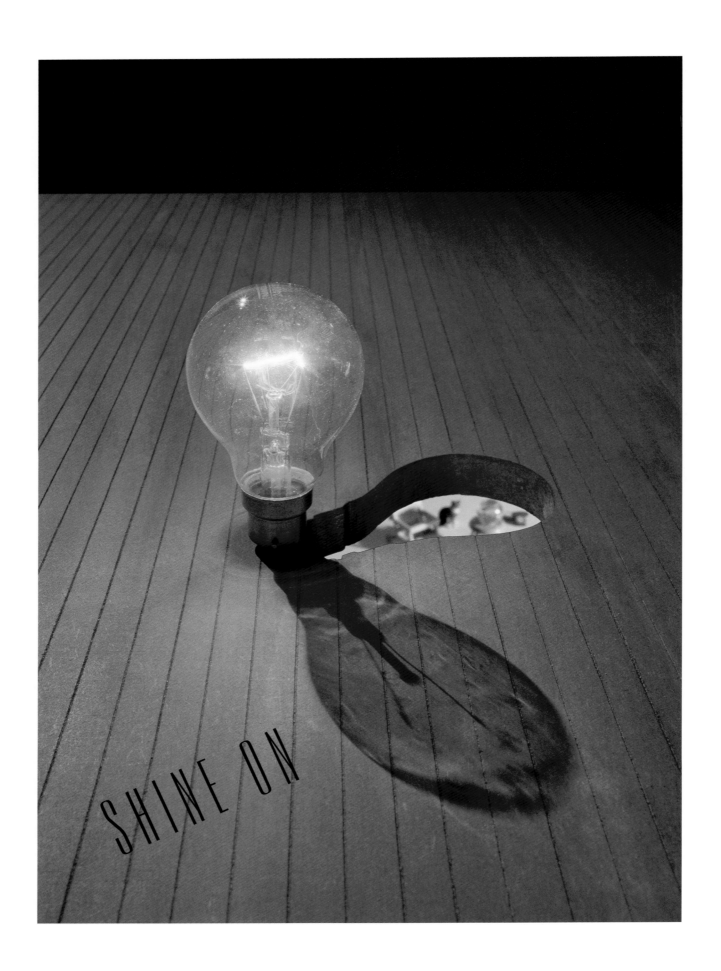

SHINE ON

ONE UNNERVING ASPECT of the rock'n'roll universe is its ability to be unashamedly daft. Craziness is part of the deal, whether it be operatic performance, ludicrous behaviour, wild spending, flamboyant dress, excessive stage effects or madcap stunts, or even mendacious PR. And here's an example. The Hall of Fame would seem to imply a hall or place - a physical entity, a building or space where items can be found, or objects located, a gallery or museum for example. In America, the Hall of Fame is just such a place, housing exhibits of all kinds to illustrate the history of rock' n' roll.

The UK Hall of Fame on the other hand, is nothing of the kind. It does not exist; it apparently is something that is going to exist. So there we were at a TV Show to applaud the inclusion of various rock 'n' roll luminaries into the so-called Hall of Fame, thought there wasn't one, but the presenters in front of our eyes behaved as if there was. The whole thing would have been quite surreal if it hadn't been rather sad. Pete Townshend thankfully pointed this all out in his semi-vitriolic speech, welcoming Pink Floyd into the Hall of Fame, which in a way was even weirder, 'cos why was he there saying, why are we here? Why bother admonishing a chimera as opposed to staying at home and having a cup of tea? Indeed why was I there? Or why is there a light bulb?

The light bulb in question (see opposite) was a central part of a congratulatory advert placed in the 'real' programme at the 'real' TV show at the 'unreal hall' to mark an unreal institution. The light bulb is part of an ongoing pre-occupation ('*Delicate Sound of Thunder*', Alan Parsons '*On Air*') and was a design idea we had in our cupboard which could be deployed at short notice and inexpensively. The other preoccupations inherent in this image are the issues of shadows and holes, or rather the issues of degrees of substance, how substantial is something? ie. what's real and what's unreal, how real is a shadow? how real is a hole? preoccupations, I expect, of many artists as well as ourselves, related to the Floyd also, and uncannily to the non-reality of the event itself. Either way the image joined its strap line (see pg 120) in happy coincidence, and that was real enough.

HALL OF FAME

"STILL FIRST IN SPACE," Floyd often liked to say, a veiled reference to technology I s'pose, but they were a tad slow to absorb DVDs into their system. The *Pulse DVD* was initiated, I think, as far back as 2002. I know Steve was alive, since we argued about the budget as we always had, though not so lengthily on this occasion. In fact he motored the project for the first year, but then it got 'delayed', and instead of being ready in 2003, it didn't appear until 2006. The reasons for this delay are not entirely clear, and I guess it was a mixture of practicality (passing tests), creativity (agreeing assets) and technology (building a complex product and getting it to run properly), not to mention psychology (was this the last Floyd release ever?) and other family priorities and, of course, the untimely loss of Steve. I'm sure he would have been proud of the final product when it appeared, because it's a very nifty little item, with lots of great stuff to explore, wonderful sound, good picture and clever navigation, all at a reasonable price and, of course, smartly packaged. My God, I sound like a man from the record company, I'm going mad. I knew it.

One of the really difficult issues with a DVD is how to optimise the streaming, how to get a lot of content which is very feasible, and to then have it accessible and for it to play with the best quality, both picture and sound. The band hoped for a single disc at first, but the concert was too long and had to be spread over two discs. Since the band were keen to maintain a connection to the concerts of 1995 and the CD thereof, namely *Pulse*, I felt I couldn't depart much from the previous imagery. What the DVD offered over the existing VHS was greatly improved sound and many more visuals, so it seemed appropriate that the design should

PULSE DVD

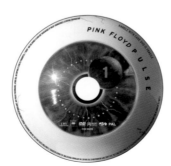

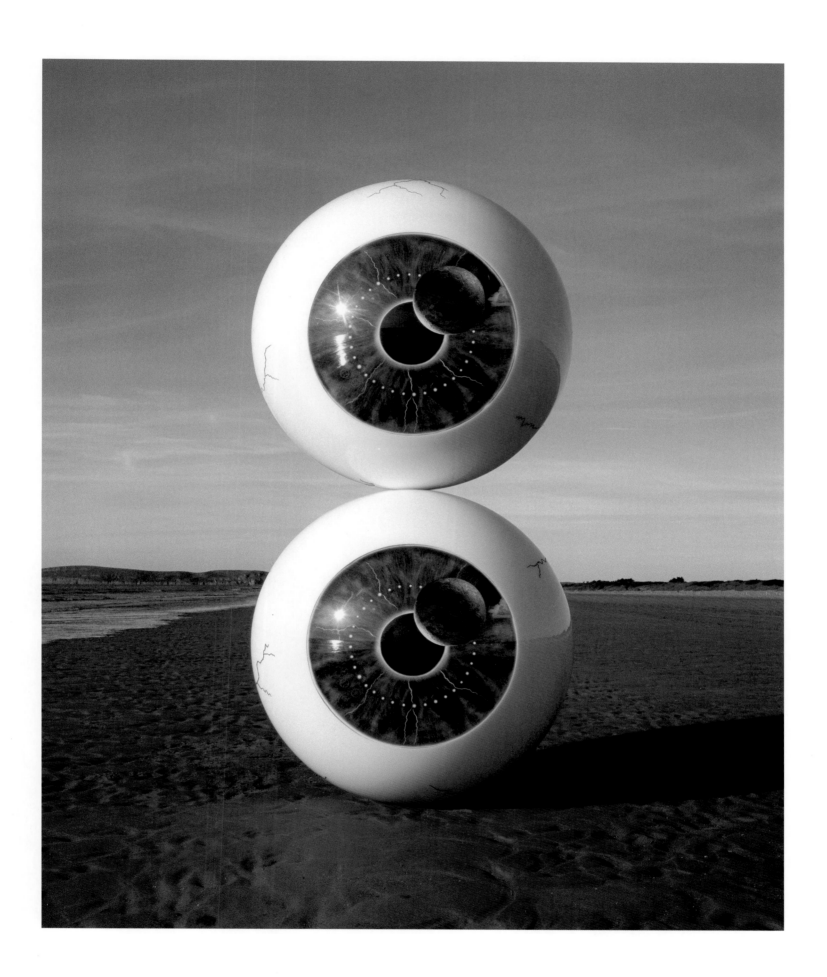

consist of two things and be eyes, after the original - thus two eyeballs, two large glass eyeballs, round like the discs and made as a sculpture to sit in some open landscape to echo the spaciousness of the music. Seemed fine to me, but my colleague James Guthrie, who was mixing and producing the DVD, was diffident and unconvinced by it, said, "If you really like it Storm, you'd better do it", so I did (I wonder if he likes it now?).

Hothouse made perspex hemispheres and we used prints of the original iris to be inserted and made a glass eye, each one measuring about four foot across. We made two, took them down to Burnham Beach on the west coast of Britain, and photographed them in natural light, balancing one on top of another, which always struck me as musical, though I don't know why. the image is a real thing in a real place, echoing the audio CD, proclaiming twoness (two discs within) and being elegantly balanced and atmospheric and so terribly appropriate, so I thought. Even the record company liked it, describing it as ideal packaging - or is that the kiss of death?

We redesigned the menus due to the continuing change of content and included a navigational map of the assets in the booklet, so one could see at a glance where everything was. On the front of the booklet we placed another picture of the two eyeballs, this time located in a wood near Slough, coincidentally called Burnham Beeches, do you believe that? But I don't know why a wood - maybe because we needed two covers (one for the booklet and one for the outer case) and two images seemed fitting because it was two discs, two eyeballs and two locations. Now I've said that two times.

But why a wood? Answers please on a postcard, if you would.

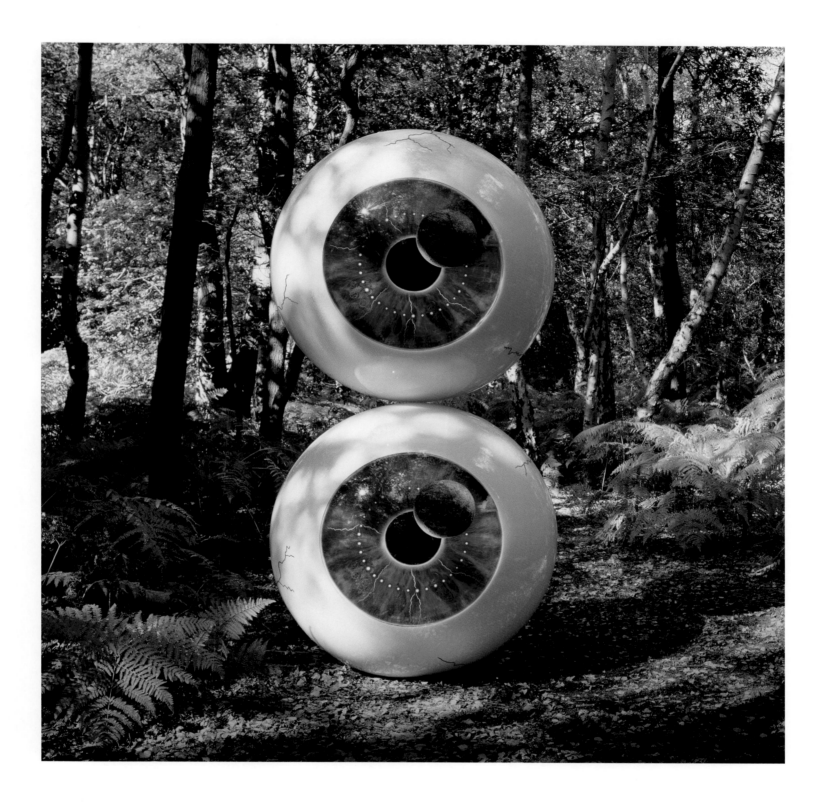

Insert Pulse DVD 2006

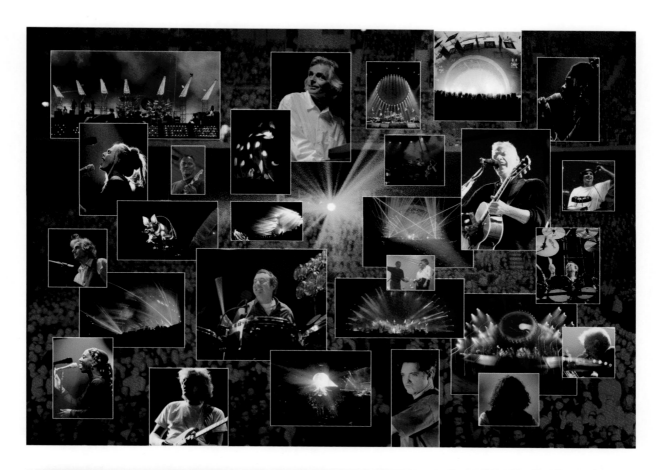

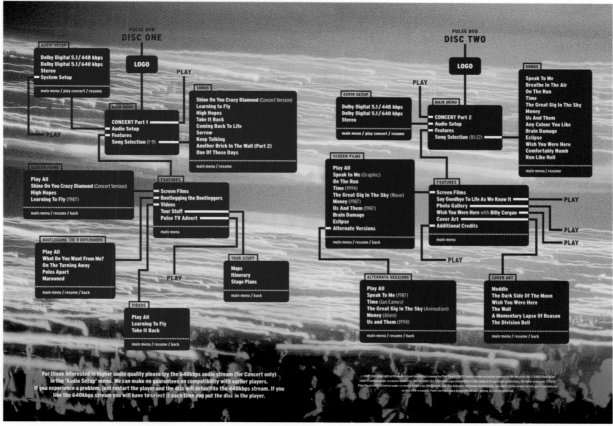

Navigational Map Pulse DVD 2006

WASHING LINE

EMI, Pink Floyd's long term record company - in fact their only record company in the UK - decided to mount a catalogue campaign, i.e. a campaign to promote the sale of all Pink Floyd's albums in the summer of 2006. Whatever one may think of the ethical or financial merits of such an exercise, it's quite difficult from a design point of view to visually represent the albums without showing the albums themselves - which would be obvious and repetitive. New and (hopefully) imaginitive imagery is often too expensive for the record company and too idiosyncratic for the band to all agree in the time.

I envisaged that the covers were like sheets or blankets hanging on a washing line seen stretching away into the distance, an unusually long line representing, as it were, Floyd's long history. In addition this 'washing line' recalled a lyric from Floyd's very first single 'Arnold Layne': 'Moonshine, washing line'. The idea seemed appropriate and a little different for it contained the covers, but presented them in an unexpected way, not just a picture of actual album covers. The idea, or so I thought, had distance and perspective and was an interesting kind of outside installation or 'exstallation'.

Things, however, are rarely so straightforward, especially in Floydland. Firstly the weather on this occasion was thankfully bright and sunny but very windy, which meant that the large prints/blankets hanging on the line were buffeted and torn apart and deposited in bits at various points across the field. Disaster. We were obliged to physically hold the reserve prints in position, and photograph each one individually, then paint out the offending supports. It was difficult and tedious considering the number of images/sheets hanging on the line. Having comped it all together - another painstaking process I might add - it transpired that the band were less than thrilled. David thought the line nowhere near long enough, Roger didn't like the order of the images, Nick thought it was average, conceptually speaking, and Rick said very little.

It's enough to make you weep.

But are we mice or men? These disappointments are seemingly part of the job caused either by circumstance like bad weather or technical limitations, or by critical clients like the Floyd. But then who wants uncritical clients? or even ideas that are not so clever? which I guess might be true in this instance, or even lack of funds, which is definitely true in this case. Thing is...we couldn't afford a re-shoot (EMI being the clients not Pink Floyd) wherein one would have printed the images on canvas (which would not have torn in the wind) and made the washing line a good deal longer with consequently more prints to hang and, of course, photographed it all in a more exotic location. I dunno...excuses, excuses.

Washing line, moonshine, it's not fine.

Back Jack, do it again, but no... not enough sheckels this time.

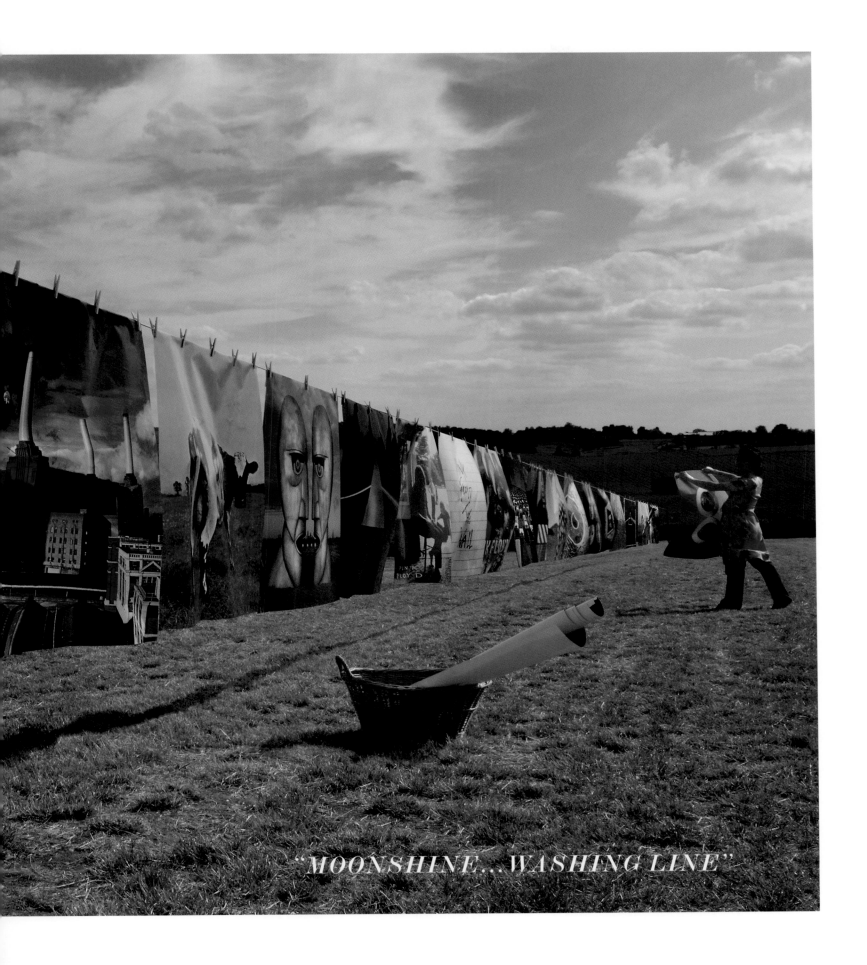

"MOONSHINE...WASHING LINE"

HERE

WISH YOU WERE SACD

I AM GOING to take a liberty. I'm going to show some work in progress - a project now half way through. It is not due for release until February 2008 (and strictly speaking might not make it to the finish, you never can tell). "You saw it here first", as they used to say in newspaper circles. The *Wish You Were Here* album is being remixed for 5.1 surround sound or SACD by the ever youthful James Guthrie. At the time of writing James has just organised a playback for the band, so folks, fingers crossed, though the grapevine tells me it sounds fantastic.

Like *The Dark Side Of The Moon* SACD (pg197) it seemed appropriate to re-present the imagery in a different fashion, same thing but seen differently, just like the music,

which would be the same thing but heard differently due to the remix (a remix tailored to the six speakers involved, which of course you have to go out and buy, being as you are living in a consumer society).

One of the features of the original *WYWH* cover is the involvement of the four elements of antiquity, Earth, Air, Fire and Water or, in our case, sand, wind, fire and water. Thus we decided to subject the original artwork, or print thereof, to the element in question, such that the burning man is now seen as a print on fire, the man in the desert is now a print buried in a desert, the diving man is a print viewed underwater and the veil is a cloth picture blowing in the wind.

Cute huh? Well, I thought it was cute, so there. Same imagery but presented differently, such that the listener would know that this one was the SACD whereas the previous was the Stereo. As you know, dear reader, in the Floyd's ongoing and conscientious aim to offer value for money, production detail is often paramount, thus the original picture of the man in the desert has been embedded in the same desert in which he was first photographed, namely the Yuma desert in California, though not in precisely the same spot. You can take attention to detail only so far.

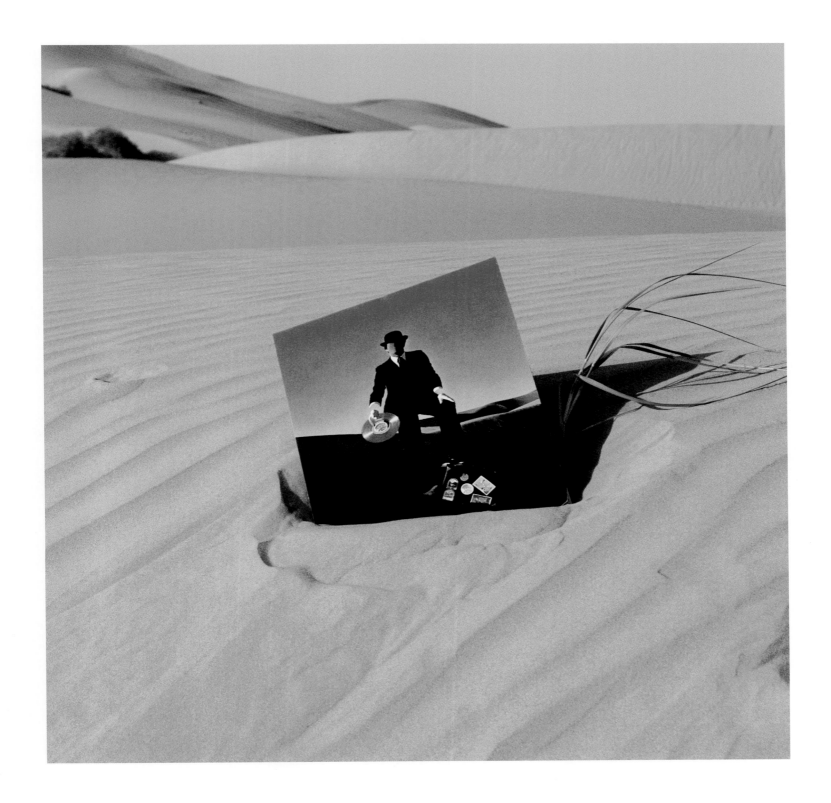

'Man In Desert' Wish You Were Here SACD 2007

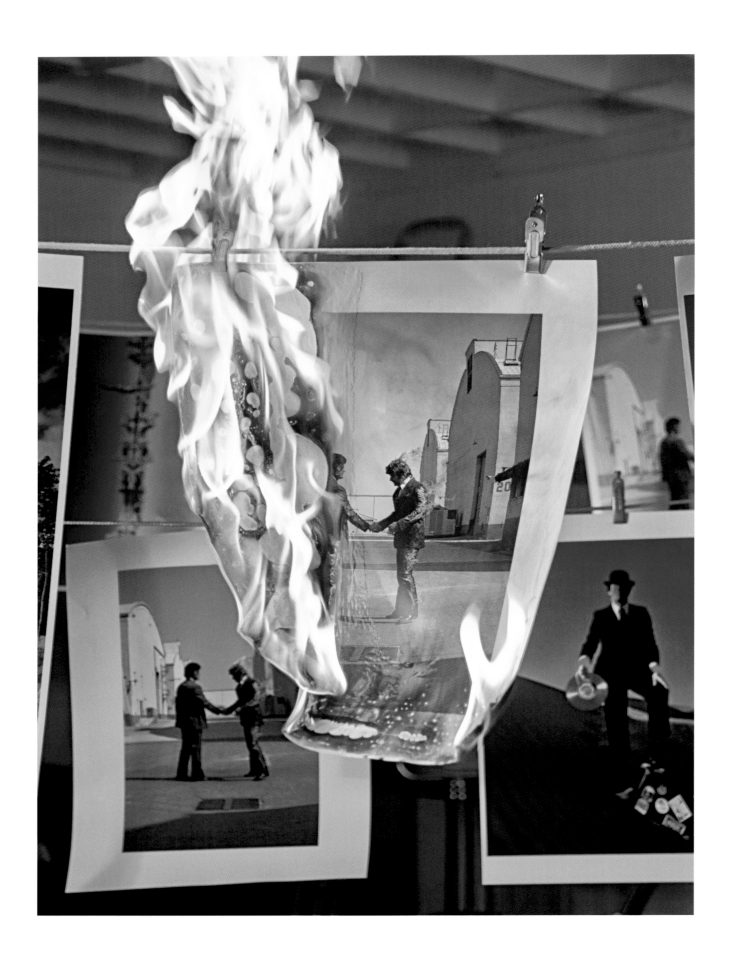

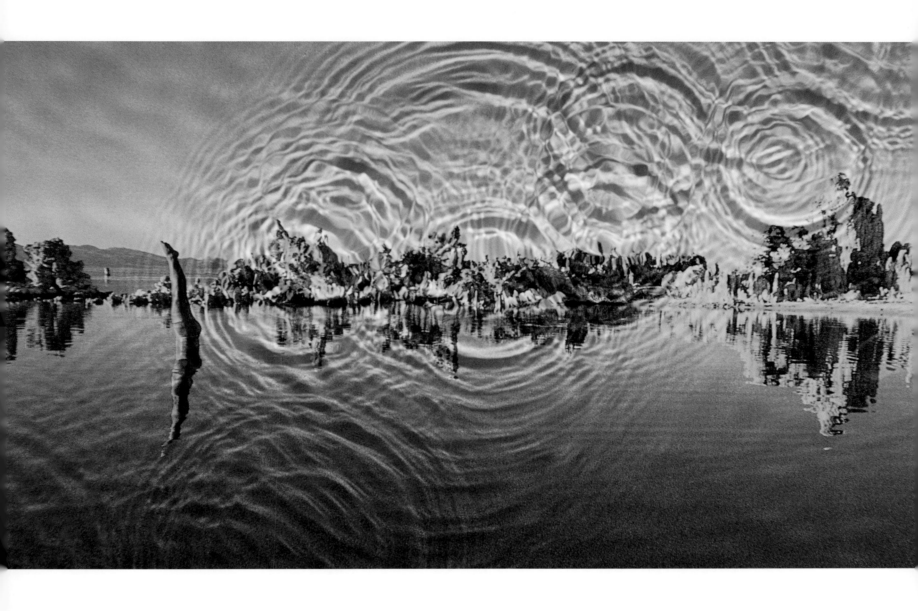

Wish You Were Here SACD
Burning Man On Fire - Watery Diver

What are the 10 greatest rock'n'roll bands in the world ever? (No guessing now, this game is serious business). Or, the shortened version, what is the number one best band in the known universe? Ever?

Firstly we had better establish some criteria/qualities (room for lots of home argument here). I tentatively suggest the following 14 divisions: consistency, chart positions, style/attitude, longevity, musicianship, live presentation, critical acclaim, column inches, songs, cultural importance, groove factor, record sales, size of audiences and, lastly, number of fansites or fanzines devoted to them. Then, once you've agreed the categories, you can award points out of 10 for each band in contention. Since there is no corroborative data to validate any of these, there's room for loads of disagreement and family enmity. What better way to spend an afternoon?

The next step is simple - having awarded the points in the specified categories for the contestants via rational debate and deductive reasoning (oh yeah?), you simply add them up and the band with the highest number of points is, of course, the greatest band of all time, ever, in the whole universe.

It may come as no great surprise that my unbiased opinion, after deep and exhaustive research, is... wait for it... that Pink Floyd are the world's greatest band. I simply refuse to consider any argument to the contrary (unless accompanied by money).

This is, clearly, all daft, but this year 2007 is the 40th anniversary of Floyd's inception - 'Arnold Layne' and *The Piper At The Gates Of Dawn*, their first single and album, were both released in 1967 — and that's forty years ago for crying out loud! Forty years! (It's time they retired, I can hear you murmur, but why? It is, after all, their prerogative... I always thought Keith Richard's response was very fitting when asked to retire. He replied: "They'll have to carry me off stage.")

In celebration - or is that exasperation? - we thought it appropriate to mark the occasion by the subtle deployment of forty images as a motif for a poster, fine art print, and t-shirt. At the time of writing these are proposals only and therefore not yet ratified. Same goes for the logos. We may of course be tempting fate... but we are over forty and don't give a fig.

DON'T YOU FIND those list books that people give at Christmas rather irritating? You know… the 10 best films, the 50 best lawnmowers, the 100 greatest records etc. You want to dislike them, but yet they are pleasantly distracting, and certainly nowhere near as annoying as TV programmes like the 100 best sex scenes, 50 films you must see before you die, 100 adverts that will make you a better man, or woman, the eight million worst reality TV clips and so on. Cheap television at its zenith. However, parlour games of a similar ilk played between family and friends are a different proposition, and can be good fun, sparking healthy and vitriolic argument, deep memory trawls, not to mention moments of ridicule, hilarity and sarcasm - kinda useless but kinda diverting. Let's play one now, or at least a shortened version.

OPPOSITE PF40TH FINE ART PRINT INKJET 2007

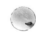

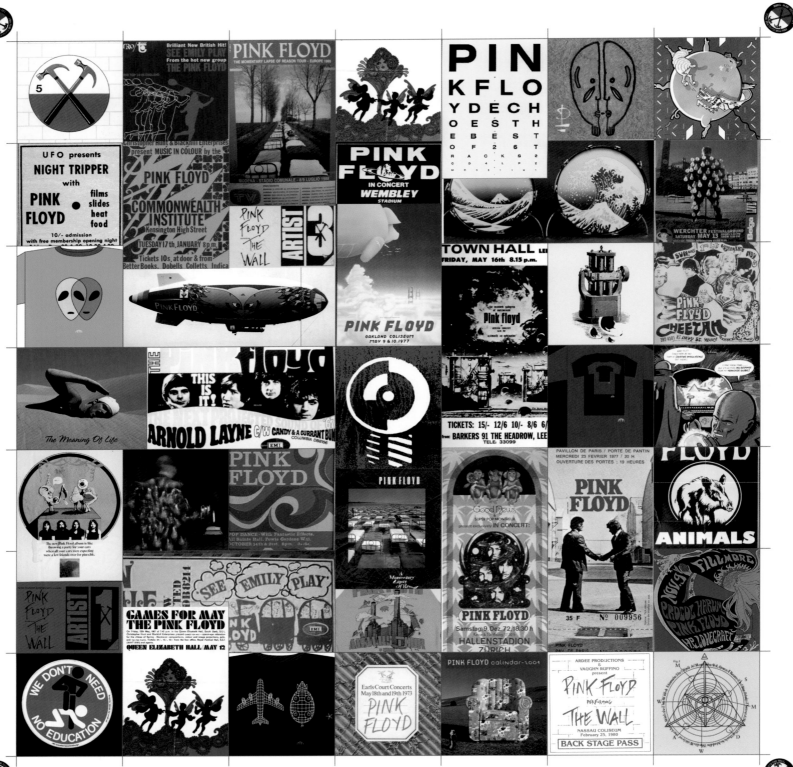

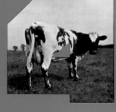

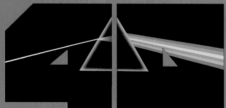
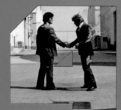

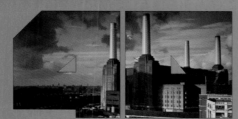

PINK FLOYD 40

I MEAN NO disrespect but I find Japan strange and fascinating, probably the most otherworldly place I've ever visited; alien, but in the purest sense of the word.

Three of the very best things in Japan are:

The bullet train, or shinkensen, or rather its timetable. The bullet train is never late - never? Can you imagine that? A train that's fast, comfortable and on time. It was mind-blowing for your humble reporter from Potters Bar. There I was standing on the Tokyo platform telling my interpreter Yuki that the train was a minute or two late despite her assertions to the contrary and I was saying it with a little smirkette of self righteousness, thinking to myself, "Huh, bullet trains are never late, my arse". Oh foolish me, for I had my back to the platform and turned to find the train right in front of me. It had slid quietly into the station without me hearing it, bang on time (as it was in Nagoya and in Kyoto and in Osaka, to the minute). "Yeah," said Yuki, "you were saying?" I was schtum until we reached Mount Fuji, racing on down to Osaka, but then couldn't say much 'cos the view was exquisite - a perfect volcano, identical to paintings and postcards, serene symmetrical and elegantly snowcapped.

Secondly, the food in Japan is brilliant though it is, of course, advantageous to like sushi and rice, but Shaba Shaba (wafer thin strips of meat and veg dipped into boiling water right in front of you) is something else, although in Osaka they do a pancake pizza kind of thing which was simply mouthwatering. I am not a food writer nor a foody so cannot describe accurately but if you like eating, my humble opinion is that Japanese cuisine is second only to Italian. Mind you, I say this with more than a twinge of conscience since half the world is starving and doesn't get to sample either.

The third amazing characteristic is the Japanese ability to make copies fastidiously, copies of anything, from cars to cameras, from hair pins to biros, displaying extraordinary attention to detail, in effect producing facsimiles that are often better than the real thing. Of particular note to this department are mini vinyls, CD size versions of old vinyl covers, be they single wallet, gatefold or even more elaborate constructions, containing inserts, mini posters, shrink wraps, etc etc. Whatever was in the original is duplicated but in miniature, and executed and printed well and faithfully. Sometimes known as paper sleeves, they are so much nicer than the dreaded jewel case and are nostalgic and functional - and just as good at housing yer more modern CD.

The entire Pink Floyd studio oeuvre, all fourteen albums, is planned to be re-released as CDs in said paper sleeves or mini vinyls, the whole shebang contained in a robust box and slipcase. Our design for the slipcase was an amalgam of *Ummagumma* and *Echoes* and here on the following page is the finished photograph, providing the band approve. (This book is so hot off the presses it is steaming.) The idea required a set build for we need to construct a special 'Floyd' room, full of suitable references, including custom wallpaper, framed portraits of the chaps and a short corridor opposite leading to a kitchen or study type area, in turn having a French window onto the garden bathed in daylight, against which a shadowy silhouette can be made out but not identified. One's viewpoint is into a mirror on the near wall which reflects the opposite wall and the aforementioned corridor. Similar framed portraits but of different guys hang next to the mirror on the near wall and next to the corridor on the opposite wall. Are you following the story? Remember this will be a photograph.... and the question is... what is the mystery, the conundrum, the impossible nature of Pink Floyd's durability and of this photograph?

Answers please with a fifty quid note to my mother.

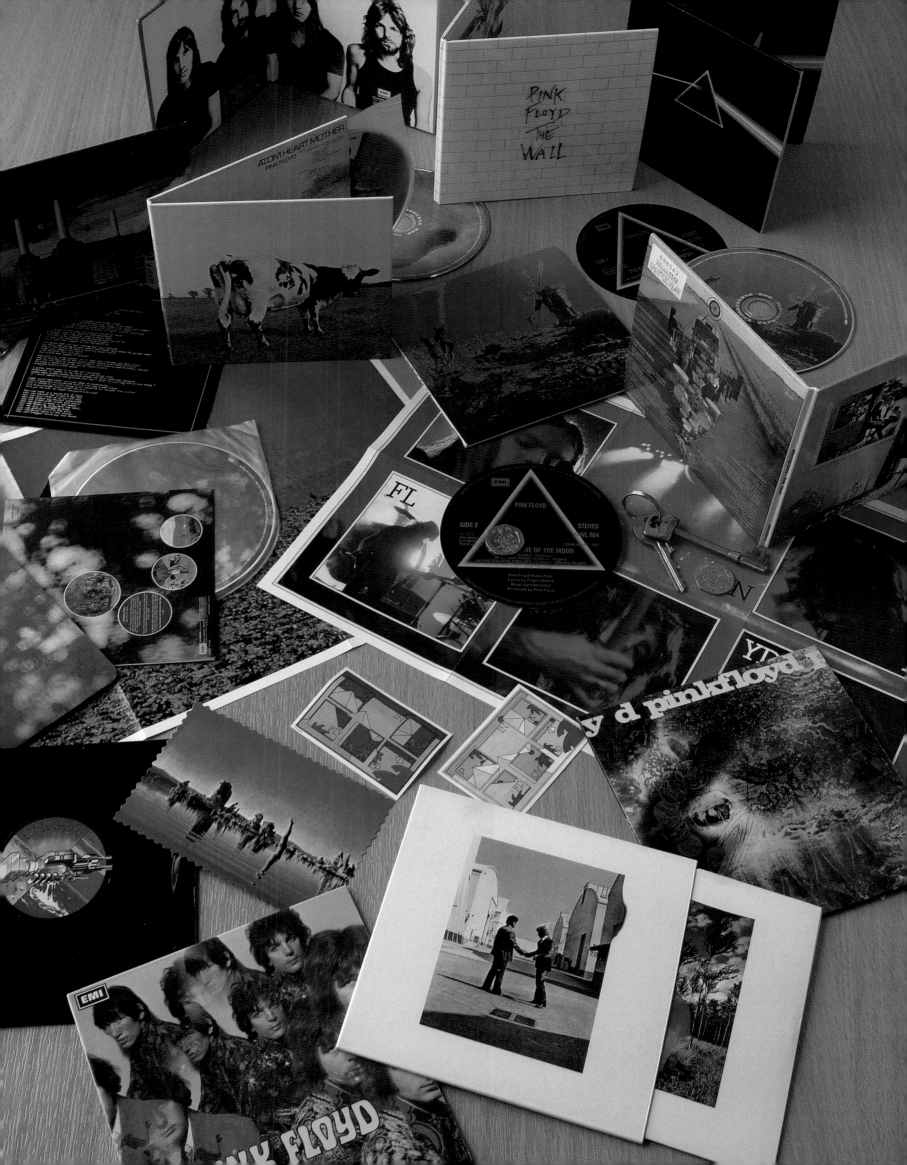

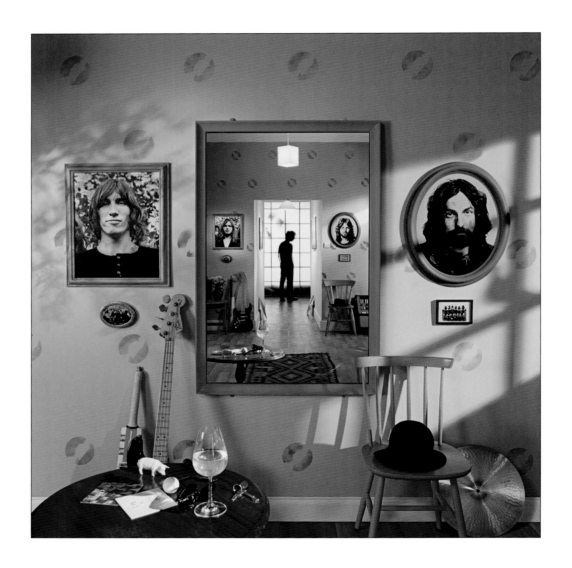

APPENDIX

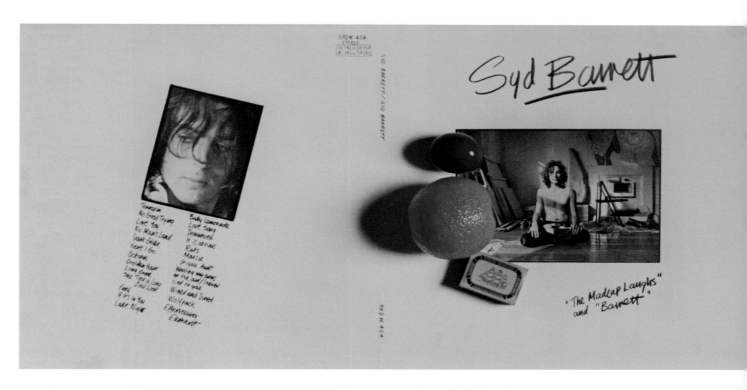

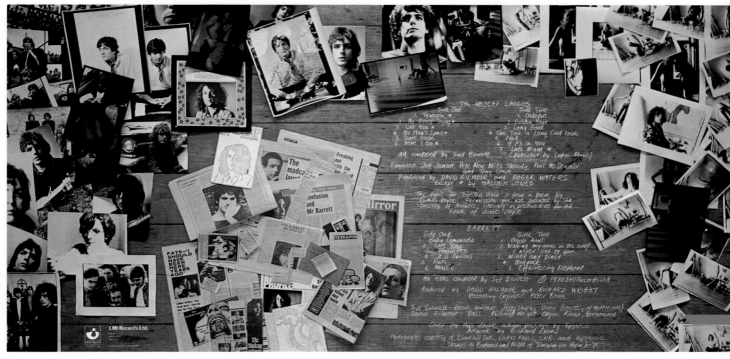

SO THERE SYD WAS in the early seventies cloistered in this warren of a place halfway between a hotel and a mansion block called, appropriately enough, Chelsea Cloisters. He was retreating inexorably into some isolated place far away from the rest of us. It was very sad. And very difficult to know what was the right thing to do. If he

SYD BARRETT

wanted to be alone, what could we friends say? I think most, if not all, of us were having enough trouble coping with our own problems and didn't have enough of a clue, or sufficient conviction, to take matters in hand.

I visited once, walked slowly down the cream coloured corridors, with their unremitting drabness and featureless walls, and knocked on his door. No answer. I heard movements within. I knocked again. I said it was me. Nothing. A week or two later I returned and knocked on the same door and said I'd come to talk to him about an album cover for the double album (re-release of his two solo albums) that the record company were planning to put out. He responded this time. He told me to fuck off. He didn't want any photos. I repeated that it was me. He mumbled again that he didn't want any photos and would I go away.

I went away feeling sad. Not rejected, because it wasn't like that. Just sad. It seemed that he was out of reach. Whatever problems were there, if the man didn't want to be involved then that was the way it was. Po and I discussed the issue, possibly with David as well, and decided that in all probability Syd could do with the royalties, the record should go ahead, and would therefore need a cover, and we should do it rather than the record company (or anybody else). Syd himself was not in a condition to do it. I made up the design (previous page) from photos already taken at the *Madcap Laughs* session and added special insignia – plum, orange and matchbox – from one of Syd's journeys in space (see page 15). We didn't incorporate these objects as two-dimensional graphics, or a collage, but as a three-dimensional event, placed on top of the Syd portrait. In addition we inscribed the titles on the same photo and then attached the back photo and track listing onto the same surface, and the

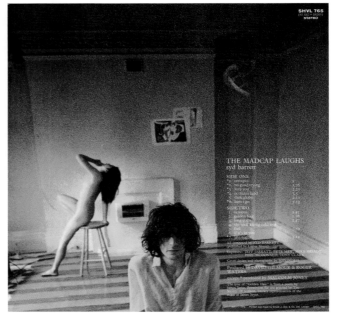

logo and catalogue number, then re-photographed the lot. In this way there were no additions, no dropped-in graphics. Everything was real. There at the time. The plum, orange and matchbox are particularly real, sitting up (casting shadows) strong and vivid, like they were to Syd way back in 1966 in David Gale's garden in the sunshine of our youth.

But things were different for *The Madcap Laughs*, which is on the opposite page. This was Syd's first solo album. It seemed probable, if not desirable, that the best way to capture his dislocated and haunting uniqueness on the sleeve design was to take a portrait. A photo session was duly arranged at Syd's request in the flat in Earls Court that he shared with the painter Duggie Field. Unlike the time at Chelsea Cloisters, Syd was very enthusiastic, albeit in a scatty fashion, and felt energetic enough to paint his own floorboards in strips of alternating red and blue. He cleared the room except for a small vase of flowers, and proceeded to take the position you see opposite, crouching like an alert animal, no shoes, and hair straggly and unkempt. I didn't do much. It was mostly him. Which is perhaps why it has particular, yet elusive qualities, very ordinary and conversely very strange. My only decision was to use a 35mm camera (to adapt to Syd's mercurial moods) and upgraded colour transparency, partly because of the low level light conditions, and partly for the grainy effect. Artificial light (flash) seemed unnecessary, given Syd's personality and changeability – I thought I needed to catch him on the run, in case I missed him or a particular moment, when his spirit might have been fleetingly available.

Friend and photographer Mick Rock, later famous for his Bowie photos amongst many others, also came on this photo session, but I can't remember why. I think it was to help me, which seemed ironic given his subsequent lensmanship and success in the rock business, especially in New York.

Also present was a naked girl, as you can see on the inset picture here. This was the back cover for *The Madcap Laughs*. I don't know where she came from, who she was or where she went. There were always girls around Syd, for as long as I can remember.

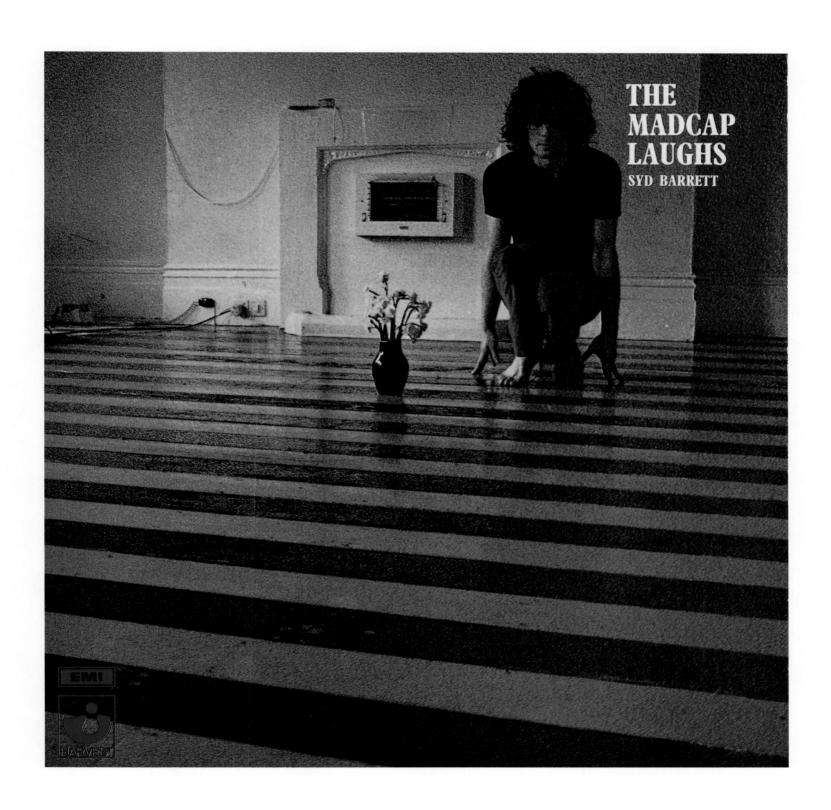

FRONT COVER THE MADCAP LAUGHS 1970

DAVID GILMOUR

THIS INSET PICTURE is of David Gilmour's first solo album succinctly entitled *David Gilmour* in order, I guess, to separate it clearly from the Floyd oeuvre. The photograph is taken with a Hasselblad using wide angle lens, available daylight and colour negative film. The location is the rear of David's house in Essex back in the strange old days of a previous existence. The other gentlemen in the shot are drummer Willie Wilson and bassist Rick Wills. These are good friends of David's and were part of a group called Flowers, after Jokers Wild and before Pink Floyd. What's in a name, eh? Roger answered this in an interview once just after *WYWH* by saying the name 'Pink Floyd' was worth a million units in and of itself, whatever the music on the album. Some people think he underestimated.

I used colour negative because it's softer than transparency and a little warmer. I also used it so that I could print it through some intervening transparent material in order to impart a texture to the finished artwork. In our time we have used muslin stockings, handkerchiefs, lingerie, various bits of plastic, etc, etc, but in this instance it was the neg bag, the greaseproof-like paper in which negatives are protected, and this is what gives the mottled effect.

On the page opposite is David's second solo album *About Face*, titled I think, to indicate his turning the other way, ie going his own way, not just the Floyd's way. But I could be wrong. Perhaps the title refers simply to his vanity. Or to his flexibility, though once he's set his mind, it's not that easy to change. In the shifting world of rock 'n' roll, this is a good thing, and a great strength. My impression is that he doesn't suffer fools too gladly, has little stomach for record company bullshit, no blind faith in popularity ratings or press adulation and is very dependable, especially on tour, where he manages to remember lots of lyrics and play pretty good nearly every night – and he's not bad looking either, as you can see. The photo opposite was part of a session taken by Charlie and Star, in a studio in London. They used a Hasselblad with normal lens, flash lighting and a backdrop of painted canvas. This particular snap is taken when David is slightly off guard, in between more formal shots, perhaps when he's asking where someone has gone, or where the loo is.

I know it's bordering on the sentimental but I'm going to say a few words. David is a good friend, especially in the support department. If the shit hits the proverbial fan he will be there. One might have to call him, but he will arrive. In some form or another. His stubborn streak, so useful in the shark-infested waters of the music business is, of course, less helpful in the world of personal relationships. You have to beat the door a bit. We have known each other for thirty-five years or more since I went to watch him sing Beach Boy harmonies so beautifully in the Dorothy Ballroom in Cambridge in a group called Jokers Wild. He was allowed into our peer group, despite being two whole years younger, on account of course, that he was good looking and a wiz with the guitar. We have had a friend/working relationship since *Saucerful* and it has gone on so long that it is part and parcel of our lives. That doesn't mean that there aren't occasional heated arguments and disagreements. Some protracted differences of opinion even…but awkward as it often is to be friends and work together, I just have to say that it has been very fruitful and enjoyable, and a measure of our respect and affection that it has lasted. A good long innings, if you know your cricket.It may not last much longer once he's read this little piece, of course. Sentimental twaddle, I can hear him say.

Opposite Front cover About Face 1984

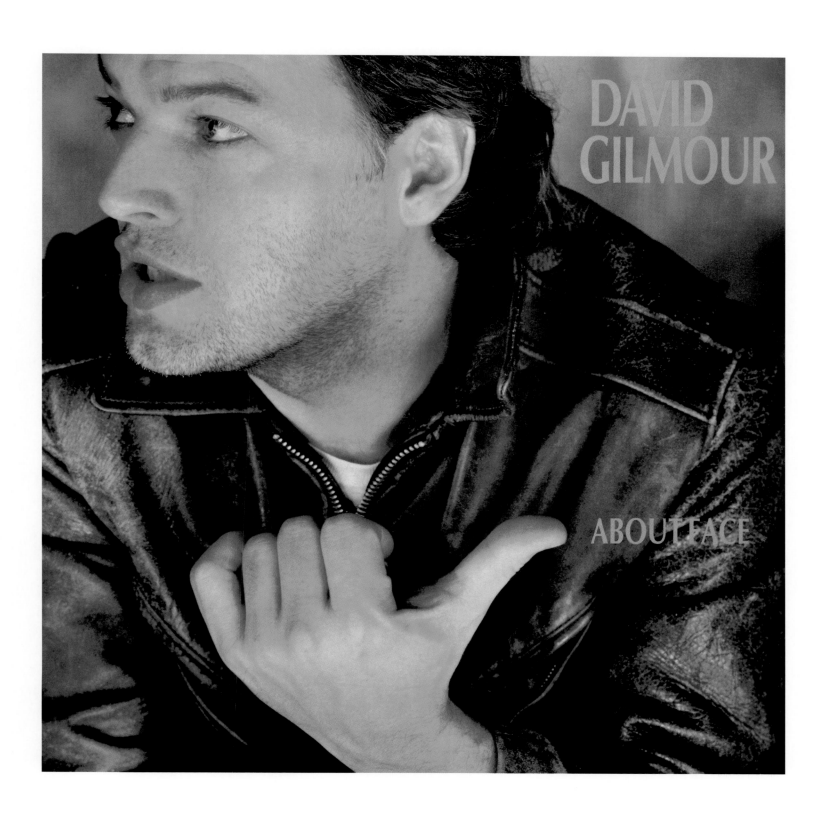

WORK BEGETS MORE WORK.

Ideas beget more ideas. It's not that
one image sets off another exactly, more that the feelings
and perceptions that inform an image resurface or reappear
in another guise to inform a subsequent image…especially if
the first image is unused or unsold. (For a commercial artist
ongoing work is not only central to his economy, it also leads
the eye and mind into further work.) At this point the set of
emotions, or pattern of thinking, hasn't found a home, a hook
upon which to hang, and it floats around the airwaves
untethered, clogging our heads, demanding like a late
pregnancy to be let out — which is what happened here.

Rick Wright, keyboard player, new father and doyen of
fashion (see page 26) decided to make a solo album in
conjunction with Anthony More. Rick assembled some fine
musicians (including Tim Renwick, Pino Palladino and
Manu Katché) and embarked on an ambitious and unusual
journey. He devised an album in four parts telling the
imaginary story of an abused life — firstly a child's
uncomfortable experiences, then the early teenage years of
rebellion or escape, then the young adult's emotional decline
into neurosis and depression and finally some partial break-
through and recovery via therapy. The album is dedicated to
"those brave enough to face their past".

The CD booklet is therefore divided into four parts to
represent the appropriate sections plus one separate unrelated
spread for the credits. Each of these four parts has a similar
format, but different elements — a focused item floating on an

unfocused background, like Rick's melody 'voice' against a
background swash of keyboard chords. The spread shown
here is for part three — a wheel in blurred motion, like the
mind cracking under stress, spinning in circles like a
whirlpool into which the poor depressive is sucked. Overlaid
is a sharp, small, clear item, the broken twig, representing the
snapped mind of a person descending into confusion
(reminiscent of the snapped twig in *Momentary Lapse* page
123). We enjoy devising defocused backgrounds (see
Obscured By Clouds) either by short focus, motion blur or
time lapse, all of which are used in this booklet.

The main image for the CD front is on the page opposite
and derives from Rick's scheme of things and other details he
supplied in the original brief. But it also derives from a design
Pete and I submitted to 10cc a year previously, which they
turned down. This consisted of a man holding onto a large
hula-hoop through which a diver is passing from night-time
within the hoop to daytime outside. The standing figure, plus
hoop, made the number ten (you might think this obvious but
they didn't notice it). For *Broken China* the hoop was
transformed into a ring of water, a liquid disc suspended in
mid air, through which the diver is passing, changing from
flesh and blood to broken china. This design is supposed to
work graphically as a diagonal bisecting the space. Here the
diver stretches corner to corner. On the actual CD cover both
the diver and the axis of the disc of water go corner to opposite
corner. Like a cross dividing the space into four, or X marking
the spot. The design is also supposed to echo the music visually
— the refined nature of Rick's lead lines etched against the
dark background key-board swashes.

Metaphorically the design attempted to represent the idea
that something in one's past can affect one's behaviour later in
life. An event (a trauma) is the early input, which is then
submerged for some time in the unconscious, to re-emerge
much later as a disturbed emotional state. The water is the
psyche, the initial event is the entering and the subsequent
effect is the leaving. The personality was initially intact (the
legs), but surfaces later as a fractured entity (the torso). The
child is treated badly or emotionally abused and the resulting
adult is impaired, or confused and scattered, broken like china
into disparate pieces, needing to reassemble in order to recover.

OPPOSITE FRONT COVER BROKEN CHINA 1996

NICK MASON

(nm)

OKAY, YOU SPORTING TYPES out there, do you know what this picture is? Well, it is a photo of something, with added photographic textures and a couple of painted lines. But a photo of what, precisely? It was designed for the front cover of Nick Mason's solo album with Carla Bley, called *Fictitious Sports*. The idea was to design a sports pitch for a game that did not actually exist. We decided that the markings must bear some resemblance to real sports pitch markings or else the design would become too much of an art piece, a graphic or abstract painting. And that wouldn't be very sporting of us.

It was important that the different textures were (photo-graphically) real. Though we used actual playing surfaces, they are arranged unusually — such playing surfaces are never adjacent in real life. We seconded graphic designer Geoff Halpin to devise the fictitious sports pitch, and to embody its geometric principles in the rest of the package design. I then photographed the different elements to fit Geoff's graphic plan.

Despite the use of diagonals, which I like, despite risking my precious neck hanging out of the cherry picker basket 50ft above the ground, despite the exact fitting of the different textures and even despite the pair of shoes visible in the top left-hand corner niftily placed to give scale, I have some misgivings about the design. Not about the technique, which consisted of masked multiprinting onto a single photographic piece of paper (such masks made on clear acetate film according to Geoff's precise instructions). Not about the artwork, which is a neat mix of graphic and photographic media. And not about the idea, which relates well to the title. I think it's a problem with 'prolonged' aerial views. They are so removed from our everyday experience that they are in some way uncomfortable. Perhaps I actually suffer from mild vertigo. Every time I look at it I remember being queasy in the bucket. 'Queasy in the bucket' — that sounds like a fictitious sport.

For you sporting types this is an aerial photo of the corner of a bowling green, some of the grass 'replaced' by tarmac, sand and red clay from a tennis court. For photo types this is shot on Hasselblad using Ektachrome colour transparency by available daylight from the aforementioned 50ft high bucket.

RELICS

WHEN WE BEGAN the 'all purpose Pink Floyd CD repackage make over programme' in '93, it seemed only fitting to 'remaster' the designs to accompany the remastered music. For example *Dark Side's* prism graphic was 'remastered', or refined, as a proper photograph. But how could we remaster *Relics*, which was originally a quirky line drawing by Nick Mason. We couldn't clean up the lines (they were already clean). Couldn't redraw it, or it wouldn't be what it was.

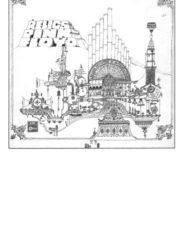

We had recently met John Robertson, sculptor and model maker, who had constructed the metal heads for *Division Bell*. We pondered the feasibility of turning Nick's drawing into a model, an object, a three-dimensional sculpture. The drawing was after all of a thing — a weird and wonderful thing — but a thing nonetheless. Being as faithful as possible to both the original intent and the actual shape and proportions, texture and fittings, we set about building a wooden model. This was conceived in the manner of those large, incredibly detailed, models of boats, yachts and steamers that sit in the foyer of shipping companies and yacht clubs gathering dust.

So that's what we did, and that's what Tony photographed. Jon Crossland designed the graphics. And the model, much like its natural, realistic counterparts, sits appropriately enough in the offices of Nick Mason. That's Nick Mason RN to you.

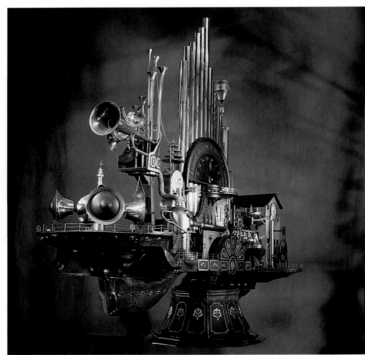

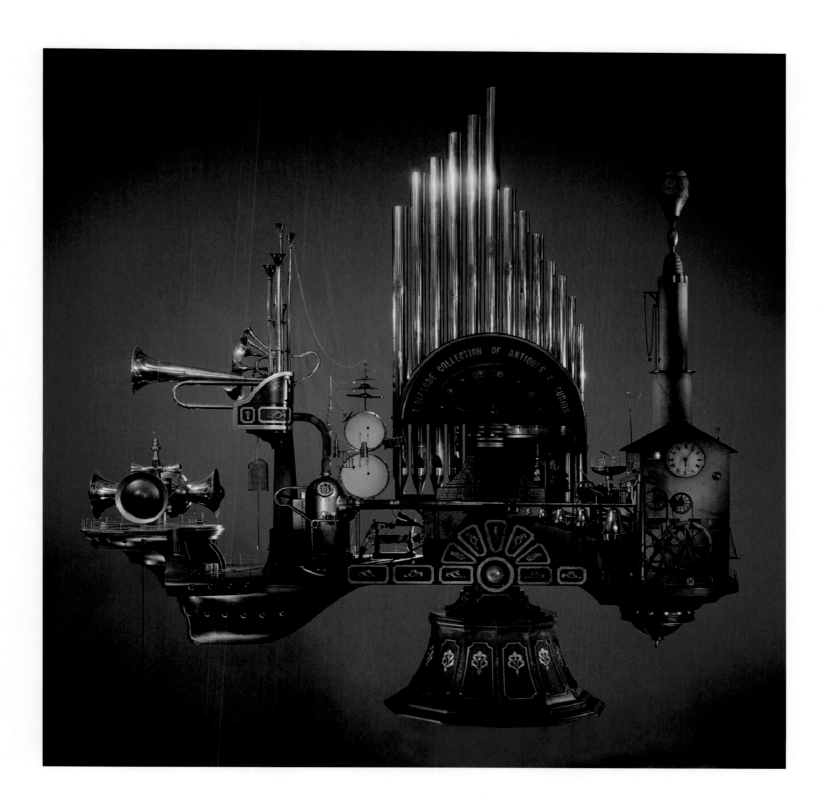

NICK MASON, DEBONAIR DRUMMER, brilliant pastry chef and fearless racing driver, completed his long awaited book, *Inside Out*, a personal history of Pink Floyd, in 2004. He asked us to come up with some ideas for the book's cover, which we duly did, and we tried our hardest to reflect the history involved yet at the same time offer something quirky if not new. Of the roughs submitted I liked our cow with milk bottles on the outside and our Magritte pig in the woods, most particularly the flying dog, appearing suddenly from the fore-deck hatch of a boat (see adjacent).

Nick was not overly keen on animals, so these ideas were soon jettisoned. He preferred the mirror design (opposite) whereas the publisher preferred the contortionist lady (pg 246), her body painted with Floyd imagery, turning herself 'inside out'. Strange to relate the publisher asked his marketing department for their views on these competing designs and surprise, surprise, they preferred the mirror. This was an unexpected twist of the tale — 'Marketing department prefers arty obscure piece to more obvious commercial imagery shock' — and all very unexpected, very inside out one might say. We got to use both in the end, one design staged outside, the other staged inside. Outside in, Inside out.

The mirror design was part of a long running theme or inquiry into the very nature of things, visually speaking, and it followed from some ideas my colleague Peter was exploring, about seeing the other side or the back of things, not just the front which is the view more usually presented. What one sees as a sphere, the moon front on, is in fact revealed as only half a sphere in the mirror, and we can now perceive what it's made of too, namely a type of Emmental, or holey cheese, since as of course you know, and we know, the moon is made of cheese. The shadow cast on the ground is yet a different shape. All in all, what you see is what you know only when you see it from all angles, when you know it inside out.

The contortionist lady turning herself inside out is more straightforward but was at first very disappointing, largely because the painted imagery was poorly executed though the shapes she made were very interesting, one particularly reminiscent of the Manx symbol, very elegant and pretty damn hard to do - the hardest one in the book according to ol' bendy boy himself, one Dan Abbott from sunny Rushden. It is fairly stupefying to see contortionists close up doing their thing. It looks easy until you try it, and then you realize how much effort and skill goes into it, not to mention good genes. It simply appears impossible, especially to maintain the position for several minutes while being photographed, utterly impossible.

We held auditions in our modest studio and discovered later that two of the only three who turned up were related, first cousins I recall. It made for a weird sensation - maybe all the contortionist in the greater London area might come from the same source, some super-granny contortionist whose convoluted shapes were legendary. The only known person to do the three legged swap over whilst making dinner. I josh but contortioning is serious stuff and is a skillful and dangerous business. Please do not try this at home, or make your younger sibling imitate our image. Thank you.

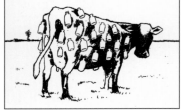

Back cover Inside Out 2004

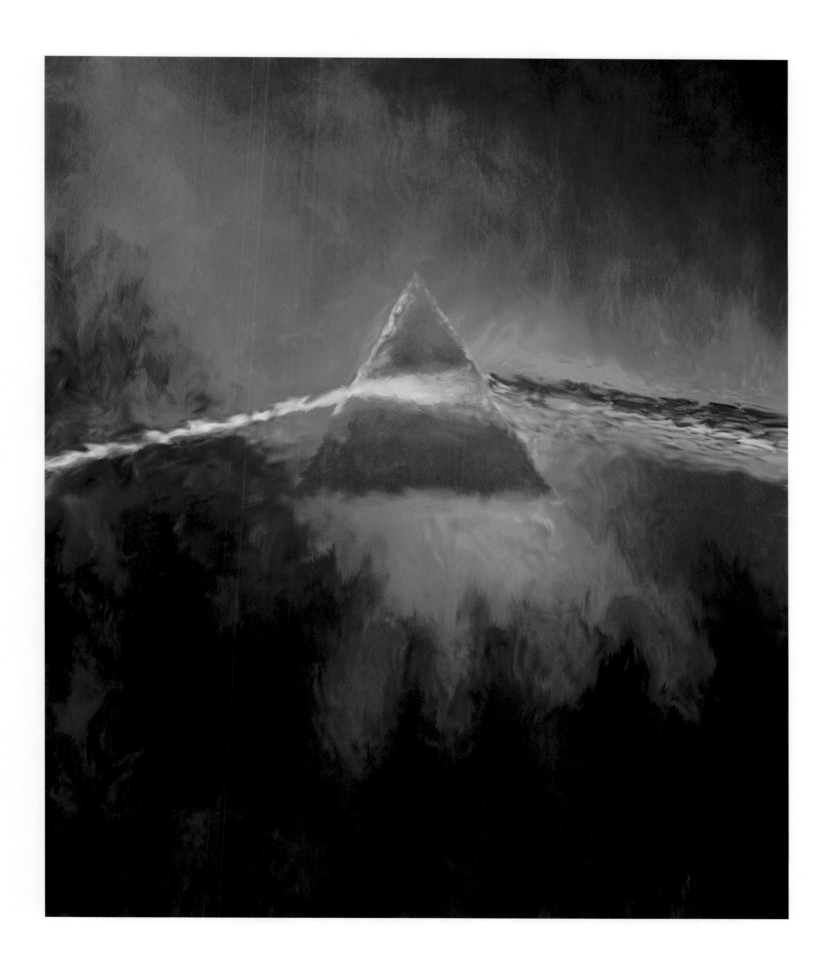

ROGER WATERS TOURED in 2006, playing *The Dark Side Of The Moon* in its entirety. In recent times Roger has not been part of Pink Floyd technically speaking, and probably not legally speaking, and perhaps not even ethically speaking, though historically and creatively he is essentially an integral part. Fans may see him still as founder member, or a 'true' member. Roger's manager, the urbane Mark Fenwick, asked me if they should/could use the original prism design to promote Roger's gigs and I said definitely not, it is forever a Pink Floyd thing, not a Roger thing. However *Dark Side* is *Dark Side* so I suggested a reworking of the idea to provide something redolent but different, though in retrospect this may look a bit thin. I think I really felt that I'd better do it lest they ask some other joker, who might screw up our 'precious' design - I didn't want someone else messing with my bits (would you?), a more pronounced feeling now since doing the *Dark Side* SACD (pg 196). But where to begin? How was this going to work? How to make it interesting, especially after completing said SACD?

When in doubt, go silly, look for lateral thinking, head into the unconscious... Roger's first gig was in France so let's be French, let's be painterly, and not graphic or photographic. Okay, name a famous French painter. How about Monet, 'cos it sounds like 'Money' of course (a song you may recall from *DSOM*) and Monet is impressionistic and thus tres Francais and tres painterly. We used an outtake from the archives, gave it to le grand Badgere and asked him to make it like Monet, just like that. "Haven't you got an impressionist button on your fabulous compooter monsieur Badger," we asked, and he replied, "Mais oui," and he did it promptly and brilliantly, including a fake signature. A little tidying and amending and adding an arrow and a few squirty bits and it was done - a painted version of the prism and spectrum in green, the proverbial colour of money, and we thought it was indeed tres bon, as did the French promoter. Not to be too narrow minded, we also attempted a cubist prism and a pointilliste version after Seurat, which were rejected, but dotty Seurat deserves an airing, so here he is.

We then concocted a Monet gold version for Roger's gig in Istanbul and then a purple one for his gig in Rome, purple seeming like a suitable colour for the imperial legions. Roger stopped on the purple but we carried on, fools that we are, and submitted a further set of 'homages' for his US tour, prisms in the style of so and so, of Jackson Pollock, of Andy Warhol, West Coast psychedelia and, of course, in the style of pop artist Roy Lichenstein, a homage to the homager par excellence. Roger did not go for any of these, but Peter's splendid rendition of a 'Lichenstein' was used by Italian Rolling Stone as a special cover for the gig in Rome (pg 251).

When in Rome do as the Germans.

ROGER WATERS

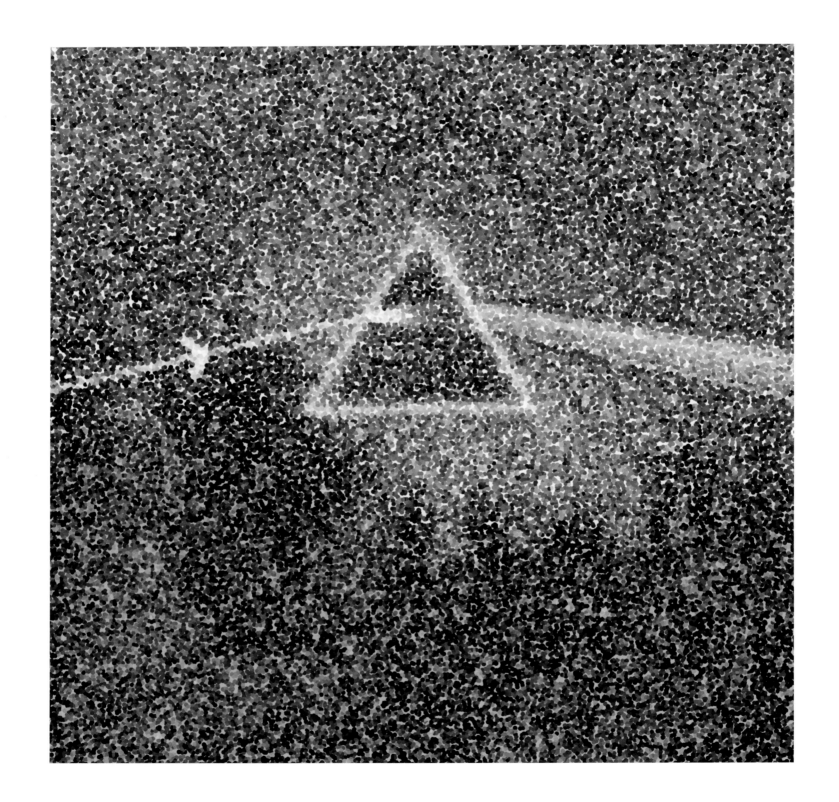

'Apres Seurat' poster demo 2006

INDEX

L'EQUIPE COURANT

STORM THORGERSON BORN IN MUTTON LANE, POTTERS BAR, FIFTEEN MILES NORTH OF LONDON IN 1944, EDUCATED AT SUMMERHILL FREE SCHOOL, BRUNSWICK PRIMARY AND CAMBRIDGE HIGH SCHOOL. BA HONS IN ENGLISH, LEICESTER UNIVERSITY; AND MA IN FILM & TV FROM THE ROYAL COLLEGE OF ART. SELF-TAUGHT PHOTOGRAPHER AND GRAPHIC DESIGNER. FOUNDED HIPGNOSIS WITH PO (AUBREY POWELL) IN 1968 DISBANDED IN 1983. AUTHOR SEVERAL BOOKS ON ALBUM COVERS. FILM DIRECTOR OF NUMEROUS ROCK VIDEOS, LONG FORMS, COMMERCIALS AND A FEW TV DOCUMENTARIES, AND HAS CONTINUED DESIGN VISUALS, ALBUM COVERS, POSTERS, ETC FOR ROCK'N'ROLL BANDS ESPECIALLY PINK FLOYD OF COURSE, UNDER THE AUSPICES OF STORMSTUDIOS - A LOOSE AND CHANGING AFFILIATION OF DESIGNERS, PHOTOGRAPERS AND ILLUSTRATORS (PETER CURZON, DAN ABBOTT, RUPERT TRUMAN, FINLAY COWAN AND SOMETIMES LEE BAKER, WHEN HE BEHAVES).

BROUGHT UP ONE GREAT SON BILL, THIRTY-FOUR. NOW LIVES WITH BARBIE, WHO HAS TWO CHILDREN OF HER OWN, AND THREE CATS IN WEST HAMPSTEAD, LONDON.

PETER CURZON BORN IN WARE, HERTFORDSHIRE IN 1965. HE WAS EDUCATED AT VARIOUS SCHOOLS IN EAST ANGLIA BEFORE STUDYING GRAPHIC DESIGN AT COLCHESTER INSTITUTE AND BARNET COLLEGE. AFTER GRADUATING IN 1986 HE WORKED WITH KEITH BREEDEN AT DKB DESIGNING ALBUM COVERS FOR ABC, THE COMMUNARDS, GANG OF FOUR AND OTHERS.

SINCE 1992 HE HAS BEEN WORKING FOR HIMSELF AND WITH STORM ON A VARIETY OF PROJECTS INCLUDING DESIGNS FOR AIRSHIPS, RACING CARS, EXHIBITIONS, WEBSITES, BOOKS, A MUSIC FESTIVAL, DVDs AND ALBUM COVERS. LIVES IN EAST FINCHLEY WITH SALLY AND THEIR DAUGHTER MABEL.

DAN ABBOTT BORN 1969 IN RUSHDEN, NORTHAMPTONSHIRE, BUT ESCAPED TO LONDON 22 YEARS LATER, AND HAS NOW FULLY RECOVERED. SELF-TAUGHT ILLUSTRATOR AND DESIGNER, ENJOYS TAKING A LINE FOR A WALK. HAS SO FAR BEEN COMPLETELY UNSUCCESSFUL IN CURTAILING HIS CHRONIC RECORD BUYING HABIT, ESPECIALLY LESSER KNOWN 65/69 TRANSWORLD EXOTICA.

RUPERT TRUMAN BORN 18 MAY 1960. AFTER GRADUATING FROM KINGSTON UNIVERSITY WITH A BSc HONS. IN GEOLOGY, HE PURSUED A SHORT CAREER IN THE OIL INDUSTRY BEFORE BECOMING A FREELANCE PHOTOGRAPHER IN 1986. HIS PHOTOGRAPHIC WORK IS DIVERSE - ENCOMPASSING ARCHITECTURE, INTERIORS, LANDSCAPE, STILL LIFE, AND STORM'S PROJECTS. HE HAS WORKED WITH STORM SINCE THE LATE 80s, PROGRESSING FROM TEA BOY TO PHOTOGRAPHER-AND-TEA-BOY. THIS HAS BEEN AN EDUCATION IN ITSELF.

FINLAY COWAN BORN IN OXFORDSHIRE IN 1966, THE SECOND SON OF SCOTTISH PARENTS. SELF-TAUGHT, HIS MAIN INTERESTS ARE ARCHITECTURE AND FORGOTTEN STORIES OF HISTORY. HIS HOBBIES ARE BURYING TREASURE AND INVENTING NEW FORMS OF SLEEP.

ALSO THANKS TO JON CROSSLAND, TONY MAY, SAM BROOKS, LEE BAKER, JULIEN MILLS AND JOSHUA RICHEY.